This edge
hardlined

Soft over round

form into leg

Hard line
of arm

hole into
leg--use
 to attach

Ebony plugs

form into
seat

Lestuneh on
same This
point

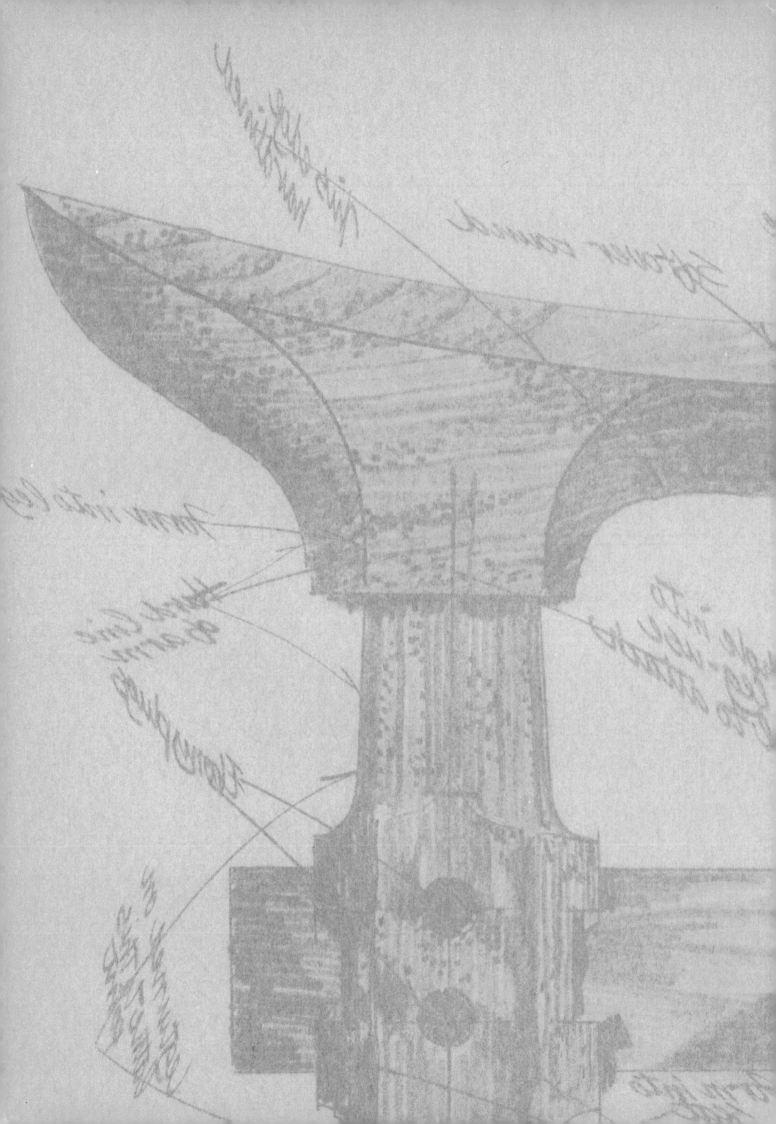

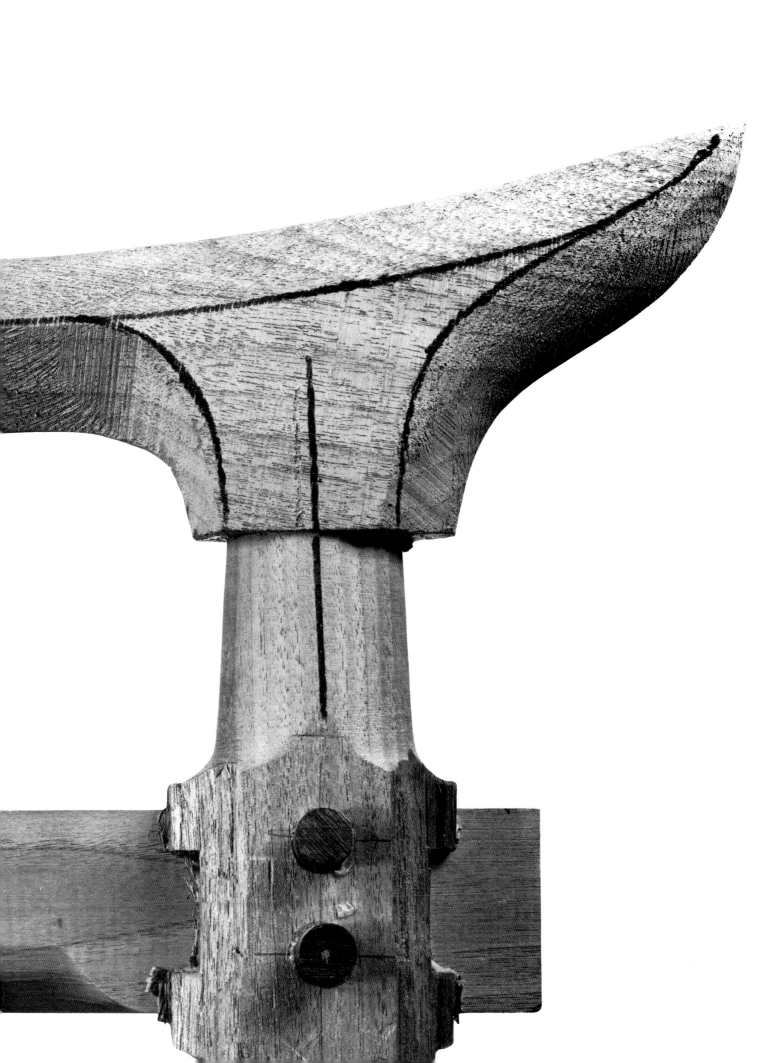

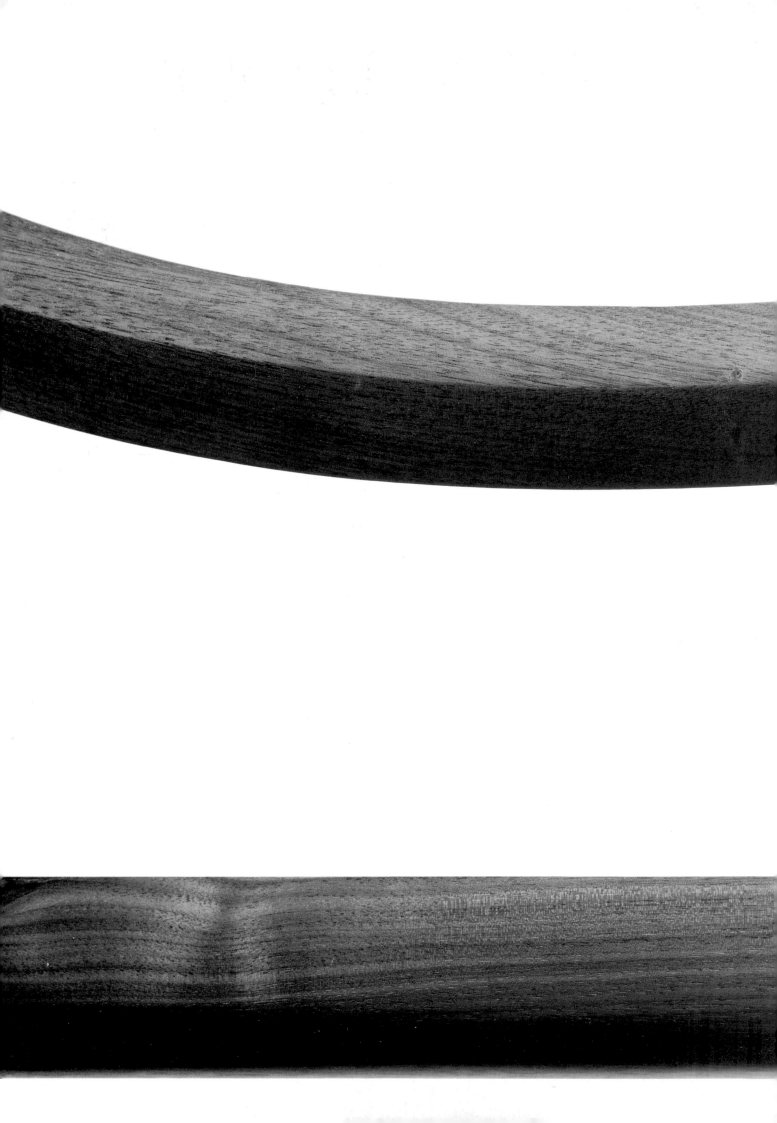

SAM MALOOF
WOODWORKER

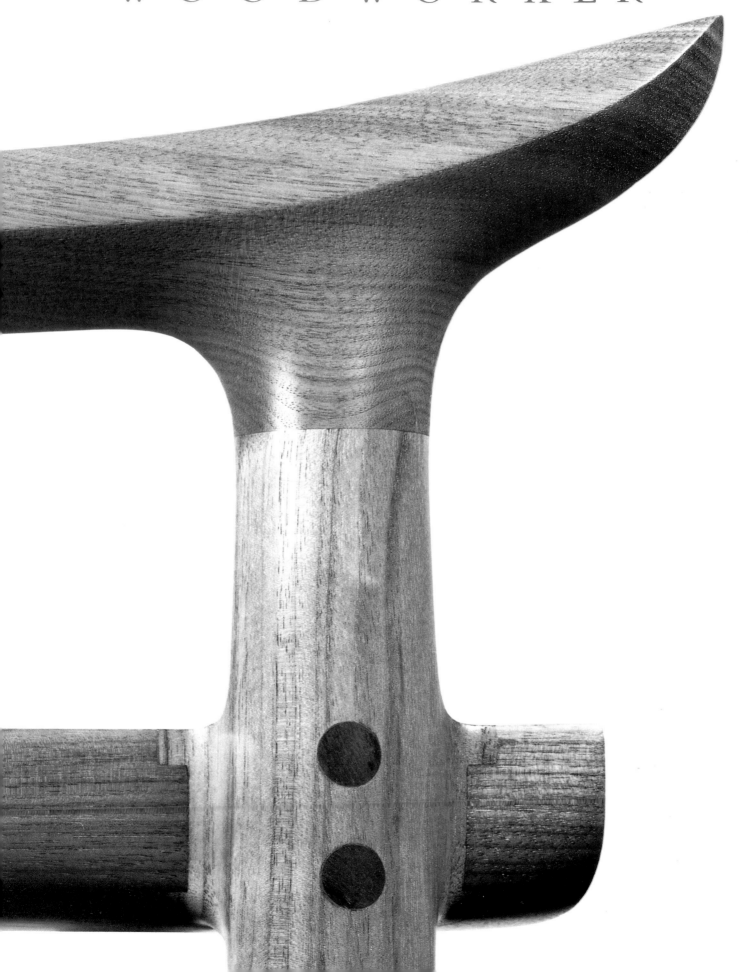

SAM MALOOF
WOODWORKER

By Sam Maloof

Introduction: Jonathan Fairbanks
Photographs: Jonathan Pollock
Book design: Dana Levy

KODANSHA INTERNATIONAL
Tokyo • New York • London

Design: Dana Levy
Jacket photographs: Jonathan Pollock

JACKET, FRONT: Walnut rocking chair, Sam Maloof's most
famous design (see pages 122–23).
BACK: Spiral staircase in Alfreda Maloof's studio.

Distributed in the United States by Kodansha America, Inc., and
in the United Kingdom and continental Europe by Kodansha
Europe, Ltd.

Published by Kodansha International, Ltd., 17–14 Otowa 1-chome,
Bunkyo-ku, Tokyo 112–8652, and Kodansha America, Inc.

First edition, 1983
First paperback edition, 1988
ISBN 0–87011–910–9 (U.S.A.)
ISBN 4–7700–1410–4 (Japan)
10 09 08 07 06 05 04 20 19 18 17 16 15 14 13 12 11

Library of Congress Cataloging-in-Publication Data

Maloof, Sam.
 Sam Maloof, woodworker.

 Bibliography: p.
 1. Maloof, Sam. 2. Furniture—United States—History
—20th century. I. Pollock, Jonathan. II. Title.
NK2439.M28A4 1988 749.213 88-23104

www.kodansha-intl.com

For Freda

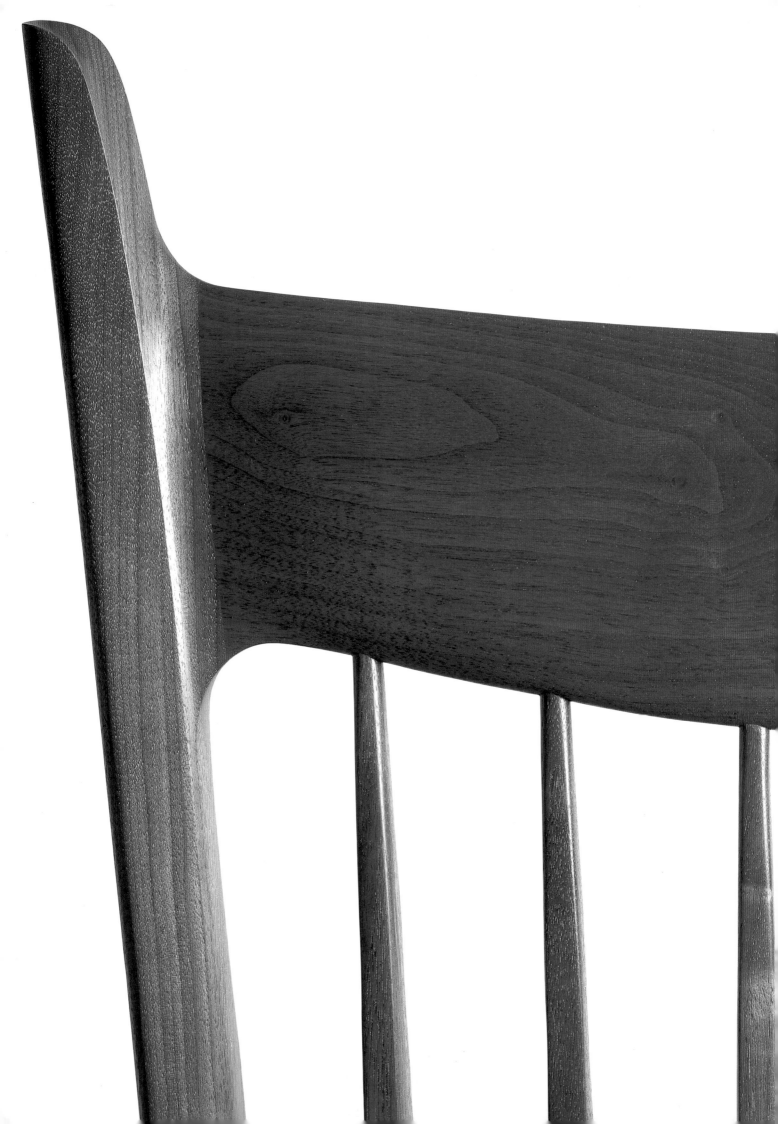

Concave
Swirl

Form curve
into crest

Curved
Hardline

Halfround

Front and back
of narrow part & sides
Spindle is flat-sides
are slightly rounded

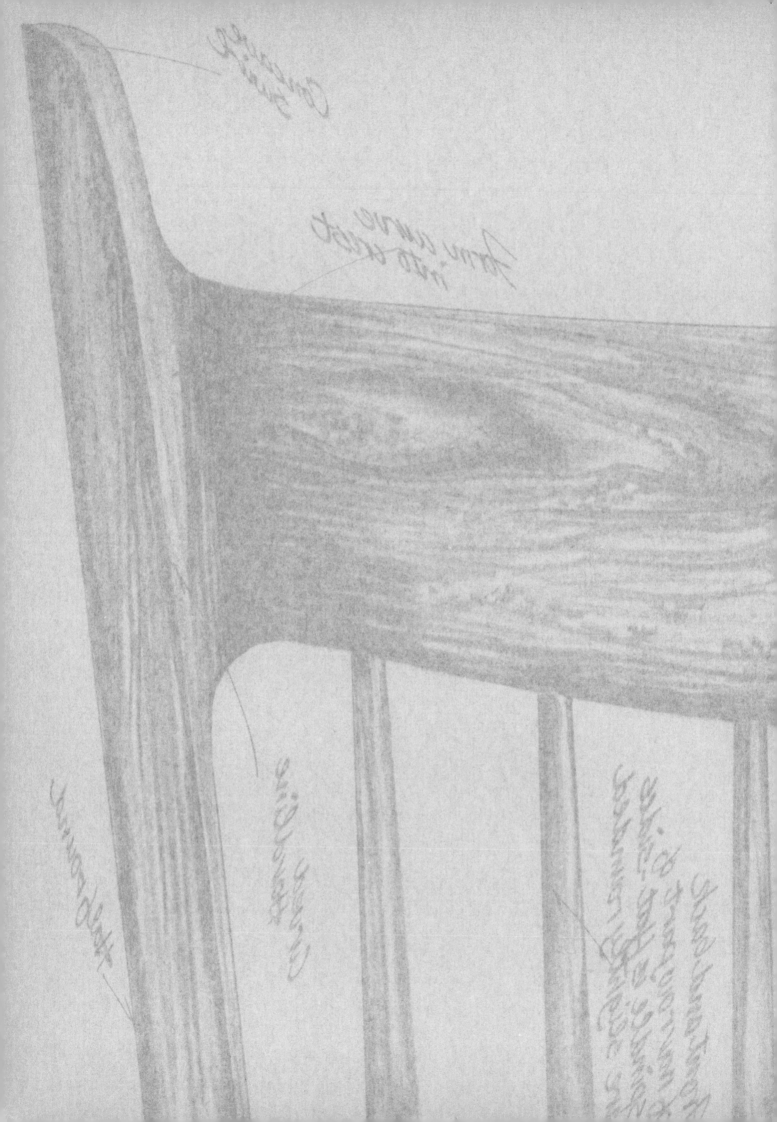

Contents

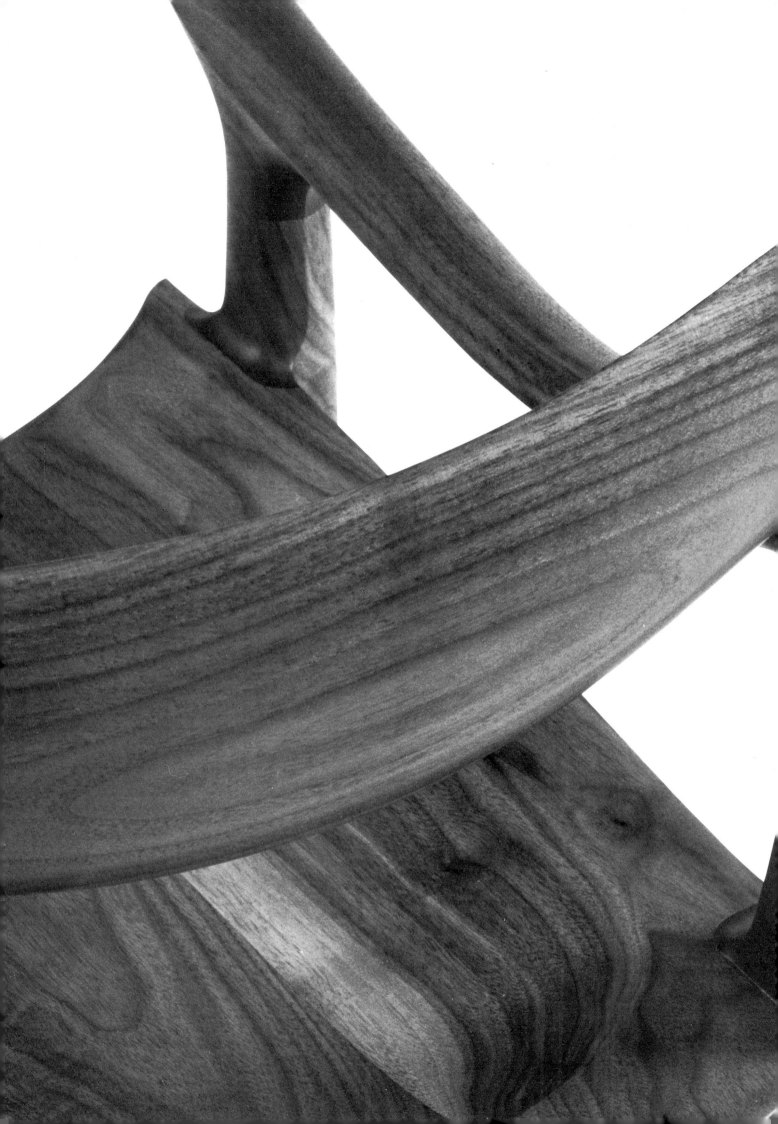

Acknowledgments

THANK YOU:

David Gardner, who first gave me the idea of writing this book;

Susan Peterson, who interested Kodansha in publishing it;

Dana Levy, whose book *Bamboo* was so beautifully designed that I hoped somehow he could do ours;

Jonathan Pollock, who worked with me so many years, for the very beautiful photographs in this book;

Jonathan Fairbanks, curator, American Decorative Arts and Sculpture, Museum of Fine Arts, Boston, who took time from his busy schedule to write the introduction and sometime ago helped me tape my thoughts, asking questions and making it all so much simpler for me— we did have a marvelous time;

Joy Cattanach Smith of the Museum of Fine Arts staff, who edited Jonathan's introduction;

Diana Williams, who transcribed all of the tapes that Jonathan and I recorded while traveling through the Indian country of the Southwest;

Tish O'Connor for helping and advising with problems I did not know how to approach;

Mitch Tuchman, who did a superb job of editing the manuscript so that it was readable;

Tad Akaishi, who kept things rolling between Kodansha, New York and Tokyo;

Marilou Maloof-Kent, our daughter, who did so much of the typing;

My son, Slimen, who worked for me as a small boy and as a young man; Nasiff, my nephew, Larry White, Paul Vicente, and Jerry Marcotte, who all worked for me for several years; Mike Johnson and Mike O'Neil, who now work with me in the shop;

To all the people for whom I have done work, who liked what I designed and made, and who have supported me in so many ways;

And to my wife, Alfreda Ward Maloof—without her love and help nothing would have been accomplished.

Thank you all.

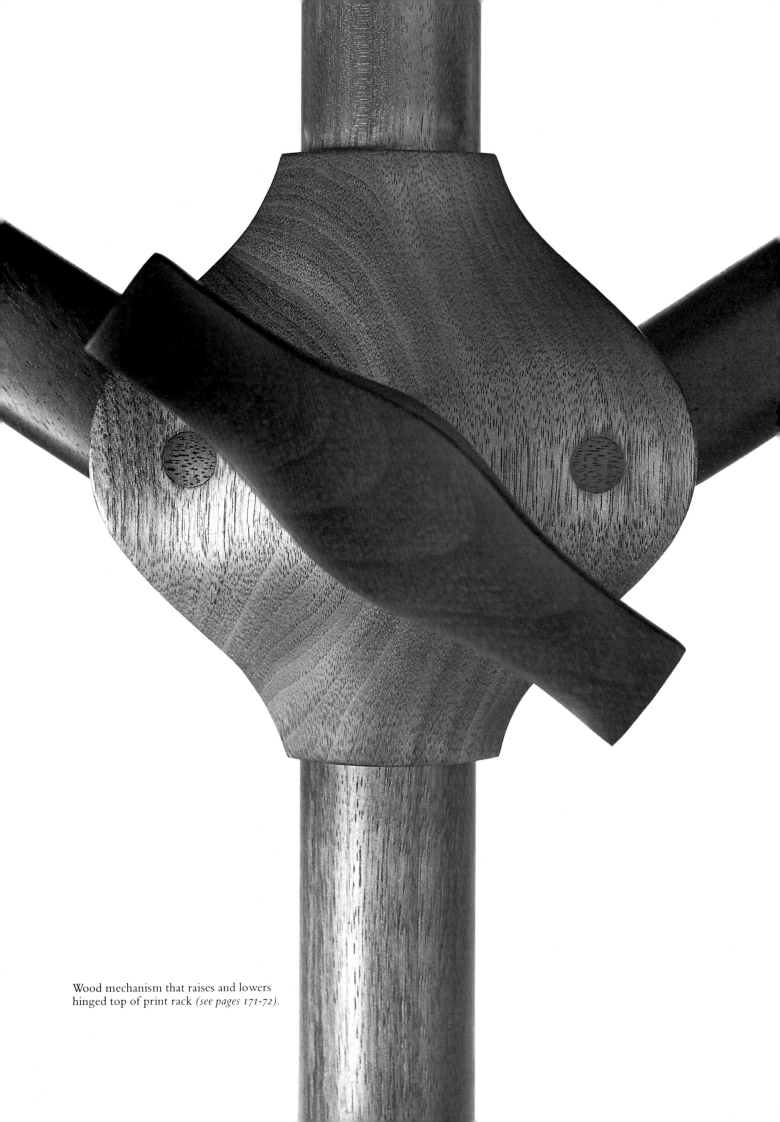

Wood mechanism that raises and lowers
hinged top of print rack *(see pages 171-72)*.

INTRODUCTION

I N THE SPRING OF 1966 I met Sam Maloof at a conference, "The Role of the Crafts in Education," in Niagara Falls, New York. This gathering brought together craftsmen and educators from across the nation. Most of the participants were well known to Sam; many were new to me. Sam was then a mature woodworker with an international reputation, having earned a living for more than fifteen years by making elegant, handcrafted furniture. At the time, I was a member of the curatorial staff at the Henry Francis duPont Winterthur Museum, a superb collection of Americana in Delaware. At Winterthur, only objects made before 1840 were collected; the founder of the museum had assumed that fine craftsmanship ended after this date. This view held no appeal for me, and I was delighted to encounter Sam, a person whose quality of work proved otherwise.

The meeting with Sam was memorable. His manner was direct and incredibly friendly. He was opinionated and frank about almost any issue. His style of dress was informal and western. It consisted of Levis, cowboy boots, a Navajo silver belt, and a dark turtleneck shirt: apparel

he continues to wear. Sam's appearance is one of self-contained vigor and controlled muscularity, characteristics reflected in the design and construction of his furniture. Reading a person into his work, however, is both right and wrong. It is right in Sam's case, because one cannot completely understand his work without knowing him. Yet comparison of the craftsman with his art is also wrong because it underestimates the work itself. Sam's work needs no words of explanation nor insight into his personality; his furniture is immediately appreciated for its functionalism, beautiful craftsmanship, and pleasing design.

If, in fact, Sam's furniture requires no explanation, then why write a book about it? Thousands of people know his work firsthand in both private homes and public collections. They enjoy his furniture when they grasp it, sit upon it, or use it daily. Such experiences, however, cannot fully convey an understanding of Sam's personal philosophy, the ideas that motivate and distinguish him. Nor can the visible aspects of his furniture reveal the nature of the environment in which he works or its place in the larger context of contemporary wood craftsmanship. This book will introduce the reader to Sam's world, showing how his furniture in design and production is inseparably related to his personality, his family, and his self-built environment in a seven-acre lemon grove in Alta Loma, California, near the foot of the San Gabriel mountains.

Craftsmen do not build fine furniture automatically. There are enormous risks involved in setting forth in this field, economic as well as emotional and spiritual risks. A fine woodworker makes what he believes in. He makes what he sees in his mind's eye. He makes what he feels a chair, a table, or a chest ought to be, by and through whatever means he possesses: training, impulse, or self-discipline. As in all arts, truth is both internal and external: the idea and the translation of the idea into a three-dimensional reality. Risk occurs during the process of transforming the concept into tangible form. This risk is eliminated in the mass production of furniture, where the potential for failure is minimized. In crafting furniture, with its complex joinery and mutiple steps of finishing, there are innumerable opportunities for the maker to fall short of his vision. In Sam's case, the concept and its realization are well matched.

The art of fine furniture making is a subject abstruse to most Americans; it requires explanation. Popular culture presents furniture as consumer merchandise. Fine furniture is different: it derives from the same aesthetic impulses that produce fine paintings, sculpture, and architecture. There is no basic difference between fine arts and fine crafts. Profound appreciation of any art work requires time, thought, and a developed taste. Certainly one aim of this book is to assist with that cultivation by offering a wide variety of magnificent images of Sam's works and by examining the explicit and implicit dimensions of these pieces.

I first saw Sam's furniture at an exhibition at the State University, Utica, organized for members of the Niagara conference. I was not overwhelmed. Sam does not make furniture that is imposing. His

works do not scream for attention in an exhibition. Yet his furniture did leave an impression with me which persisted long after the memory of other objects in the exhibition had faded.

Sam's works are quiet, sensitive, and serious. Their character results from Sam's early experience in working in designers' and artists' studios where he developed his skills of drawing and hand lettering; by contrast, his creative woodworking skills were self-taught. The spare, graceful lines of his furniture form a marked contrast with the zealously patterned furniture of today's New Wave woodworkers. The latter designs capture attention momentarily, while Sam's work has already achieved a certain timelessness.

The design sensibilities of the 1940s influenced the style of Sam's furniture, which has evolved steadily over the intervening years. His forms successfully balance tensions between traditional and nontraditional techniques, impulsive and calculated elements, simplicity and complexity. Such balance allows little latitude for startling changes but encourages refinement. Sam still makes furniture he designed at the beginning of his career, but he subtly adjusts the contour, structure, spatial divisions, and joinery to improve each new execution. The distinctive shapes and surface patterns of Sam's furniture are often derived from his observations and appreciation of nature, especially of wood itself: its "beat," as early craftsmen called the figured grain, and its response.

Sam speaks plainly about his work:

> Craftsmen in any media know the satisfaction that comes in designing and making an object from raw material. Mine comes from working in wood. Once you have breathed, smelled, and tasted the tanginess of wood and have handled it in the process of giving it form, there is nothing, I believe, that can replace the complete satisfaction gained. Working a rough piece of wood into a complete, useful object is the welding together of man and material.

Those who understand fine workmanship can grasp Sam's meaning. Even more important, of course, is the nonverbal statement made by his furniture. Any attempt to analyze the essence of those qualities that constitute the art of his craft are futile; one can only observe that Sam's working process reshapes the craftsman and his perceptions with each piece he makes.

Sam's furniture embodies intangible qualities that transcend the sensory delights of sight and touch. He uses the words *soul* or *spirit* to explain this concept, which is further explored in Sōetsu Yanagi's famous book, *The Unknown Craftsman: A Japanese Insight into Beauty* (Kodansha International, Ltd., 1972). In his introduction to the book, Bernard Leach writes:

> Handcraftsmanship, if it be alive, justifies itself at any time as an intimate expression of the spirit of man. Such work is an end in itself and not a means to an end. If, however, it ceases to serve a functional need, it runs the risk of becoming art for art's sake and untrue to its nature, depending upon the sincerity of the craftsman.

Unquestionably Sam and his wife, Alfreda, shared these convictions as early as the 1940s, long before *The Unknown Craftsman* was published. A treasured copy of this book in the Maloofs' selective library reaffirms their belief in the spiritual essence of fine craftsmanship.

Both my wife, Louise, and I have had the good fortune of knowing Sam and his wife during the seventeen years since the Niagara conference. Gradually and naturally we have become a part of the wide circle of Maloof family friends, staying with them, and they with us. During this time I've learned about their superb collection of works by important craftsmen and friends, including Bob Turner, Laura Andreson, Bob Stocksdale, Paul Soldner, and Maria Martinez. Sam has a deep appreciation for other cultures ranging from that of the Spanish-Americans and the New Mexican Pueblo Indians to that of the Navajos and his Lebanese ancestors. The Maloofs' home, which Sam has built over the years, offers multiple surprises and chambers; it is like a magical nautilus, filled with contemporary and antique works by native and foreign artists. Any visitor is impressed with the quality of their collection, the discipline of their shaped environment, and the warmth of their family.

With his shop attached to his home, and in a relaxed atmosphere of easy interchange with visitors, Sam produces about seventy-five pieces of furniture each year. This is an amazing performance, given the fact that he employs at most two assistants. Sam cuts and assembles each piece, receiving help only in shaping, sanding, and finishing. In the custom of the eighteenth century, Sam sells directly to his customers, not through galleries or agents. Each sale is as personally directed as the work itself. Each piece is signed, dated, numbered, and logged into a record book kept by Alfreda. In other words, the entire Maloof production is that of an artist's studio, with each work tailored to the needs of maker and buyer. There is no speculative production other than the periodic introduction of three or four new forms each year, made specifically for clients and then included in Sam's repertoire. This highly structured and sophisticated operation is completely integrated. It depends on highly technical skills, outstandingly productive capacities, and, more important, on the artist's sense of values. No commercial firm can produce or market the Maloof product. Although he has received tempting proposals, he has consistently refused commercialization, which he feels would be unfair to his patrons and a travesty of his beliefs.

In this computer age of mass-produced commodities, mankind suffers from a high degree of professional specialization, which separates rather than binds society together. The loss is especially evident in our depersonalized culture, which seeks information unrelated to feeling and interpersonal exchange. Many years ago, when village life brought diverse people together for daily barter, the artist's and the craftsman's work formed a basic material matrix in the community. In general that does not happen today; buyers almost never meet producers.

Sam's way is different. His art reaches people from varied backgrounds who share an appreciation for his furniture. It matters little to

him if they are serious collectors, businessmen, educators, young couples, laborers, or doctors. All sense the special qualities that make Sam's furniture appeal to an audience or community that is, not local, but national. He keeps in touch with those who have purchased his furniture. Whenever possible he visits owners' homes and offices to see his furniture in use, to help with its care, and converse with customers who have become his friends. His aesthetic embraces the essential element that is lacking in much of today's fine arts, which do not serve any use but to decorate art museums as dead art, divorced from their context and divested of their relationship to humanity. By contrast, Sam's furniture unites fine arts and craft, the beautiful and the useful, the poetic and the practical.

I witnessed the appeal of Sam's furniture in December 1977, when the Museum of Fine Arts, Boston held a small exhibition entitled "Contemporary Works by Master Craftsmen," offering objects for sale to the public; Sam's pieces sold promptly. The woman who purchased his superb settee (like plate 147) marveled that mere cash could secure such a work of art. Although the buyer had never met Sam and knew little about him as a person, she instinctively recognized the authority and intensity of his workmanship and the perfection he had attained in shaping the settee. She appreciated the way it functioned as comfortable seating, while delighting in the imaginative play of shapes and edges, lost and found forms for the hand to encounter and the eye to discover. I was astonished to hear these comments from a person who was not a collector of contemporary furniture. She responded directly to the work itself. Like all of Sam's furniture, the settee reflects the artist's attention focused on each part of the whole, a process that imbues each piece with strong personal qualities.

Sam's commitment to his work extends beyond design, execution, and sales. In 1976 a grant from the National Endowment for the Arts, matched with funds from the Gillette Corporation, enabled the Museum of Fine Arts, Boston to acquire twelve pieces of Maloof seating. These works are the museum's first examples of American furniture made by a living craftsman and accessioned as part of the permanent collection. Intended for public seating in the galleries, the Maloof furniture offers visitors a physical experience in permanent exhibition areas where they are allowed to see, but not touch, historic works. On visits east, Sam inspects his pieces and advises the museum on their maintenance. Although vandalism is always a risk, Sam's benches and chairs have received thoughtful consideration from the more than two hundred thousand people who have used them, and show few signs of wear. The success of the Maloof furniture has led to the expansion of the contemporary seating program to include thirty-eight more pieces by sixteen other artists or craftsmen working in wood.

Why and how do these works by Sam succeed in public spaces just as well as they do in private homes? When Sam came to the museum to study the places where his furniture would be used, I expected that he would design works that were site specific. Instead, he built furniture which, by its scale and shape, was like his designs for home or office

use. This was fortunate because the seating has been used in a variety of locations; the furniture has proved thoroughly adaptable. It looks as well in classical galleries as it does in early American. It makes a strong individual and educational statement without detracting from other works. The visitor who sits on the furniture experiences sculptural form directly: how its contour fits the human frame and how its gentle play of edges contrasts hard and soft lines, which blend into lost and found forms. Sam's furniture also helps the visually impaired visitor understand the essential nature of light and shade; the soft and hard edges are similar in feeling to the shadows cast from windswept beach sands.

The success of Sam's furniture rests largely upon its sureness of form and its proportions. When asked how he determines his furniture's proportions, Sam is disarmingly direct. Proportions derive from his own comfort. To analyze those proportions one begins with the clear congruence between the human body and the works themselves. A chair back, for instance, is divided into four sections corresponding to cervical, thoracic, lumbar, and sacral (or pelvic) regions. Chair legs correspond to heights averaged according to practical experience. Except for his rockers, which are low (the museum's rocker measures approximately twelve inches at the front edge), Sam's seating generally elevates the sitter to a comfortable sixteen inches. In addition, the seat's pitch, size, and shape, combined with the angle of the back, prevent the sitter from sliding forward. Sam tests a chair's design by sitting on it to determine if the back is comfortable and if the seat contains the sitter. If the seat makes Sam slide forward, the design is a failure.

Occasionally, a client's specific need has led to a wider application. For example, one customer needed a chair with special support in the lumbar region of the spine. Sam instinctively came up with the right solution by fitting a series of vertical pieces against his own back until the necessary supporting arc was obtained. He then translated this shape into a series of vertical splats reminiscent of the arrowback shapes of early American Windsor chairs. The chair was so comfortable that Sam integrated the shape into his repertoire of seating. Unlike some manufactured seating, which is contoured so the shoulders are hunched forward leaving the lower back unsupported, Sam's chairs give rest to the human frame.

During the years when Sam was gaining his knowledge of anatomical proportions, the nearby, preeminent industrial designer Henry Dreyfuss was calculating the measure of man for use in his anthropometric data charts, later published by the Whitney Library of Design. Whereas the Dreyfuss designs conformed to the scientifically analyzed mechanics of the human body and its clearances, tolerances, and needs, Sam used his own body, experience, and intuition to develop comfortable furniture. His solutions actually appeared in his furniture, long before the Dreyfuss research was made public. As Sam recounts in this book, he and Dreyfuss knew and greatly respected each other's achievements. Henry Dreyfuss ordered furniture from Sam without dictating its proportion, style, or design; he admired and wanted the personal expression of Sam's work.

For Sam, beauty arises in response to necessity and develops, first, through design and, then, through execution. This evolutionary process is in contrast to the procedures of many other designer-craftsmen. In a sense, Sam's work and his attitudes toward art parallel those of the ancient Egyptians, who, like Sam, depended on a sense of balance and harmony, an established order in a seemingly chaotic world. Like them, Sam maintains a consistent style, which changes slowly over time, stressing surface refinement and using a complex program of modular measure. The joinery and contour of his work also recall the superb craftsmanship and tactile richness of ancient Egyptian furniture. Since the cost of labor was for them not a factor in design, the Egyptians spared no pains with finish and with the exquisite articulation of parts; Sam does the same, applying a beautiful finish to all surfaces of his work and carefully defining each element with visible joinery. Sam's furniture is not derived from that of the ancient Egyptians; the similarity results from what the cultural historian calls "convergence." Convergence occurs when similar problems in different historical periods yield apparently similar solutions; the techniques, however, are quite different.

More important than superficial likenesses between Sam's work and that of other times are his noteworthy contributions to the recent craft movement and to the "California school" of modern woodworking, known for its organic shapes and sculpted joints. Sam's work has influenced so many craftsmen that one is tempted to place him at the head of a "school." Ask a fine woodworker what Sam has contributed to the field, and the answer will be technical. His creative use of tools impresses his fellow craftsmen. Unhampered by tradition, Sam shapes much of his work on the band saw with amazing facility. The seats of his chairs are "scooped" by the band saw, even before assembly. This procedure eliminates 80 percent of the waste, which would normally be laboriously scooped out with an in-shave. His use of the scraper, router, spindle shaper, rasp, and Surform is equally unorthodox and efficient. To shape the contour of a seat, Sam employs a mallet, gouge, and seven-inch disc sander, followed by hand smoothing.

Perhaps the hallmark of Maloof furniture is its half-lap joint, exposed where the legs meet the seat. This is a complex tongue and groove joint, which follows the contour of the chair surface. Structurally sound and visually appealing, this joint artfully provides detail at the point of transition. Similarly, Sam uses decorative ebony plugs to cover steel screws used in joining. When he abuts planks, Sam employs wooden dowels and white glue; at stress points steel screws provide added strength.

One of the most famous pieces of furniture Sam makes is his rocking chair, an example of which is illustrated in *Masterpieces from the Boston Museum* (Museum of Fine Arts, Boston, 1981) and on pages 121–125 herein. The great sweep of this chair's rockers became possible only after Sam had eliminated a problem inherent in the structure of traditional rockers, that is, exposing the grain of sawn wood along the ray weakened most rockers. Sam's solution lay in laminating seven layers of wood to form his rockers, which are almost as strong and resilient as

steel. For a California "upstart" to have introduced such a fundamental revision of a cherished form in the very town that, for more than a century, made the "Boston rocker" famous was no small achievement!

Finish is another area where Sam is innovative. He makes no secret of his formula: a fifty-fifty mix of boiled linseed oil and raw tung oil with a handful of beeswax, applied over a primer of equal parts urethane varnish, boiled linseed oil, and raw tung oil. This final coating is rubbed in over a three-day period, then buffed with very fine (0000) steel wool for an admirable eggshell, semigloss finish that highlights the grain of the wood without producing a glossy surface. The urethane undercoating protects the surface from water stains.

Woodworkers know about Sam's techniques through articles in journals, such as *Fine Woodworking* (November/December 1980,) and through workshops and demonstrations he has given at crafts centers in Aspen, Boston, New York, Hanover (New Hampshire), and Penland (North Carolina). Sam is the first to state, however, that technique does not form the essential art and mystery of any craft, that tools and methods are simply means for the craftsman to attain his goals.

The word *work*, which occurs frequently throughout this book, suggests a fundamental precept in Sam's life. The world of work, or physical labor, is an essential part of the regular rhythm and production of the craftsman's world. For Sam, it is central to his being and involves daily discipline. In his sense of the word, work is an affirmation; it is not drudgery or the exchange of toil for solvency. Work involves planning the next day's tasks (or anticipated challenges), then efficiently setting out to accomplish them. Sam merely steps from his home to an adjacent thousand-square-foot machine room with connecting shops. Here he shapes the raw material of the natural world into his ideal world. Sam works with the conviction that there is a guiding power or destiny beyond himself. His work reflects the inner influences of the mind and body, as well as the effect of these outer forces. Some people call the latter culture, and others identify it as the unseen.

Observers of Sam's demonstrations at the band saw are amazed and almost hypnotized by the freedom with which he shapes the wood. He works each piece with precision and confidence, having done so thousands of times. To honor the motion of his hands as the key to his mastery is to misunderstand the fundamental nature of the craftsman's job. The fine woodworker's purpose is to improve upon raw material through processing, shaping it from a merely useful object to one that is also a beautiful expression of his inner vision. Perhaps the general public misunderstands craftsmanship because contemporary society is largely comprised of spectators rather than shapers of the environment. Sam's work provides a healthy antidote to the growing trend of consumerism and commercialism.

Once vast acres of lemon groves surrounded what is now the Maloofs' isolated enclave; now housing developments approach their compound, which functions as a reminder of earlier times and values. Complete with a shop, gardens, and guest quarters, the house contains personal treasures collected and traded over more than thirty-five years.

In a sense this isolation is a symbol of Sam and Alfreda's ideals and their struggle against what the world calls "progress." Their enclave, which embraces the homes of their offspring and grandchildren, is an oasis and inspiration for many visitors who come to share the Maloofs' friendship, warmth, and values.

For many younger craftsmen, Sam has become a model whose life proves that one can make a decent living working with wood, while transcending the competition of the commercial world. A convergence of forces has shaped Sam's natural gifts, developing his imagination, skills, and insights in unique ways. Although his special talents and training cannot be duplicated, Sam willingly shares his abilities to help aspiring fine woodworkers toward the fulfillment of their personal dreams.

JONATHAN L. FAIRBANKS, Curator
American Decorative Arts and Sculpture
Museum of Fine Arts, Boston
May 1983

1

Starting Out

IT WAS 1948. I was thirty-two years of age, and I decided I wanted to be a woodworker. From the day I started I have been able to make my living working for myself and doing what I like to do: work in wood. I love the feel, the character of wood, no matter what the species, and I enjoy making objects that are both functional and beautiful. My aim is not for recognition or for monetary reward. Working with my hands is a joy. It gives me a sense of fulfillment—something so many seek and so few find—and for this I am thankful.

When I started working with wood, I did not know another woodworker. Before that I had a job as a graphic artist, which of course means working in two dimensions. I was not happy working in two dimensions; somehow a drafting board lost its appeal. I had made some furniture in the past, and I thought it would be wonderful to earn a living doing that.

Perhaps unconsciously I had always wanted to make furniture, although at the time I started it seemed like everything just happened. My sisters like to tell stories of all the things I made in wood when I was a child. I carved all sorts of things, including beautiful pistols with cyl-

My parents were married in Douma, Lebanon. My father was twenty years old. My mother was eighteen. They immigrated to California immediately afterwards. My mother did lace and crochet work, which my father peddled.

inders that actually turned. One time I made a truck, and I used my mother's best scissors to cut springs from a tin can. She remembered that incident for years. I made a paddle when I was eleven for taking bread out of the oven. Someone once pointed out that it was constructed on surprisingly sophisticated lines for an eleven-year-old: it had a dado joint and was so well built it is still used by my sisters. It seems wood always has held an attraction for me. I still have scars on my left hand that bring back fond memories of those childhood projects.

I grew up in Southern California as part of a large family. My father and mother were from Lebanon, and I was the seventh of nine children. My mom and dad ran drygoods stores, first, in Chino, then, for a short while in the Imperial Valley near Calipatria, after which we returned to Chino. We moved next to Ontario and finally back to Chino once more. Chino was a thriving farm community. There was a big sugar beet refinery there. The Great Depression, however, was hard on my family, as it was on many other families. About this time, my eldest sister's husband died, and she and her six children came to live with us. There were fourteen people living then in a small, three-bedroom house on Sixth Street in Chino.

People often ask me how I have the discipline to work alone; I think it must go back to this time in my life when we all lived together. My parents ran a very organized household; they had to with so many people. Discipline has always been a part of my life.

Our house was full of love and tolerance. Our neighborhood was like a small League of Nations, mostly first-generation Americans like my family. My parents spoke Spanish better than they did English. Most of our friends were the children of other merchants.

Naturally, it was always pounded into our heads—gently—that we should go to school and then on to college. I think my father was very disappointed that I did not go to college and become a professional something or other, but it did not take him long to change his mind. I remember one time—my dad was quite elderly then—I took him to see an exhibit of abstract art at Scripps College. As I showed him around, he looked at the paintings and did not say a word. We walked out, and as we were getting into the car, he chuckled and said, "I'm sure glad that you didn't stay a painter. Those painters: they're crazy." Perhaps it was his way of showing approval of what I had chosen to do with my life. I do not know whether or not my parents were interested in art, although my mother used to crochet beautifully and tatted lace; so she was a craftsman. They were busy raising a family and making a living. They never learned to read or write English; and although they could not speak English very well, they spoke it openly, without shame. They could not help us with our homework; so we learned to work on our own in school. As it turned out, most of my sisters went to college, my brother was graduated from college, and I attended a trade school and later a community college.

I had two fine teachers in high school who encouraged me in my artwork. Charlotte Reed, a teacher at Chaffey High School in 1931–32, and later Eleanor Corwin in Chino: they helped me tremendously. Miss Corwin was responsible for the first job I ever had. She encouraged me

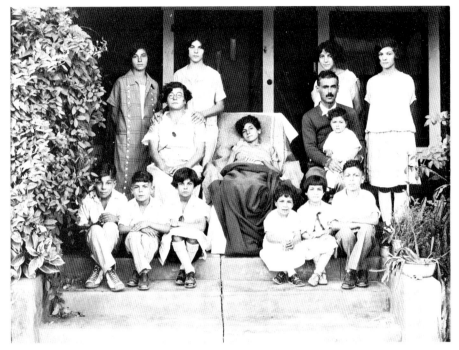

Our family doctor and his wife arranged for this photograph to be taken. It is the only one of our entire family. I am at the left in the front row; I was ten years old at the time. The young girl on the cot was my sister Olga, who died a week later. Back row *(from left)*: my sisters Mary, Victoria, Rose, and Sara; middle row: my mother and my father, holding my nephew Saba; front row: my brother, Jack, my sister Eva, my nieces Sara and Thelma, and my nephew Richard.

in 1933 to enter a poster contest for Southern California high school students. The poster was to advertise a play being presented by the Padua Players, a theater group in Claremont. *Oliver Twist* was the play. The design had to be reproducible by silk screen. I do not think most high school kids knew what silk screen was way back in 1933. Luckily, I won the contest, and that led to my first job.

I was always drawing. I cannot recall a time when I did not draw. In fact, when I went to my fiftieth high school class reunion recently, I was surprised that people recalled how I used to draw this and draw that.

I think that a woodworker who is going to design his own things must have an appreciation of all the arts. I recommend to young woodworkers that they read as much as they can, go to museum and gallery exhibitions, and open their eyes to all the arts and to nature. This experience is what develops design ability.

It was not until I was out of the army that I turned to the arts. I had made furniture for my parents, I had drawn and all, but I really did not know what the art world was all about. Thanks to the artist Millard Sheets and to the designer Harold Graham, whom I have always considered my mentors, I was introduced to a completely new world. Millard opened up the world of art to me, talking about painters and sculptors. There was a sculptor, Albert Stewart, who was a protege of Paul Manship. I would go to Albert's studio and watch him work. I would sit and talk with my friend Phil Dike, the painter. Another good friend, a minister, and I would sit by the hour just talking, not about objects but about life itself. All of these people and these experiences were important in my life. Just before I started working full time in wood, I did drafting for an architect whom nobody could work with. It turned out that I could work with him very well, and we became very close friends. He would tell me of his experiences. He had gone to school with Geor-

I was graduated from Chino High School in the middle of the Great Depression, 1934. I was eighteen years old.

gia O'Keeffe and was a good friend of hers and would talk about her. He talked about this person he had worked with and that person he had worked with and the people he had done homes for.

So, here I had an architect who talked about his houses, I had a painter who talked about his paintings, an industrial designer who talked about industrial design, a sculptor who talked to me about sculpture (the sculptor's wife was a weaver; so I even learned a little bit about weaving), and they all talked to me about the most important thing: life.

I think that it is essential to learn about design on one's own. Design is not something that can be taught, although it can be nurtured and encouraged. Because I never studied design in any school, I think I escaped being influenced by popular trends and fashions that flowed through the design world.

Based on winning that poster contest, I went to work as a commercial artist after leaving high school in the midst of the Depression. Herman Garner, who owned the Padua Hills Theater and who had sponsored the contest, hired me. He asked if I had ever washed windows, and I said, "Oh, sure. I like to wash windows." So, I washed windows in his factory, which produced automotive air cleaners and which had not had a window washed in about ten years. I did this for three months, and by that time, I guess, he realized that I was a good worker; so he put me into the company art department, where I did graphics for both the company and the Padua Players. I worked there for about four years. I think hand lettering was what I did best, though I picked it up on my own.

I then went to work for Harold Graham, who had studied at the Bauhaus in Germany. As I mentioned, he was an industrial designer and was based in Claremont. Harold was one of the very few, maybe the only industrial designer that I knew at that time. He was of that rare type who could actually make what he designed. Harold could work in all kinds of materials; he knew how to operate machine tools as well as woodworking tools. This was during the Depression, and I was very fortunate to be able to work and learn with him.

Harold designed the windows and interior displays for Bullock's Department Store in Los Angeles. When we did the big Christmas display, for example, we would make the elves, the reindeer, the Santa Clauses: all the little characters that moved. At Easter we also made animated displays. This was long before the holidays got very commercial, and it was a great learning experience for me.

I had no training period when I went to work for Harold but started right out on projects. We never worked from drawings. Harold would simply say, "Let's make this," and he would do a rough sketch. Unfortunately—or fortunately—we never knew just what the end result would look like.

I learned a great deal from Harold Graham. His designs were influenced by the Art Deco period and also by the Bauhaus school. It was interesting, but it did not change the way I wanted to work.

I went into the army after working for Harold. I was a private in an

old outfit where some of the fellows had been in the service for twenty-five years and were still privates themselves. I was one of sixteen draftees who came into this outfit. Our mascot was an ocelot. In the evenings there was nothing to do; so I began cartooning and produced all kinds of little drawings of this ocelot doing all kinds of things, like firing an antiaircraft gun and carrying ammunition. A young fellow who happened to work in the battalion office saw these cartoons and asked if they were mine.

"The colonel wants a little drawing of the mascot," he said. "Can I show these to him?"

Needless to say, I said, "Sure."

The next morning we were lining up, and the old first sergeant called my name and told me to step out and report to battalion headquarters.

"Oh, my gosh," I thought, "what have I done?"

When I reported to him, the colonel asked, "Did you draw these things?"

Nervously I said that I had.

"Have you ever done any drafting?" he asked, and I answered affirmatively. "Here," he said, "draw this out," and handed me a sketch of a gun emplacement.

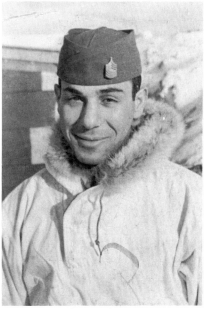

I spent part of my military service on Kiska in the Aleutian Islands (1943).

The sketch he handed me was horribly amateurish; so I sat down and did a good drawing of a gun emplacement. From that time on, I was assigned to that office. I was promoted to master sergeant shortly. In fact, I was the youngest master sergeant in the army at that time. I was stationed in Southern California, in the Aleutian Islands, and then later in Alaska.

I thought the army was a great experience, and it did wean me away from my mother. She was wonderful, but she was very protective and never wanted her children to leave home. It was probably the best thing that ever happened to me—and I say that kindly.

As soon as I was mustered out, which was in 1945, I went to work as a graphic artist in Los Angeles for a decal company called Angelus Pacific, which had produced decals from some of my wartime drawings. While I worked there, I lived in a little furnished apartment. The furniture was awful. I enrolled in night school to use the machinery to make furniture so that I could stand living in the place. A painter friend who taught at Chouinard Art School in Los Angeles happened to see what I had made for my little apartment and, to my surprise, said that she thought people would like and buy my furniture.

Just then Millard Sheets contacted me—I had been introduced to him by Harold Graham before the war—and asked if I would do a silk screen for him. Based on the result, Millard asked if I would come work for him as a studio assistant. Millard was the head of the art departments at both Scripps and Claremont colleges. I had always respected Millard, and the job opportunity was exciting. Besides, it got me out of Los Angeles and closer to home.

I had a little background, though no formal training, in the different art media. In the years I worked for Millard Sheets, I was introduced to sculpture, painting, murals, mosaics, pottery, and various

I made this furniture in 1948 for our first home. I could not afford walnut, or any other wood, but had some plywood cement forms, which I had sandblasted. This was the result. Moral: when you have to, you can.

crafts media. Most important of all, I felt that I was beginning to experience life.

Without a doubt, the best thing that happened to me while I was working for Millard was that I met my wife, Alfreda. Before the war, she taught art at Santo Domingo pueblo in New Mexico. She was then appointed director of arts and crafts at the Indian school in Santa Fe. She worked there for several years, then was asked to go to Montana and Wyoming to organize arts and crafts cooperatives on the reservations there. When the war broke out, she enlisted in the navy and worked as a therapist at St. Albans Naval Hospital in New York. After discharge, she studied for her Master of Fine Arts degree at Claremont Graduate School. That's where I met her in 1947. We were married immediately, just like that. She had taken a leave of absence from the Indian Service, and instead of going back, she married me. That's when I started making furniture full time.

Freda has been a true partner all these years. We have worked together twenty-four hours a day for thirty-five years. My wife and I are very close, and I feel that if it were not for her I would not have been able to struggle through those first years as a full-time woodworker. She was—and is—understanding and has always been supportive of what I wanted to do.

Often young couples come to my shop to seek advice about getting started. I usually ask them if their partners are equally interested in what they want to do. Sometimes there is hesitation, and if there is, I tell them that both partners must be equally committed because, very bluntly, the kind of money that a woodworker earns involves hardship and sacrifice. The rewards of woodworking are not monetary. It is a long road. But there is basic, deep, emotional satisfaction as well as a spiritual satisfaction that comes from working with your hands.

When we were first married, Freda and I had no furniture of our own. We got along with lemon crates that Freda fixed up and made to look quite nice. I was designing and building furniture then but had to sell everything I produced to make ends meet. Then a friend of mine, a contractor, gave me some plywood that had been used as cement forms. To clean them I had them sandblasted by a tombstone cutter. I must have been his only living customer. Together we produced the first of the etched-grain plywoods. (A bit later U.S. Plywood started producing wall paneling using the same idea.) I made all of our dining room and living room furniture with this sandblasted plywood. Millard Sheet's brother-in-law Harry Baskerville, a photographer, had an assignment from *Better Homes and Gardens* to photograph a tract house interior. There were not too many of them. Millard's wife, Mary, told Harry about our house. He photographed it, and the magazine did a big spread on it. The magazine also asked if I would do drawings of the furniture from which they could make patterns to sell. (I still occasionally see some of these patterns advertised in magazines.) I did not realize I would be paid for this and later received a check for $150, which at the time seemed like $150,000. This came at a time when things were very bleak. On the strength of that article and the interest shown in my work, I left my job with Millard and plunged into furniture making completely.

I have often wondered if I would do it again, and I think I would. I really would. Freda backed me up on my decision. She was willing to get along on nothing, so to speak, and nothing is just what we had, except faith and our certainty about what we wanted to do.

About nineteen years later, I had a conversation with my son, Slimen, which I will always remember.

He said, "Dad, I'd like to talk to you, but don't get upset until you hear my story."

"Okay," I said, "go ahead," but already I was bristling.

He said, "I'm not going to go back to college next year. I would like to come to work for you and be a woodworker."

For an instant my hair stood on end. My first reaction was, here he is quitting college to be a woodworker, of all things. But then I calmed down when I realized, "Well, goodness, there is nothing wrong with being a woodworker."

I always think of Kahlil Gibran's *The Prophet,* the part about parents and children: parents want to cling to their children. We want to possess them, whereas, really, we are the bows and they are the arrows. We bring them into this earth, but we cannot possess them. We shoot them like arrows, then they find their own ways. Freda and I had ideas of what we wanted our son to do, not taking into consideration what he might want to do for himself.

Then Slimen said, "Again, now, don't get angry, but, Dad, you're the first hippie I've ever known."

I laughed. "What do you mean, the first hippie you've ever known?"

He said, "Well, you were thirty-five years old and quit a good job to 'do your own thing.' Now, that's what I want to do. I want to be a woodworker."

So, I agreed. What my son had said had a great impact. His gift to me was not only his decision to take the same road I had taken; he acted as a mirror to show me my own decision and that it was right.

The years that followed were ones that sometimes took us through the rough terrain of life. I have walked through valleys, and at times I have climbed up hills and steep mountains. I hope that I never reach the top of the mountain, for then I must come down. Each day I learn something new.

If it was material security that I sought, I would not have become a woodworker. There are so many things in life that are more important to me than material security. To me the spiritual satisfaction my work has brought me, coupled with the satisfaction it brings those for whom I have done the work, outweighs any other benefit I might gain. There is a mutual understanding between the maker of an object and the user as there is a communion between the craftsman and the material he works with. I think the maker must respect the material. This becomes a triple communion when it embraces the person who has commissioned the piece. It is important that the craftsman consider this as a very important goal. I believe a crafted object should be not only aesthetically pleasing but functional as well. Too often a chair may look beautiful but not sit

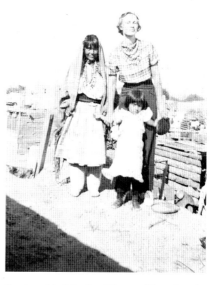

Freda with Monica Silva and her daughter at Santo Domingo Pueblo, New Mexico (1936). Freda later became director of arts and crafts at the Santa Fe Indian School.

well. I want my chairs to invite people to sit on them. This has been my objective since my first commission.

About that first commission: an interior designer approached me to make a dining table, ten chairs, and a buffet for his clients. He told me to stain the wood a dreary gray-brown.

"Are you sure your clients like this color?" I asked him.

"Never mind that," he said. "They'll take what I tell them is right."

Need I say, the clients liked their new furniture except for the color? After delivering the furniture and installing it, I had to cart it all back to my shop and strip off the ugly gray-brown stain. That and a sequence of further misunderstandings was enough to make me want to abandon my woodworking career at its inception.

My next commission was from the industrial designer Henry Dreyfuss. What a contrast with the first! I was in high school when I first heard of Dreyfuss, and he became an idol of mine. I had read about him, and at the time of tender youth I thought, "Boy, I want to be an industrial designer."

After the disaster of my first commission, I was sort of feeling low, but not very low, when I got a phone call from a man who said, "My name is Henry Dreyfuss. You don't know who I am, but I know who you are."

I nearly dropped the phone. I was speechless.

He said, "I have seen your furniture, and I like it very much. I'm building a new house, and I would like to have you make furniture for me. Could we get together?"

He invited me to lunch. Some of his staff members were there: the architect and some other people. After a lovely lunch, he asked me to stay to talk with him about the furniture.

In the course of the conversation, I said, "You want to design it, and you want me to make it."

"Oh, absolutely not," he replied. "You're the designer and the maker; that's the reason I called you. I want you to design it, and I want you to build it for me."

What a lift!

I made drawings. He needed a coffee table, end tables for the living room, a dining table, and some dining room chairs. I also did some

Presentation drawing of my first furniture commission.

bedroom furniture and one piece for each of the children's rooms. He approved of everything I designed, and I commenced building it. I received $1,200 for all the furniture I made for him—which shows how long ago that was. I received $225 for a refectory table that sat twelve people. I did not know much about pricing. I thought it was expensive.

When I told him what it was going to cost, his wife, Doris, said, "Goodness, that's a terrible amount of money, isn't it?"

Henry turned to her and said, "But, dear, we haven't bought furniture for thirty years."

That was the beginning of a very long friendship. Years later, after Henry and Doris died, their house was put up for sale. The purchaser would not finally agree to buy the house until the estate allowed him to buy the furniture as well. So, the children selected one piece each and let the rest stay with the house.

After designing the Dreyfuss furniture, for a period of about five years I received commissions through Kneedler-Fouchere, an interior design showroom. Eventually, enough commissions came directly from individuals, and I could no longer work indirectly through interior designers.

In 1955 the United States State Department hired several well-known industrial design firms to make a survey of indigenous crafts throughout the world. After the survey, which took two years to complete, the State Department, in cooperation with the governments of certain countries, embarked on a program of encouraging and developing crafts, both traditional and modern, in order to create sources of income for those countries. Again, the State Department relied on private industrial design firms to do the work in the various countries. The Chicago firm of Dave Chapman, Inc., was awarded a contract to work in Iran and Lebanon in the medias of wood and textiles. Dave Chapman asked me to be a design and technical adviser. The idea was to work with local craftsmen: to help them with design but to maintain the integrity of the indigenous work.

This aim was more idealistic than realistic because in Iran there was no wood. That is not completely accurate. There was a type of sycamore, or plane tree, whose wood was available, but it was not cured correctly and was used green. The method of "drying" this wood was

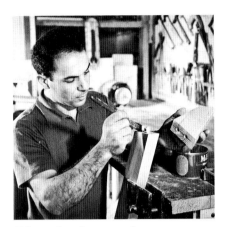
Taken when I was much younger.

to lean slabs of it against a building in the sun for a day or two, then turn the pieces over and let the sun hit the undersides. Needless to say, this procedure had little, if any, effect. I never saw a wood-drying kiln during my stay in Iran. It was necessary, therefore, to find some other materials to work with. Plywood was made in Teheran; plastic sheets and metal tubing were imported from Germany. I decided to use these materials and proceeded to design fifty-two pieces. I made full-scale drawings of each piece, showing front, back, and sides of tables, chairs, and storage cabinets.

In the meantime I was also looking for shops to work in. I found one on the outskirts of Teheran. Copies of my drawings were made, and word was spread that the drawings were available to anyone who wanted to use them. Several small shops with which I had no contact took advantage of this opportunity.

The main structural material of the furniture made in Teheran was square, tubular, and angular iron. Table legs and chair frames were made of the square iron tubing. Cabinets had metal bases, legs, and frames, and plywood was used for the sides, doors, and shelves. (The plywood was fabricated in a little shop run by four brothers of the Baha'i faith. They were some of the kindest and most sensitive people I have encountered in my travels.) Plastic sheeting was used to surface the plywood before it was cut. Plastic-surfaced plywood was also used for all tabletops. The upholstery textiles were handwoven under the supervision of Roy Ginstrom, an American who was working with weaving as I was with furniture. (He was the project director in both Iran and Lebanon. We became good friends.) We found a local upholsterer, who did all the chairs that we made. It was difficult to explain how I wanted the upholstery done, but after some frustration and some laughs, everything turned out well.

Thus, the place where I found myself working was a metal shop, not a wood shop. It was winter. I had thought that I would be working in the heat of a desert and had only brought summer clothes. I had had no idea that it got so cold in Iran. The small shop had some very sophisticated machinery and also some that was quite primitive. Our workshop had a tin roof but no walls and no protection from the wind. The boys who did the manual labor were very young and undernourished. They wore many layers of old clothing to keep out the cold and wrapped their feet in gunnysacks. Their cheerfulness, humor, and generosity were boundless. Their poverty was heart-rending.

We worked directly from the full-scale drawings rather than from measurements. That is to say, I would put the drawing on the floor, select the tubing, place it on the drawing, and mark where it should be cut. After it was sawed, I would bend it, hold two pieces in position, turn my face away, and the boys would arc-weld the pieces without eye protection of any kind. Why they did not lose their eyesight or why none of us was electrocuted I do not know. We produced dining tables, chairs, and cabinets for a restaurant during my three-month stay, numbering about sixty pieces. All tables and all chairs were the same. We were not in Teheran long enough really to contribute much to the crafts there, but in the little metalwork shop, the owner was enthusiastic

about continuing making this line of furniture. I have often wondered if he did.

Next I flew to Lebanon. I had stopped briefly in Beirut on my way to Iran for orientation and to make preparations for my stay. At that time I had visited also an aunt and uncle who lived high in the mountains. I was the first of my family to return from America to the old country. I was treated like the prodigal son.

When I was hired by the Chapman organization, they did not know that I spoke Arabic, at least enough to get along; so I was given an interpreter. We visited many woodworking shops in Beirut to find one that would be compatible with what we wanted to do. At all of them I was referred to simply as "that American." At several of the shops, my interpreter proceeded to tell them that I was from the U.S. State Department, that we were going to work with them and give them orders for thousands of dollars' worth of furniture. I listened the first few times but finally could not go on with this, though perhaps it was the proper Middle Eastern way of negotiating business.

I told the interpreter, "I do not think you are telling them what I asked you to tell them."

"Oh, yes, I am," he insisted.

Then I answered him in Arabic. His surprised expression is vivid to this day.

I finally selected the workshop of a young man whom I had met in Beirut on my way to Teheran. It was a modern, three-story factory, the most modern furniture factory in Lebanon. The machinery was sophisticated; the owners had hired two European technicians for two years to teach their workers to use it. The factory contained wood-drying kilns, plywood-making facilities, an upholstering department, and a finishing department.

The furniture they made was rather interesting. In the Middle East at that time, one did not simply go into a store to buy ready-made furniture. One would go to a furniture shop, show the shop people a photograph in a magazine—usually an Italian magazine—then the shop would make what the customer wanted. The workmanship at many shops that I visited was very good, but I think most of the time the proportions of the furniture were not correct. The chairs were too deep, too narrow, too wide, or too high. Yet in the factory where I worked they seemed to know pretty much what they were doing.

Here, as in Iran, I made full-scale drawings—thirty-five drawings to be exact—but only six prototypes were produced, as compared with the many produced in Teheran. Several of the prototypes were made of walnut. (All the woods used in this shop were imported from Europe.) These wooden pieces continued to be made until the time of the Lebanese civil war, when the factory was destroyed.

Some workshops that I visited in Lebanon were quite fascinating. The furniture designs with curved, compound veneering were right out of the *Arabian Nights*, I remember a bed that was shaped like a giant peacock; the tail was the headboard. It was being made for a member of the Saudi royal family.

The system of some of the workshops was reminiscent of an older

Douma, Lebanon, where my father and mother were born, a beautiful village with its terraced apple orchards, olive groves, and gardens. I was the first of our family to visit Douma. My uncle was the priest of the Greek Orthodox church.

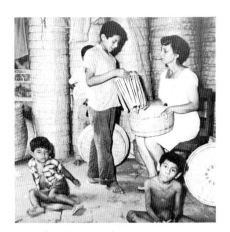

Freda in one of the areas in which she worked during our two months in El Salvador. The people were wonderful to work with. How sad the turmoil there now.

system found in Europe. I thought it was archaic, but it seemed to work well. The shop proprietor owned all the equipment except the workers' personal hand tools. Each craftsman worked independently, and each bid for the jobs, which the proprietor brought in. The craftsman's only overhead was materials and the commission he paid for use of the shop.

As this book was being written, an amusing incident from my stay in Lebanon was revealed. I was having lunch with a young cousin whom I had first met and befriended in Beirut. After some embarrassed hesitation he disclosed that my relatives, whom I had often visited in my father's mountain village, had a startling opinion of me. They had asked this young cousin what kind of work their American relative did in his own country. My cousin did not know how to explain that I designed and made furniture; so he told them that I was a carpenter.

"Ah," they exclaimed, "how sad that our uncle's son has not been successful in the United States and must work with his hands."

In 1963 Dave Chapman's office called me again to ask if I would be interested in going to El Salvador, as I had gone to Iran and Lebanon, to promote woodworking techniques and design. I agreed and traveled with a weaver, a potter, a silk-screen artist, and a worker in basketry and doll making. Roy Ginstrom was the weaver and project director. Bob Turner was the potter. Henry Glick was the silk-screen printmaker. And my wife, Freda, was the maker of baskets and dolls.

Our three months in El Salvador were among the most rewarding I have ever spent. I worked at three small factories: one was primitive, one was semimodern, and the other was very modern. I designed pieces for each of them, hoping that with the equipment available they could produce the designs. I also designed some pieces that village woodworkers could make with simple tools. This project was quite successful.

In El Salvador, there is an abundance of wood, but at that time it was not kiln- or air-dried long enough. We had to use wood with a high moisture content. As long as the finished pieces stayed in the area where they were made, there was no problem. I am sure that if the pieces would have been shipped to drier areas, however, they would have warped and cracked. This happened, in fact, with some pieces sent from El Salvador to its consular office in New York.

The Salvadoreans with whom I worked were fine craftsmen. The somewhat primitive shop had only a few power tools; so most of the work was done by hand. The workshop was outdoors; so everything had to be moved under a roof when it rained. I designed an executive desk, two side chairs, a swivel chair, and a storage cabinet. These pieces were made of *genisaro* wood, which is in the mahogany family. While there I saw slabs of this wood seven feet wide. Seeing the finished pieces in this primitive workshop and then in an executive office was a startling contrast.

Things went more smoothly in El Salvador than in Iran because I spoke Spanish and could communicate easily. I went there to share my ideas and designs, but perhaps I received more than I gave. I learned about simplicity, both in woodworking and in people's lives. For exam-

ple, chairs that I designed were ready to be assembled, but there were no clamps. How could chair legs be secured tightly to the seat frame until the glue set? I talked about this problem with the shop owner. He smiled knowingly and tapped his head. Finding a piece of rope, he wrapped it securely around the legs that had just been glued to the seat frame, then twisted the rope with a stick as one does a tourniquet. The legs were secured. When I exclaimed how simple this solution was, everyone laughed.

Another time we had a tabletop to put together. It was ready to be doweled and glued when the same situation arose: no clamps. I thought that, since the owner had solved the chair problem, he would know what to do in this case as well. We used two sawhorses—one at either end of the tabletop—and nailed a two-by-four across the sawhorses at one end. The tabletop was then doweled and glued together and laid on the sawhorses, snug up against the two-by-four. Another two-by-four was then nailed across the sawhorses with a slight gap between it and the tabletop. Wedges were then driven into this gap to secure the glued tabletop tightly.

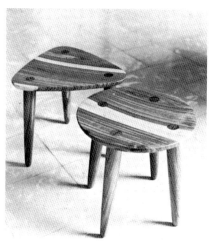

Two of many pieces that I designed while working in El Salvador. The men and boys with whom I worked were very skilled.

So often the American craftsman thinks that nothing can be accomplished without all the tools and inventions available on the market, or he might go to the opposite extreme and opt for antique hand tools. But while his attention is captured by tools and techniques, simple, direct ways of doing things are overlooked or forgotten. It is not a matter of nostalgia or romantic feeling for the past: the commonsense answer is the simplest one.

The semimodern shop was in a village outside the capital, San Salvador. There I designed two chairs. The shop was quite large and had many employees. I was assigned a young craftsman and his helper. For whatever reason, work proceeded on the pieces only when I was there. The pieces were finished, but I do not believe anything was done with those designs after I left.

The third place I worked, the modern factory, had the latest types of woodworking machinery. The owner was cooperative and helpful, and I was assigned a very fine craftsman. He made a dining table, six chairs, and a buffet, using a native laurel (not our familiar laurel) according to my designs. About three months after I returned from El Salvador, this craftsman appeared at my door. He wanted to work with me, but at that time I really could not afford to hire him. He stayed with us for about a month until I found a job for him in Los Angeles at the woodworking shop of a friend of mine. I believe he eventually returned to El Salvador.

Several years later I met a young woodworker on the East Coast who approached me, saying, "I bring you greetings from Fabrica Capri" (the very modern shop that I had worked in). I asked him how he knew I had been there, and he replied that he recognized my designs in the furniture they made. This is the only evidence I have that furniture based on my designs continued to be made.

My experiences in three countries were positive in every respect for me. One thing that has continued to nag over the years, however, is the fact that with all the good intentions and idealism that went into that

State Department program, there was never any followup that I know of. After our contract expired, there was no further effort by any of the governments involved, including the American, regarding local and export marketing, support of continuing production, and the fostering of similar efforts. Though subsequently I was contacted by the State Department about similar trips to Nigeria and Sri Lanka, each for two-year periods, my answer was no. I felt that, without an appropriate followup program, all my efforts would be for naught. What is more, my own work at home was being neglected. During the six months I was in Iran and Lebanon, clients here for whom I was making furniture were kind enough to wait for my return. I enjoyed working with people in other countries, but to be able to work in my own shop is what I enjoy doing most.

In the two decades since my travels, my efforts have been directed toward consolidating what I received and toward developing my designs and work. I think it is true that you grow when you share with others. Over the years I have attempted to share by means of workshops and lectures and by opening my shop to visitors.

2
Sharing

THE CRAFTSMAN'S COMMUNITY is a large one. Total strangers become friends because they share the love of an object.

The craft language is truly universal. No matter where we may travel, craftsmen can converse through their mutual interest and shared experiences in crafts. This understanding transcends all barriers. We all recognize the value of each other's work no matter what social or ethnic environment we may come from; the crafts make the world a universal family.

A craftman's world encompasses much more than his fellow craftsmen however. A craftsman's communion with his customers is also very important. In my own practice I prefer to work directly with the person for whom I am doing a piece. Most of my commissions have resulted from people having seen my work in homes, offices, galleries, museums, or in my workshop. Many have come through word of mouth, and articles written about my work have been a great help too. I like this kind of direct experience as a reason for buying something. (I

hope the same things occur for other craftsmen.) The individual-to-individual vibration that occurs because of two people's shared respect for an object is important to me and symbolizes what crafts are all about. This is one of the important differences between industrially produced items and handmade ones. I thoroughly enjoy getting to know the person for whom I am making something. The many different kinds of furniture I have made during the past thirty-five years have made my work interesting, while the opportunity to know the individuals for whom I have made them has given my work an even deeper meaning.

I have had some interesting experiences and have met some interesting people through my furniture. I have been fortunate because I have become friends with all of my customers but one, the first.

Another experience was irritating when it happened, but turned out well, and I can chuckle about it now. One good client and friend is a very successful businessman and a frustrated woodworker I think. I know him so well: when he calls me it is his custom to tell me how good I am for the first five minutes, then how I could have improved a particular piece for the next twenty. I made a big dining table for him that sat twelve people. It had a single pedestal and was round; it opened into an oval shape. After he had had it for about a year, he called me one day and said, "Sam, the table is absolutely magnificent and all"—I knew the next word would be *but*—"but I have a very good carpenter here, and we have it upside down and are trying to take it apart to add another leaf to it."

"You can't," I said. "There is no way you can take it apart, and there is no way you can add another leaf because the extensions won't go out far enough. If they did, the table would rock without a drop leg.

"Why don't you leave it alone? I can sell it to someone else, and I'll make you a new one, any size you want."

He said, "Now, listen, Sam. . . ."

It was hot. I don't have air-conditioning in my shop, and I had been turning on the lathe and was covered with dust, which was becoming caked on my perspiring skin.

"Now, listen to me. . . ."

I said, "Please. You're going to ruin it. I can sell it, and I'll make you another one at no extra charge."

He said, "Hold on a minute. I have something to say to you that you've had coming ever since I've known you." He started telling me what he thought of me, and, oh, jeepers, I can't repeat what he said. I listened to him patiently, but I was getting angry. I tried to get a word in: "Let me. . . ," but he interrupted: "Now, you listen. . . ." Finally I said, "I don't want to work for you anymore. Your current order is canceled. You go straight to Hell!"

My wife, who was on the extension phone, came out to the shop. Her lower lip was trembling. "Sam, I'm so upset!" (I was expecting sympathy.) "I've never heard you use that kind of language before."

I said, "If he calls back, I'm not here!"

So, for about two or three weeks, every time the phone rang, I thought, "Oh, no."

Finally he called, and Freda pleaded, "Sam, you have to answer the phone."

I picked it up, and he said, "Hello, Sam. I love you, and I forgive you."

I made him a larger table, sold the first table for a higher price than it had brought originally, and everybody was happy once more. Recently I did another dining table in teak for him to replace one that his daughter had always wanted.

You run into all kinds of things; they are all part of the craftsman's world, and sometimes they can try your patience.

I have had some very interesting commissions ranging from complete houses to chairs for young couples with no money. My wife has kept track of each piece I have sold. We know nearly every purchaser of one of my pieces, what the piece was, and what the price was. A lot of pieces have been resold for more than their original prices. In two cases the original owners died, and the new owners called to tell me what they had bought.

It is not unusual to start out designing a single piece of furniture and end up doing many more. The first house that I ever did completely was in Corona del Mar, near Newport Beach, California. These people had seen my furniture and had talked to me nearly twenty years earlier. Now they had come with an interior designer to order a rocking chair. That evening they called back wondering if they could talk to me about some other furniture. I ended up doing forty-seven pieces for them. That was my largest commission to that time.

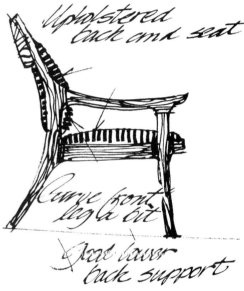

This sort of thing has happened to me so many times (so if you are a woodworker, do not get discouraged). After doing the dining room for a house in Brentwood, California, for example, I was asked to do some of the living room furniture as well, then the master bedroom, then the family room.

I was commissioned to do all the furniture for a large house on the island of Maui—forty-three pieces; I still have three bedrooms to complete.

I have a sizable backlog of orders. Working the way I do, I always shall have a backlog. This is because, according to my wife, I cannot say no. Often she says, "Tell people that you just can't take on any more." But word passes along quite rapidly, and if I said that, people would think I had retired. I am not going to retire until I die, and I hope that is not for a long while.

What I do is sort of intertwine orders. For example, some people from Texas ordered two settees, a rocking chair, and a side chair. I completed the pieces by adding to orders already in progress. Sometimes, however, it may take a while before I can start an order.

Jan Hlinka, who is the principal violist for the Los Angeles Philharmonic, wanted me to make some pieces for him. We have a mutual friend, and this friend had promised to bring Jan by sometime to meet me. Time had passed, and the friend had not introduced us; so Jan showed up one day alone, and we hit it right off. In fact, the very next day he came back and brought his prized viola to show me and at the

same time to order one of my music racks. He wanted it made of Brazilian rosewood. I made it, and later he asked if I would make a chest of drawers of the same wood for his sheet music, which I also did. Another time he asked if I would make him a chair.

"Now, Sam," he explained, "it has to be a very special chair. I sit forward, and yet I need very good lower back support. It can't have any arms because they will interfere with my playing." He said, "I'll leave it up to you though. You go ahead and make it any way you want."

I had the idea that what I should make for him was an adaptation of a folding chair. I made a couple of sketches, but work on Jan's chair did not begin. Months went by. Jan would call or drop in, wondering how I was getting along. I kept telling him that I was thinking about it, until one day he said, "Oh, Sam, you really were a cause of embarrassment to me."

I said, "What do you mean, Jan? What did I do to you?"

He said, "Well, you know, I have been rehearsing for a viola and cello duet with Gregor Piatigorsky, and I have been going to his home to practice. When I was there last time, he said, 'Well, Jan, I want to come to your house to practice.'

"Everything was ready for him. I rolled out the red carpet. I opened the door, and he said, 'Jan, the reason I have come here is, I want to sit on that chair that Sam Maloof made for you.'"

Jan told this with evident humor, acting it all out. But he said, "Sam, you have embarrassed me terribly. Here the great Piatigorsky came to practice in my little house, and he had to sit on a folding chair. Please, please make my chair."

Within a week I finished Jan's little Brazilian rosewood chair. But, you know, it is the only one-of-a-kind piece that I have ever made. For some reason, I just have not gotten around to making more pieces with this design.

A young lady and her mother came to my shop one day. I had made furniture for the mother in the past. Somehow I remarked that I had never sold any of the pieces I had made for my wife. I had put her name on them, and they were hers.

The mother grinned at me and said, "Well, it happens that I have an occasional chair that I purchased from you some time ago, and there is lettering inscribed on the bottom: 'To Freda, with all my love, Sam.'"

I was speechless.

The mother wanted to buy a piece for her daughter as a wedding gift. They looked at chairs, and the daughter picked one out. The mother thought it cost more than she wanted to spend and told her daughter that she was not getting a Sam Maloof chair for a wedding gift after all.

The daughter said, "I'll buy it myself then," whereupon her mother offered to pay half.

The one they chose was one of my favorite chairs, but I had made it rather small.

The daughter said, "This is what I want, Sam. Please make it for me. But make it a lot wider," she added. "I've got a big fat fanny."

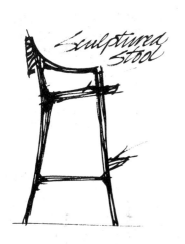
Sculptured stool

The point is that when I make furniture, I design for the person for whom I am working. In a sense I work for the client, and yet I maintain my integrity and individuality. I can be very pliable because I do not have set dimensions for any of my pieces. I do not compromise my design ideas however.

I have had young people come to me who cannot afford much. One particular couple wanted one of my chairs and wanted it so badly I could feel it.

"Well, how much do you have to spend?" I asked them.

"We have one hundred dollars," they answered.

"You really want the chair?"

"We would love to have the chair."

"Well, all right then," I said. "You can have it."

I did not tell them how much I got for such chairs at the time—I think it was about $350—but made it for them at their price. I have done this several times when I have sensed a clear, strong, honest desire that was thwarted by lack of money.

A friend of mine, the owner of a primitive sculpture gallery in La Jolla, told me a story along these lines. One Saturday a serviceman came into the gallery. He returned the following Saturday and while looking around kept coming back to a particular piece, examining it with obvious admiration. This went on for several Saturdays.

One day my friend approached the young man and said, "You like that piece, don't you?"

The serviceman replied, "I love it. I just can't come back often enough to look at it. I wish I could afford it, but I can't. I enjoy just looking at it though."

My friend told me he simply reached up, took hold of the piece, turned, held it out, and said, "Here, it's yours."

That always stayed with me, and then the same thing happened to me. I was having dinner with the sculptor Albert Stewart. We went into his studio, and I looked up at a piece and said, "Bert, I think that is one of the finest pieces you have made."

"You like it?" he asked.

"Yes," I said.

"It's yours."

I wish that pricing was not part of my work. It is a particular embarrassment to me; yet I have to make a living. Most people tell me I do not charge enough. One friend said he would not buy any more furniture from me unless I raised my prices. He had contracted for a piece, but when I sent him the bill, he sent me two hundred dollars more than I had charged.

I think morals and integrity must enter into pricing. I know how much time I put into making a piece; so I feel I should get a fair price for my time, my materials, and the shop overhead. Also my years of experience are real. Still, it is not right to overcharge. A painter or sculptor, once he becomes well known, can put just about any price he wants on his work. Some craftsmen can too. But a piece of furniture, it seems to me, is worth just so much and no more.

Maria Martinez, the legendary potter of San Ildefonso Pueblo, and I at our home. Freda first met Maria in 1936 and stayed with her before assuming her position as director of arts and crafts at the Santa Fe Indian School in 1937.

A meeting of hands.

Many years ago I was called by a lady in Los Angeles to do some furniture. She told me that she wanted a dining room set to seat fourteen people and a buffet made in three sections. She wanted a table and chairs for a game room plus end tables and some living room furniture. I took measurements of the dining room and did a little floor plan, which she approved. As I recall, all three pieces of the buffet had to be on wheels so that they could be moved easily for cleaning. The drawings were made, and I left copies with her. She carefully made corrections in pencil. I got the commission.

When I delivered the work, she was very pleased and remarked, "Now, Sam, don't you think that two people working together make a project much better?"

I laughed and agreed.

Her husband was not a bit interested in the furniture I first made for them. He said his wife was in charge of all that. Much later, when I knew him better, he admitted, "Sam, I just about passed out when I overheard you quote my wife prices. But when I saw the chairs, I thought they were inexpensive, that you had priced them very low, that they were worth much more." (Of course, I get more for them now.)

This lady and I became close friends. She ordered two pieces for her entrance hall a few months before her death. Her husband called and cancelled the order, then called again saying that he felt his wife would have wanted the pieces and asked me to go ahead. These are the kinds of things you remember, things that bring people close together.

EXHIBITIONS

I have never asked for museum or gallery exhibitions—everything has simply fallen into place—but I am very grateful for the exhibitions in which I have appeared.

In 1948, for instance, I was first exhibited at the Los Angeles County Fair, which is more than a county fair really. The arts building at the fairground housed an exhibition of painting and sculpture of national scope. There was a juried exhibition of crafts as well. (Millard Sheets directed these activities.) I won second prize that year and each of the other two years I showed there. It was a strange system because the first-prize winner became the juror for the following year. I think it was quite political, but interesting nevertheless.

Each year the Pasadena Art Museum presented a show called "California Design." The exhibition was a showcase of crafts and industrial design, bringing handmade and machine-made objects together. These exhibitions had great influence not only in California but throughout the United States. I was represented in every show, from the first in 1954 until 1971.

I was surprised when I was contacted to exhibit for the first time on the East Coast. That was for the inaugural exhibition at the Museum of Contemporary Crafts (now the American Crafts Museum) in New York in 1956. Mrs. Aileen Osborn Webb, the founder of the American

Craft Council, was really the catalyst behind this, as she was with so many things in the crafts.

I was not aware of the American Craft Council at the time and never learned where they had seen, or even heard of, my furniture. Thus this invitation was both surprising and very good for my morale. Furthermore, one of my pieces was purchased by a fellow woodworker who was also exhibited. Having a fellow woodworker purchase my work gives me great satisfaction. Woodworkers see furniture from a professional viewpoint; they are very critical. If they buy it, my work must say something to them.

The New York World's Fair in 1964 was the first grand event in which the American Craft Council participated. A number of us were asked to represent American craftsmen. Alice Parrot, the weaver, who lives in Santa Fe, New Mexico, participated; she also wove the fabric to upholster my chairs. Before the exhibition, a photographer was sent to my house and shop. He lived with us for about a week, taking pictures of everything I did from sunrise to sunset. These photographs were used as background for the exhibition.

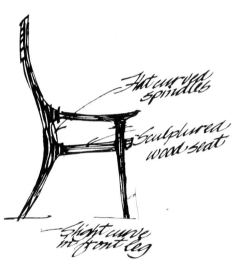

Being selected as one of the craftsmen represented in "OBJECTS:USA," which opened at the Smithsonian Institution in 1969 and later traveled to museums throughout the United States, was an honor. To this day, that remains the largest exhibition of American crafts ever assembled. It was sponsored by S. C. Johnson and Son, Inc. (Johnson's Wax). The sponsor purchased seven of my pieces, but the van carrying them was burglarized, and four pieces—a settee, two chairs, and a music rack—were stolen. A cradle hutch was also taken but found a few blocks from the scene of the robbery; it was probably too heavy to carry. Somewhere there are four pieces of which I have no record. I hope they are being enjoyed.

I was invited to participate in "Woodenworks" (1972), the inaugural exhibition of the Renwick Gallery, which is part of the Smithsonian Institution in Washington, D.C. Five craftsmen were selected: Wharton Esherick, George Nakashima, Art (Espenet) Carpenter, Wendell Castle, and I. Each of us was asked to do ten pieces of furniture that we considered most representative of our work. The pieces I made for that exhibit were for Freda; I told her they were hers and that I would not sell them, even though there might be opportunities to do so in Washington.

After six months at the Renwick, the exhibition was installed at the Minnesota Museum of Art in St. Paul. It had been there for a while when I was contacted by the museum. They said that a supporter of the museum was interested in the pieces. I hemmed and hawed and finally broached the subject with Freda.

"Go ahead," she said, "sell them. I knew that someone would want them."

All but one of the pieces were purchased, and that one was sold later on. The funny thing about that was that years later the purchaser called me, and I designed a complete office for him. Later he visited the office of another of my clients who happened to be his friend.

Vatican Synod Hall, 1978. The occasion was "Craft Art and Religion," the second international seminar sponsored by the Smithsonian Institution and the Vatican Museum.

"I have furniture that looks a little like yours," he exclaimed. "Who made yours?"

"Sam Maloof."

"That's who made mine."

One man lives in St. Paul, the other lives in Seattle, and the furniture in each office is different in design.

With funds from a grant that stipulated that the pieces become public seating as well as part of the permanent collection, the Museum of Fine Arts in Boston purchased twelve of my pieces in 1976. That the pieces would be in constant use and not embalmed behind glass pleased me very much. The collection was first shown as a one-man exhibition with the title "Please Be Seated." Of all the exhibitions I have had, that one created the most interest. To this day I get letters from all parts of the country inquiring about the pieces in the Boston museum collection. In fact, right now I am making several pieces for people who wrote to me about my furniture after seeing the pieces there. One reason for this response is that in the Museum of Fine Arts people are able to touch, to sit on, and really to experience my furniture.

Many people think that nothing gets into a museum unless its maker is dead—figuratively as well as literally, I guess. This seems to have been true once, and some museum administrations are still old-fashioned in this way, but many other curators are interested in what living craftsmen are doing. This is a change that I heartily approve.

In 1978 I participated in a seminar held at the Vatican with the title "Crafts in Religion." This seminar was sponsored by a group of Americans called the Friends of the American Museum in the Vatican, whose purpose is to purchase American painting, sculpture, and crafts for the Vatican museum. The Friends were interested in stimulating the upgrading of the collection in the American section through this seminar. Two of us craftsmen—Brent Kington, who works in metal, and I— were invited to speak. The other speakers included mainly museum people, curators, and art historians, among whom were Charles Hummel, curator of the Henry Francis du Pont Winterthur Museum, Paul Smith, director of the American Crafts Museum, and Lloyd Herman, director of the Renwick Gallery.

The seminar was held in the Vatican Synod Hall. We were to be there for a week. The people who attended had to pay all their own expenses in addition to a fee for the lectures. Shortly before the event was to begin, a telegram arrived from the Vatican, saying, "We regret to inform you . . ."—my heart dropped—"that your fee is $1,000 rather than $500." But the Vatican also paid my fare; so Freda and I happily took off for Rome.

Each speaker had to write a paper for presentation and later publication. After about three or four days of listening to people read papers, Freda said, "Sam, you're not going to read your paper. Just talk off the top of your head," and she took my paper away from me.

So, that's what I did. I started out saying, "You have the paper that I wrote, and you can read it. I've decided to talk about something else." I also showed a few slides of my work.

Concurrent with the seminar, there was an American crafts exhibi-

tion for which twenty American craftsmen were selected. This first American craft exhibition at the Vatican was held in the little Vatican American Museum, a small room that is on the tourist route to the Sistine Chapel.

All exhibitions open up contacts and enrich the world of the craftsman. I was fortunate to have one of my pieces, a settee, selected by Joan Mondale. She displayed it, along with other American crafts, in the vice-president's mansion while she was second lady. She later purchased one of my rocking chairs for the mansion.

Elena Canavier and Joan Mondale on a visit to my workshop in 1979.

In November 1981 I donated a rocking chair to raise funds for the American Craft Museum. It was auctioned off for eight thousand dollars. The purchaser offered it to the White House collection. Freda and I were asked to go to Washington, D.C. Mr. Reagan accepted the piece for the White House collection at a ceremony in the Oval Office. In the letter he wrote thanking me, he said he had been told that it was the very first piece of contemporary furniture in the White House collection.

All of the exhibitions in which I have participated have brought me into contact with other craftsmen and with the general public. I have often thought of moving to a really isolated place, but whenever I do, Freda always points out that, if I did not have people around me, I would be very bored. She is probably right. I know that I say it all the time, but I have been fortunate in my work: I have met so many wonderful, interesting people.

Of course, I do have to make a living. Customers are waiting for pieces; so I only show in an exhibition if my work allows. I have been in only four gallery shows in the last ten years. There have been many invitations, but I have not been able to accept.

My most recent one-man gallery show took place in 1983 while I was writing this book. That was in Mendocino, California. I did not think anything would sell because Mendocino is a rather remote place. As it happened all twelve pieces that were to be included in the exhibit sold to people who came to my shop even before the pieces could be shipped. As a result, I told all the people who bought them that, if the furniture sold at Mendocino as well, they would have to wait until new pieces could be made. Well, eight of the twelve pieces sold at the gallery. Now, I have my work cut out for me—in a manner of speaking.

ORGANIZATIONS

Rapport among craftsmen is very important, both for the enduring friendships that result and for the sharing of ideas, aims, problems, experiences, and the like. In the fifties a small group of craftsmen started the Southern California Designer-Craftsmen. It was something like a guild, and it grew quite rapidly. Our purpose was to promote crafts by organizing exhibitons, conducting meetings featuring prominent speakers in the craft world, and providing a forum and means of communication between craftsmen and the public. This group's first exhibition was held at the old Los Angeles County Museum of Art, and it was here that the seeds of the "California Design" shows were sown.

The Southern California Designer-Craftsmen had its ups and downs, its prima donnas and all, but we formed a strong nucleus that has allowed continuity in the Southern California craft world. One important thing we did at an early date was to make architects, interior designers, and the public aware of the handmade object in contrast to the machine-made.

The fifties saw the rebirth of crafts in the United States due in large part to the efforts of Mrs. Aileen Osborn Webb. There was a renaissance both of handcrafts and of industrial design as a great number of people decided then to devote themselves to craft. Mrs. Webb spent her time, energy, and fortune bringing the country's craftsmen together and providing them with an organization that included a museum and a magazine, *Craft Horizons* (now *American Crafts*). Of course, we did not know at the time that we were at the beginning of a renaissance.

An important event, for me and for the crafts movement, was the first American Crafts Conference at Asilomar, California, in 1957. It brought craftsmen together from all over the United States. The American Crafts Council has sponsored these conferences over the years, but the first one was the best. It had a vitality that has since been lacking. Perhaps this was because the meeting was small and the experience new. The woodworkers who were there formed friendships that endure to this day. There I first met Walker Weed, Wharton Esherick, Art Carpenter, John Kapell, and Tage Frid. Bob Stocksdale I had met previously, but this meeting cemented our friendship. Walker Weed was from New England, as was Tage Frid. Wharton was from Pennsylvania, while Art, John, and Bob lived—they still do—in the San Francisco Bay Area.

Bob and Art were turning bowls then. Tage Frid was teaching woodwork at the School for American Craftsmen in Rochester, New York. Walker Weed was a woodworker who became director of crafts at Hopkins Art Center, Dartmouth College. John had worked for George Nelson, the industrial designer, but was by then designing and making furniture in his own shop. Wharton Esherick was a fellow furniture maker. These friendships endure because of our interest in wood and because of our interest in one another.

What we all had in common was that we were doing what we wanted to do. None of us was a conformist. None of us wanted to be tied up or bound. I believe all of us were seeking spiritual well-being in what we were doing. We were not using our work as a means of avoiding responsibility in a material sense.

I like being involved in the crafts movement, but of course time is a limiting factor. When I first heard of the American Craft Council (ACC) I felt it was something that was needed, something that would help bring craftsmen together. I became a member of the ACC in its early years.

In 1966 I was asked to be on the steering committee for a symposium entitled "The Role of Crafts in Education," to be held at Niagara Falls. Fifty people in the field of education as well as craftsmen were invited. Later (1968) I was elected a regional craftsman-trustee of the

ACC for the Southwest, the area comprising California, Nevada, Arizona, New Mexico, and Hawaii. Several years after my three-year term was over, I was elected a general trustee of the ACC, an office I still hold.

When I first became a regional craftsman-trustee, the ACC still divided the United States into six regions: Northeast, Southeast, North Central, South Central, Northwest, and Southwest. Each region had "assembly" meetings, attended by its craftsman-trustee, chairman, and state representatives. At the regional meetings, we discussed what we thought we should do to encourage the crafts and craftsmen in our areas. Once a year we had what were called regional conferences, where all the ACC members of a region would get together.

Unfortunately, this regional system no longer exists in the ACC. One advantage it did have is that it gave a kind of recognition to regional activities, styles (if any), and markets. As the crafts boomed and craftsmen became more numerous, people working in various media formed individual guilds; the glass people started a guild, as did the jewelers, blacksmiths, weavers, potters, and woodworkers. The woodworking community has several guilds in California alone. There are many others throughout the United States.

President Reagan accepting my rocking chair, the first piece of contemporary furniture in the White House collection.

The guilds gradually grew during the seventies. These guilds are independent of the ACC and do not extend beyond their own interests, but they are active in furthering those interests, both within the guild membership and in the community as a whole.

Today, when the eight craftsman-trustees of the ACC no longer represent regions, I would like to see a representative of each guild on the ACC board. It is important for craftsmen to communicate with each other, and it seems to me that an organization like the ACC should offer the maximum opportunity for that.

My involvement in the ACC and other craft organizations is a result of the fact that I feel I owe a lot to the crafts. If my activity in the ACC can help other craftsmen, then I feel that I have accomplished something.

APPRENTICES

Several years after I came back from the Village Industries Project in Iran and Lebanon, I found myself with a lot of back orders. It was then (1962) that I began to hire what you might call apprentices. The first young man I hired was Larry White. I hired him as an employee and trained him in the way I worked. Though I had no formal training myself, I could share my experience in woodworking and my ways of doing things. Larry learned rapidly and was very good. He stayed with me for seven years.

I look at the concept of apprenticeships in two ways. First, at times it would be much easier to forget about having an apprentice or trainee woodworker and just hire someone to work the way I want him to work and let it go at that. Let's face it, there are headaches: there are

times when you wonder what on earth you are doing spending your time working with some young trainee. It takes so much energy. But—and this is my second way of looking at apprenticeships—it is a good feeling to realize some of those young people have learned from you and are working on their own. Larry White, for instance, runs his own shop now in Santa Cruz, California.

The American Craft Council has given me a lot of help, and in turn I owe something to the craft movement. In fact, I believe that a craftsman who has established himself, who has been able to make a living at his craft truly does owe it to the crafts as a whole to take on trainees. He can help them, train them, share with them the ideas and the failures and the successes that he has had over the years.

It upsets me terribly when I hear of craftsmen saying, "I can't tell you because it is a secret. I had to figure it out for myself; so you figure it out for yourself." I do not have any such precious secrets. What I know is available for the asking. If nothing else, sharing my experience and knowledge may save a struggling craftsman hours of frustration and wrestling with a problem and give him time to deal with other matters. I think this is what life is all about: giving of oneself. If you do not give of yourself, then you gain nothing. By this I obviously do not mean material giving. I mean the spiritual giving. I have tried to do this. Perhaps I have succeeded, perhaps not, though I hope that I have.

The old European type of apprentice system provides a good model for a modern program. As I understand it, the apprentice and the master craftsman had an agreement for a one-month tryout period. At the end of that month, either could break the contract. But if the trial had been successful by mutual consent, the apprentice worked for a period of two years at a minimum wage. At the end of these two years, and again by mutual consent, the master craftsman would have the right or privilege to hire the apprentice at a journeyman's salary.

Working with a trainee does take much of the craftman's time. The trainees may not think so; they may think that they are doing all the work, especially all the dirty work, but with this system they are getting a very good education at no charge at all, while earning an hourly wage.

The trainee must consider that a craftsman is not earning the type of money that he would expect to find in other situations. (I believe that the union type of apprenticeship is absolutely unrealistic.) Most craftsmen working full time consider themselves fortunate if they are able to earn a subsistence wage. A craftsman can only pay his employee what his business can afford. Many times people who work for craftsmen do not realize this. They think that because he is "successful," a craftsman must be able to pay them a great deal. Little do they understand the economic realities of running this kind of business—and that is precisely the kind of thing they are there to learn on the job! Some woodworkers that I know take on apprentices and do not pay them anything. In fact, sometimes the apprentices pay the employer for working. (Then the employers think they do not have to pay workmen's compensation, but by law they are required to. This is really a touchy situation.) I feel no trainee should ever place himself in a position where he is working and being trained without being paid. Everyone's time is worth at least a

Some of the young men who worked with me and two who are with me now: *(from left)* Mike O'Neil, who works with me now; our son, Slimen; Paul Vicente *(photo in background)*, who is now working in Berkeley; my dog, Spring, and I; our nephew, Nasiff, who also works wood on his own; and Mike Johnson, who works with me now.

little. To everyone who works for me, I pay the minimum wage to start with, and after a year I grant a week's vacation; after two years, two weeks' vacation. After a year I also give my apprentices a bonus on everything we have made. Of course, I can only afford to pay according to my income, but I like to treat them the way I would want to be treated.

The young men who work for me sometimes cannot believe that I have given them a bonus for each piece of furniture we made. They say, "You just can't do it."

I say, "I can do it because I want to."

There is much more to life than earning money. You are never going to have a large income as a woodworker, I can tell you that.

I have been given grants that allowed me to take on trainees, giving them some of my time and working with them as individuals. The first such grant was from the Tiffany Foundation; I was the first recipient of an award from their Master Craftsman-Apprentice Program. Paul Vicente, the young man whom I took on then as a trainee, is now working wood in Berkeley.

When I start a trainee working with me, I take him through my workshop, and I explain all the different tools. Some have had experience, some have not. I prefer a young man who has not had experience. I would rather teach him my way of working than have him filled with ideas that he has gotten from an instructor in a school. I tell him that I want him to always observe out of the corner of his eye, no matter what. If a young man is intent on learning, he will have eyes in the back of his head.

By having an apprentice start out sweeping the shop, washing the

windows, and doing simple sanding for three months, I have the opportunity of observing and finding out if the young person is really interested in all aspects of woodwork. Unfortunately, the romanticism, the idealism of working with your hands ends then. Those who really want to work in wood carry on.

After they have sampled the different methods of flat sanding—with a belt sander, an oscillating sander, a pneumatic sander, an oscillating disk sander—I let my apprentices do a bit of sanding on very simple shapes. Before this I will let them experiment by sanding pieces after they have been shaped by me. This is a good test because, if they destroy the shape with their indifference in sanding, then they are of no use to me as helpers.

Unfortunately for the apprentice, in my shop I am the designer. I do all the layout, all the cutout, all the joining, and all the rough shaping. If it is a new piece, I shape the piece and sand it as I want it to be when completed. No one puts anything together in my shop but me. It seems selfish, I guess, but if I had other people putting pieces together, they would not be my pieces. Many designers make drawings, and artisans build the pieces. I do not do this.

If I am doing something an employee hasn't seen me do before or that I think would be of particular interest, I call him over and take time out to explain each step. I ask if he knows what I am talking about, and if he questions it, then I go through it again. He can stand and watch for an hour if he wants to. This is part of his learning process.

I feel that an apprentice who has spent a year with me can go out and at least find a job, if not with an individual craftsman then in a mill-type shop. Unfortunately, there are not that many woodworkers working in the United States today who can hire a full-time coworker.

Obviously an apprentice is not much help to a craftsman for a while. Too often a young man eager to be a woodworker finds that it is not as romantic as he thought. Some of the fault lies with people who write books that make the crafts seem more idealistic and romantic than realistic and practical. It is great to let a piece of wood sit around for three or four months or even longer before you decide to do something with it, fine to take a year to make a piece of furniture, wonderful to be so idealistic that you feel using a power tool is wrong. I prefer to use a chain saw to cut a piece of timber; it takes me a matter of minutes, whereas if I were to use a bucksaw it might take me an hour or two. I can feel the spiritual vibrations of the wood as well in a chain saw as I can in a bucksaw.

Even now young people write to me offering their services. They will work for nothing. They will do anything—carpentry, window washing, sweeping the floors—just to be in my shop. Then there are others who ask right off, "How much do you pay? I have to have so much an hour." In those cases, I am not interested. It does not work out. I have much experience to verify this. Because of that experience, I hire someone who lives in the area so I do not have to worry about how they are going to live and eat.

People have come and stayed with me for as long as a month or

two. Once a young man from Germany showed up. He had heard about me. He stayed in the guesthouse for a week and ate with us. He helped me in the shop and swept up. He was just delightful to have.

I think the best thing to do in hiring employees is to hire them at a minimum wage, even if they do not know anything. I train them in the way I think they ought to be trained, and they are free to leave whenever they want. I feel that I am not taking advantage of them, and they are not taking advantage of me. Work should be fun. In the summertime, I do not think an afternoon goes by that Freda does not bring out watermelon or some lemonade, and we sit around and talk for a while. I do not run a tightly structured shop. It is very loosely, very disorganizedly organized.

I like to keep an apprentice for not less than a year. After that year is over, if we reach an agreement, I prefer to have him stay on at least another year. I have been very fortunate with all of my employees. Most of them have stayed with me for an average of five years. Somehow I have chosen employees who are compatible with my way of working. I think it is terrible to work in a place where there is a lot of wrangling and incompatibility. Also I would feel bad if employees working for me had no feelings at all for their work but were doing it strictly for a wage. I am pretty certain that all of my employees have taken pride in the work we do and enjoy working with me.

My son, Slimen, was always interested in the workshop and was rubbing furniture for me when he was ten years old. He married while still a student and worked for me after school and on weekends while in college. He came to work for me full time after he decided that he would rather be a woodworker than continue in college. In his late twenties he opened his own workshop.

My nephew, Nasiff, came to live with us after his father died. He also became interested in woodwork and helped out in my shop for several years. Today he is also an accomplished woodworker.

Besides Larry White and Paul Vicente, the other young men who worked for me for a time were Mark Singer, Jerry Marcotte, Mike Johnson, and Mike O'Neil. The two Mikes are currently in my employ. Mark Singer is working in wood in Cambridge, Massachusetts. Jerry went into a different profession.

For the last twenty years I have always had one full-time employee, and at times more. Once a situation arose where one young man who was leaving for another position stayed on a little longer than he had originally planned. Slimen, Nasiff, and Paul Vicente were also working with me. I had four employees, and I did not have the heart to tell any one of them that I could not use all of them at the same time; so my income went to my employees for a while. We managed to take in enough so that I could pay four people. Naturally, I really do not like this type of situation. I prefer one coworker and perhaps an apprentice or trainee employee.

I do not think you can really teach something like woodworking, especially the design element. Employees learn by watching and doing. We all have a little bit of talent that can be drawn out by encouragement.

Our son, Slimen (Sammy), and I, 1973. Not long afterwards, he started his own workshop across the lemon grove from mine.

Sometimes a person seems to have no talent, but with a little patience it will emerge. Nevertheless, a woodworker must have a touch and a feel for wood from the very beginning, even if his skills are not developed.

TEACHING

First of all, many people think that I teach. I am not a teacher. I am a full-time woodworker who occasionally gives lectures and workshops. It may seem that I am contradicting myself because I give workshops although I maintain that some aspects of woodworking cannot be taught. What I mean is that a design sense cannot be taught. Certainly technique can be taught; perhaps *learned* is a better word.

Some people feel very strongly that craft teachers are unnecessary. My feeling is that teachers can be helpful. They can encourage a student, if nothing else.

Wharton Esherick was once visited by an art class, and when they asked him what training they should have, he pointed at the teacher and said, "First, get rid of him!"

I do not agree with Wharton, although it is true that a weak student can fall under the stultifying influence of a teacher. It is up to the student to learn as much as possible without being dominated. In something like woodworking, there is absolutely no point in wasting your time on problems that are easily solved by turning to an experienced woodworker or a reference for help. After mastering the techniques, the student is free to spend time on the part that cannot be taught, the design work.

I owe a debt to the crafts, as I have said, which I can repay partially by conveying what I have learned to others. For instance, it is deeply gratifying to me if types of joinery that I have developed over the years can be taught to others, saving them years of effort.

I give four or five lectures or workshops a year. Most of the workshops are held in my own shop, which is convenient because essentially I just continue to work on whatever I am working on. I have given workshops in other places, however, among them: Aspen, Colorado; Atlanta, Georgia; Penland, North Carolina; and Edmonton, Alberta.

The workshop I gave in Edmonton was very interesting. It had its origin in the enthusiastic report of two Canadians—one, an attorney; the other, a professor—who came to a workshop I gave in Aspen. They offered to sponsor a similar workshop back home. Seven months later, I received a letter from the Northern Alberta Institute of Technology, asking me questions about my methods. The institute was a bit hesitant about setting up the workshop because it had never played host to one before. It turned out to be one of the most successful workshops I have given nevertheless. The institute has several huge woodshops, each with the finest equipment I have ever seen. Usually I limit my workshops to thirty people, but because the work was monitored by video cameras, sixty people were able to attend and still see all the technical details.

There is one thing I want to touch on to end this chapter. I was one of the last speakers at the seminar held at the Vatican in 1978, and as I sat there in Synod Hall listening to the other speakers, I observed the wonderful arches, the brickwork, and the masonry that ordinary artisans had done. I believe those craftsmen took pride in their work. They revered what they did.

I cannot repeat this too many times: I have always believed that most people who work with their hands have a communion between themselves and their materials. When the user of the object enters, the result is a triune of the object maker, the material, and the "owner."

The reverence that the object maker has for the materials, for the shape, and for the miracle of his skill transcends to God, the Master Craftsman, the Creator of all things, who uses us, our hands, as His tools to make these beautiful objects. Sitting there in the Vatican, surrounded by beautiful work, I was thankful and thought how fortunate I am to be able to work with my hands.

3
What I Do

WHEN I START TO DESIGN a piece of furniture, I always ask myself what I want it to do. For example, how do I want a chair to sit? How can good lower back support be achieved? What will the arm height be? Will the piece be light or massive? I take all such points into consideration, then I think about the construction. Sometimes I make rough chalk drawings on the floor, and if clients desire, I will make sketches on paper for them.

My approach to solving many structural and design problems is to rely on my common sense and experience. I simply make decisions by eye. I use my forefinger and thumb for calipers and let my eye and intuition and years of experience do the rest. I call this "eyeballing." In making a chair—whatever kind it is—I know by experience how deep, how wide, and how high it should be. I have no formula for the cant of the back legs. I judge it by eye.

Again, when I drill holes for the spindles in a chair seat, I just dry-

clamp the crest rail of the chair and use the holes in that as a guide. Then I use a marking gauge on the seat to draw the line that passes through where the center of the holes will be, and a divider to mark the midpont of this line. Every spindle hole in a seat has a different angle, but I just eyeball and drill them. Most people do not believe me until they see the process. Naturally, almost everyone asks if I make mistakes with this freehand drilling. I honestly cannot recall doing so. A young fellow once asked me if I have crosshairs in my eyes. I laughed. It is miraculous how accurate the human eye is.

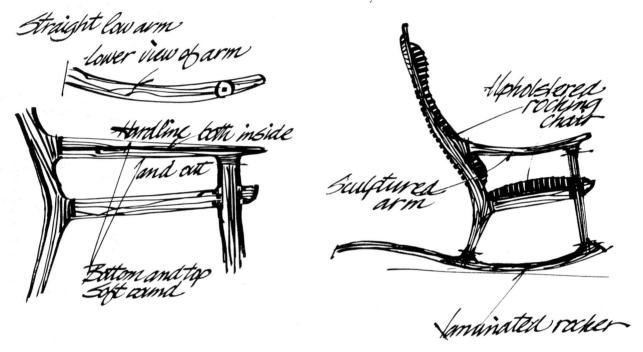

In designing a piece I use not only my eyes but my entire body as well. The flat curved spindles in the back of a chair, for example, must give good lower back support. The way I make them is to quickly cut one spindle on the bandsaw, sit on whatever is at hand, and hold the rough spindle against my back. This may seem pretty primitive, but it always amazes me that the first spindle I make fits my back perfectly. From this I make a pattern for all the spindles of that particular chair.

This brings up a basic question that is answered by an incident I recall. Once a furniture designer, a man about six feet four inches tall, told me that he had just sat on one of my chairs and found it very comfortable. His companions, of much smaller build than he, also found the chair comfortable. How, he asked with surprise, was this possible? I had no answer. What I do I have already described: I use my own body as a measure. On rare occasions I make a large chair for a large person or a small chair for a child.

I design and make each piece for the area in which it will be used. I do not have standard sizes and do not use jigs for any of the pieces I make. Sometimes the design of a house calls for furniture with heavy proportions. The type of furniture I usually make is quite light, but I can beef

up pieces to make them compatible with their surroundings. I do draw the line at deviating from my own designs and style however.

The very low arm on some of my chairs acts as a handle, and, structurally, takes the place of a stretcher below the chair seat. This arm is used to lower yourself into and to raise yourself out of the chair. It also serves as a convenient means of moving the chair forward or backward from a seated position without having to grab the bottom of the chair seat. A stretcher below the seat would clutter the clean flow of my designs. The only time I make a high arm is for rocking chairs, some side chairs, and occasional chairs. Dining chairs for host or hostess may have high arms if requested. The low arm has the added advantage of being both comfortable and not interfering with the motion of your body, particularly your elbows. Furthermore, you can throw your knee over the low arm and slouch with abandon, and the chair will endure.

Museum people have told me that lowering the chair arm and using it as a stretcher has no precedent.

I use several different chair arm shapes. The most common is narrow and runs parallel to the seat and curves out from the back leg to the front leg. Another type of arm is also narrow and gently curves down and out, from the back to the front. A broad arm is also made with the same curvature. The broad arm is attached to the back leg at a higher point than the narrow arm and serves as an armrest rather than as a handle.

I make an unusual piece that presents an interesting engineering problem. This is a double chair-back settee that has a large span (thirty-six inches) of unsupported wood between the legs. When I attach the legs, the tops or bottoms tend to splay out. The entire piece is made stable and functional by the attachment of the crest rail. This is not something that I engineered by study of abstract principles; I just did it. The first such settee was different in design than the one I make now, but it was constructed on the same principles. It has been in the corset department of a San Francisco department store for twenty-five years, and in that location, it has seen much heavy use.

The incorporation of hard and soft lines—hard edges and soft curves—in my furniture is what makes it unique. I do not know when I started to combine these contrasts; the combination evolved from the original round form that I made. I started using a sharp edge when I wanted to accent certain aspects of furniture, both visually and tactilely. This hard edge is pure design; it is not necessary structurally.

I make my chairs as simple as possible; yet when I first started working, people thought they were sculptural pieces. This amused me because I did not intend them to be looked at as works of art. The organic pieces that are being made today make mine look almost artless by comparison. But in my work there is a very subtle feeling of sculpture, which is not demanding or spectacular. It adds a quiet beauty to the chairs, I think, without interfering with their function.

For example, where the crest rails of my chairs are attached to the back legs, there is a kind of swirl that is suggestive of the swirl of a wave. When I first started working, this part of the chair had a simple, rounded form, like a comma's. One day I was fooling around, and I cut

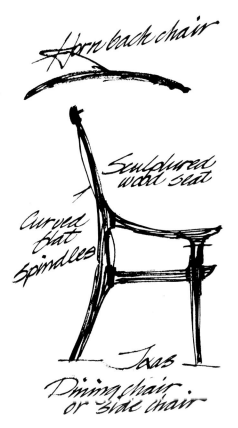

Horn back chair

Sculptured wood seat

Curved flat spindles

Texas Dining chair or side chair

in a little deeper than I wanted to. I ran my thumb over it, and I thought, "Well, instead of making this convex, I'll try it concave." So I did, and that is just the way it happened. It was an accident. I liked it, and everybody who has seen it has liked it. When you run your thumb over it, it feels good. Then I included the swirl in the seats of some chairs, just where the seat extends beyond the front leg. I had never thought of a wave, but that is sort of what it is.

I have about ten basic chair types—you might call them prototypes—that form the nucleus of the approximately fifty chairs that I make. For example, all my chairs can be upholstered or be made of solid wood. Arms, backs, crest ridges, legs may be varied. It is amazing how one chair begets many. But each chair is designed individually. It is a

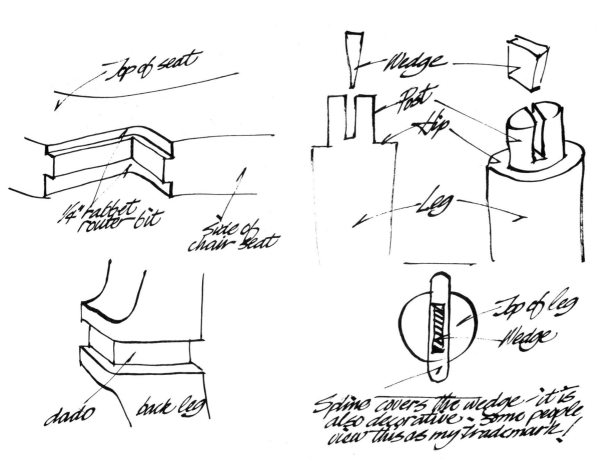

living thing. I *do not* make up a bunch of parts and reach into bins to assemble a chair from pieces. I do not stockpile any of my pieces; each piece is made for the person who orders it.

Too many woodworkers, both amateur and professional, seem to think that there are secrets in joinery. There are no secrets. It is all a matter of figuring out how a joint is made. I picked it up without any formal training, and I am still learning. There are many fine publications that show detailed, step-by-step methods of doing all kinds of joinery. Such publications are good guides for the beginner and some-

times contain hints for the more advanced craftsman. The "secret" lies in how and where to use the different kinds of joints. I do not think it is necessary to go into detail about the hundreds of types of joints that woodworkers in times past have used. I use only the types that relate to my work: dovetails, box joints, finger joints, mortise and tenon, butterflies, and so on. The joint that I use on the back and front legs of my chairs has stimulated a lot of interest and inquiries. I have shared how this is done in articles and workshops and in this book.

There are many places in my furniture where a dowel or mortise-and-tenon joint just does not work because of the thinness of the wood; so I use screws. In effect the screw is a metal dowel used in place of a wooden dowel. I am not a purist. I want my furniture to be functional and strong, and I will do whatever I must do to make it so. I have no qualms about this.

I have always had the conviction that joinery is an aesthetic part of a piece of furniture, really of woodwork in general. If a joint is well made, why go to the trouble of covering it up? I have exposed all my joints since I started making furniture.

I have had this beautiful boxwood spoke shaver a very long time — I use it a lot in my work — feels good in the hand

Woodworkers today pit themselves against the quality of the past. But that coin has two sides. I have seen an awful lot of work of the past where the exterior of the piece is very handsome, but places that are not seen are quite crude. My chairs are finished completely, underneath as well as where people see. The cabinets that I make are finished inside as well as out.

Years ago I did a beautiful executive desk. At that time I used a triple-mitred corner. An old Swedish craftsman was working in the office doing some interior work. He looked at the joinery, called me over, and pointing to an area near the floor, asked, "Why did you make a triple mitre here?"

I said, "That is the way I do it."

He said, "No one will ever see it."

It surprised me a bit; I was naive. But I laughed and said, "Well, you're right, but I would see it."

This is the way I do all my pieces.

I do not upholster my own pieces. I can and have, but for various reasons—time is the most important—I give my pieces to a professional upholsterer. I do make the seat and back frames that are upholstered and inserted into the chairs. These frames have to be precisely fitted. I will send out the frames to be upholstered while I am finishing the chair, and often the upholsterer finishes his work before I finish mine.

Good upholsterers are difficult to find. Keith Dixon, my upholsterer, is a master of his craft. Further, I have developed a fine rapport with him over the years. He knows my furniture, knows how it is constructed, and he has had much experience in the often unorthodox ways that I want things done.

People ask me who picks the fabrics. Where upholstery fabric or leather is concerned, I do not like any kind of pattern. The texture or the color of the material is enough statement (although once a client had me

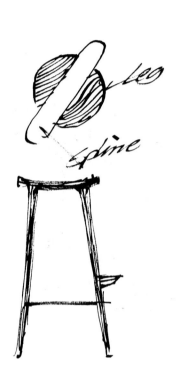

cover a piece with antique French tapestry, and the result was spectacular).

From the beginning, I liked and used Jack Lenor Larsen's fabrics, especially the handwoven textiles and the earth colors. Once in a while a client emphatically requests an upholstery textile, and in most cases, the choice has been good. All of my upholstered pieces are priced basic. That means that the client pays for both the upholstering and the fabric separately from the piece itself. When I furnish the upholstering, I add 10 percent over the fabric cost alone, which gives the client a good break. I usually ask them what their color preferences are, then show three color swatches; any more than three often creates confusion.

When someone purchases my furniture, whether it is one piece or many, I keep a record of the piece and the client and maintain contact. I try to keep this relationship on a friendly basis. Thus, I often get calls from owners of the furniture I make asking about care and maintenance, say, how to remove a water stain. If the person lives far away, I can give him advice. If he is close by, I do the work myself.

I have made several thousand pieces of furniture in the years I have worked. Of course, it is not possible to maintain contact with everyone who owns my pieces, but I have tried to keep in touch with as many as possible. Wood expands, contracts, warps, cracks, and behaves in its own way. Repair and maintenance are part of my responsibility as a woodworker. I guess I am very fortunate that I have had little major damage to repair over the years. Several times pieces have been damaged in shipping. It is challenging to bring a piece back to its original state.

The owner of one of my rocking chairs called me once, very upset. It seems that he had picked up a stray puppy, which then proceeded happily to chew the end off one rocker. I thanked him for the call, reassured him, then brought the rocker home, repaired it, and returned it. He looked at it and remarked that he could not tell which rocker had been damaged and repaired. Nor could I.

Several weeks later he called me again. The puppy had repeated its performance. But, he stated, he was not concerned because he knew that I could repair it again. I did not know what to say this time. The first time I had cut two inches off the end of each rocker. That was not possible again. Eventually I decided to replace the newly damaged rocker.

I have had so few repairs over the years that I remember all pieces clearly. Another amusing incident concerned a brown oak rocker. The owner called me after two years and said one of the spindles had broken. I told him to ship it back to me, that I would pay the air freight both ways.

When the rocker arrived, I discovered that the owner had more in mind than the repair of a spindle. He had glued little notes all over the chair indicating spots where a cat had scratched it or someone had scuffed it. These blemishes were so minute that I had to use a magnifying glass to see them. I set to work replacing the broken spindle, but because the grain and color of the replacement did not match the remaining six, I replaced all seven instead. Then I refinished the entire chair and shipped it back.

I heard nothing from my client. Later on, when I happened to be visiting his city and called him, he complained that on the underside of the crest, where a chip of about an eighth of an inch had been replaced, the colors did not match. Only by assuring him over and over that nothing left my shop until I was satisfied with it could I set his mind at ease.

This was the first, and only, time that this has happened.

About 95 percent of my work is done in black walnut, but I use other woods as well. I use Indian and Brazilian rosewood, teak, and English brown oak. Occasionally, if a client requests them, I use white oak, cherry, or yew. I prefer black walnut, however, because of its warmth and texture and the way it works. It lends itself to the way I design in texture and in color. It is a very gracious, forgiving wood, where Brazilian rosewood, for instance, is hard, dense, and unforgiving. With rosewood everything must be extremely precise—machined almost— whereas black walnut gives a little, is more pliable.

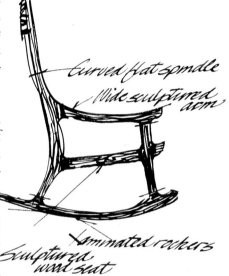

Curved flat spindle
Wide sculptured arm
Laminated rockers
Sculptured wood seat

Black walnut at one time grew throughout the United States. Today most of it comes from a belt stretching from Wisconsin through Indiana and Ohio and down through the Ozarks. I have seen stands of beautiful Appalachian walnut in North Carolina and Kentucky, though I am told that the supply for commercial use is dwindling. A small furniture factory would probably use more walnut in a day than I would use in a lifetime.

Most of my walnut comes from Indiana because the lumberyard I buy from has a small mill there. The Indiana walnut is very dense and very heavy.

I do use California black walnut, which is called Claro by the lumber industry. It is somewhat less dense than the eastern walnut and is beautifully figured. I have slabs of this four to five feet wide and twelve feet long. I will use these big slabs for tabletops when the inspiration moves me, but generally I do not design tables with slabs in mind.

Several years ago I was visiting George Nakashima at New Hope, Pennsylvania. George asked me about my woodpile.

I replied, "You ought to see some beautiful brown oak slabs that I bought in England. They are magnificent. I also have a few slabs of California walnut."

"Have you ever seen my woodpile?" he asked. "I'll show you."

We walked into a large, cement block storage room. He had slab upon slab leaning against each other and many logs that were sawed into planks. I had never seen so many pieces of beautiful wood. I gulped and thought, "I sure walked into that one."

When I purchase my California walnut, it is uncured; it has not been air- or kiln-dried. I put it on sticks and let it air. The minimum drying time doing it this way is one year for each inch of thickness.

My friend Jerry Glaser, an engineer and very fine wood turner, annually takes a trip to England and Germany to purchase logs. He finds what he thinks I would like and buys them for me. He does the same for other woodworkers too.

Not long ago he sold me an English white oak log that was entirely

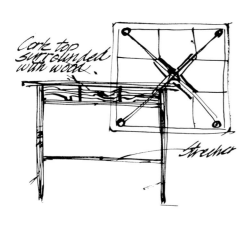

Cork top
surrounded
with wood.

Stretcher

burled. It was an expensive log, and I am still waiting for it to dry thoroughly before I use it. I also bought two beautiful English yew slabs. No sooner had they arrived when a client asked for a table made of one. The colors were extraordinary: pinks, blues, greens, reds, yellows, and browns. It looked like a rainbow. It is still drying, and I do not know if it will retain these colors when it is finished, but the prospect is enticing.

I use both Indian and Brazilian rosewood but prefer the Brazilian. In 1983 I completed six Brazilian rosewood rocking chairs. Some of these chairs were made with the most beautiful Brazilian rosewood I had ever seen.

I have stated many times that Brazilian rosewood has a very strong presence, and that I did not want to use more than one piece of furniture made of it in a room. I never had used more than one piece in a room until I was given a commission for forty-seven pieces in rosewood for a single house. While I was building these pieces, a film was being made about my work. In that film I restated my case against the use of too much rosewood.

Not long after all that furniture was installed, the film was televised. Minutes after it ended, my client telephoned. She said that she liked the film but was puzzled by my statement about rosewood's dominating character: her house was filled with rosewood. I explained that I had made that remark before I built her pieces and saw them placed throughout her home. Had the film been produced then, I would have made exactly the opposite statement. Nevertheless, I doubt that I shall ever make so many pieces in Brazilian rosewood again because it is very hard to obtain, at least of the quality I desire, and very costly. What is more, I am allergic to the dust raised by sanding rosewood; it makes me sneeze.

When people ask me about the kinds of woods I use, the topic of exotic woods always comes up. The Indian and Brazilian rosewoods are the only exotics I use. Teak and English brown oak, though imported, are not exotic woods. Black walnut, white oak, and cherry are domestic woods, and they lend themselves beautifully to my work. The type of finish that I use enhances the beauty of the latter two woods. (Cherry wood is commonly stained a darkish red, which destroys its natural beauty.)

Some woodworkers like to work in a wide variety of woods, but my palette is quite small. Furthermore I do not mix my woods and do not use metal hardware of any kind or other materials for embellishment. Sometimes I use exotic woods, such as rosewood and ebony, for pulls, plugs, pegs, butterflies, and inlays to accent the forms of my pieces.

I refuse to use ivory in any way. I do have a very good substitute however. Visitors to my house and workshop, nestled in the midst of a lemon grove, naturally ask if I use lemon wood in making furniture. I do not make whole pieces of lemon but use it decoratively as one would use ivory. When lemon wood is spalted, that is, when a dead tree is exposed to the elements for a while, it resembles old ivory.

I use softer woods in making insert frames—seat frames and back frames—for upholstered pieces. I use mostly Indian sycamore and pop-

lar for this purpose. The upholsterer's staples hold in such woods but do not hold in hardwoods. And of course, these woods are rather inexpensive.

Many times I have found pieces of poplar wood whose color was magnificent. Whenever I do find pieces of this kind, I set them aside until I have enough boards. Then I make a tabletop or sometimes a cabinet. I have found poplar with shades of red, black, blue, and green as well as dark brown.

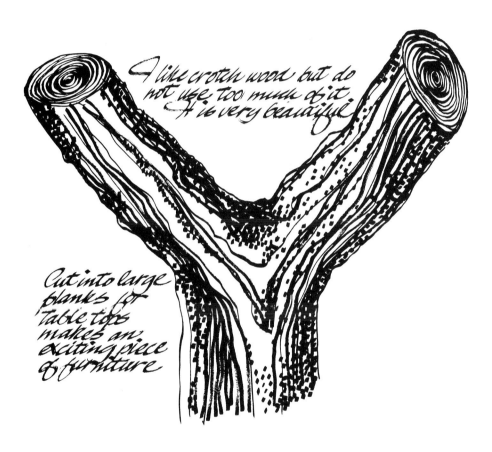

I like crotch wood but do not use too much of it. It is very beautiful.

Cut into large planks for table tops makes an exciting piece of furniture

Also when I find any beautiful walnut crotch wood, I set it aside, adding to it other pieces that are compatible. These I use for tabletops.

When I first started making furniture, I spent a lot of time going through the wood at lumberyards, perhaps wasting my time and the yardman's. Walnut seemed very costly to me then, and I hated to cut away any sapwood on the walnut boards I chose. Besides, I liked the contrast of the white sapwood and dark heartwood. From the very beginning, that sapwood appeared in my work and often became part of my design. I continue to use it except when a client specifically asks me not to.

I recall in my early years when I delivered an executive desk, some Old World cabinetmakers were installing cabinets. They came over to

inspect the desk. While they admired it, they were aghast at my using sapwood.

"You should have used a shading stain to make it look the same all over," one exclaimed.

"But that would destroy the pattern of the grain," I said.

"Oh, no," came the reply. "That would make it look beautiful."

There is still prejudice against sapwood, but I use it as long as it is sound. (Because it comes from the outside of the tree, the area of latest growth, sometimes it is quite soft.)

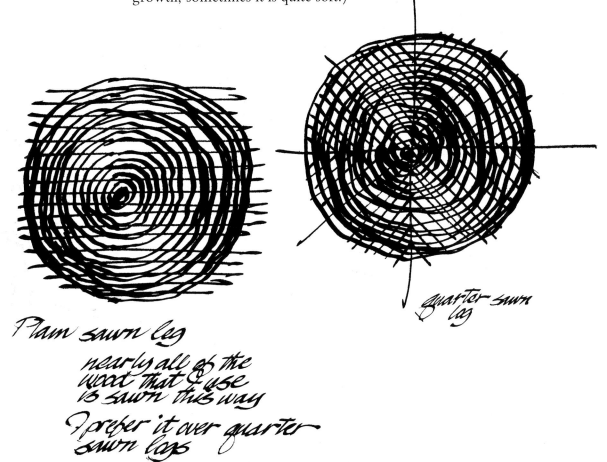

Plain sawn log

nearly all of the wood that I use is sawn this way

I prefer it over quarter-sawn logs

quarter sawn log

In selecting my wood for a piece of furniture, I do not combine a quarter-sawn wood with a slash-sawn log or with crotch wood. I usually do not like to use quarter-sawn wood on any of my furniture. It is straight-grained, and I find this incompatible with the way I design.

Every woodworker has preferences in woods and in matching woods. When I select woods for a tabletop or cabinet, I depend entirely on my experience, my instinct, my intuition, my heart, and my eye. I do not select with my head. The choices come from my gut, not from between my ears.

I stock several grades of wood in sheds. When I first started I always purchased select (the best grade) and FAS ("first and second" grades, that is, the next grades below select). It bothered me, however, that I

was cutting up clear lumber for chair seats. So, some time later I took a chance and purchased one thousand feet of common number one walnut, a grade lower than FAS. In the stack I found some beautiful crotch wood boards, some of which were eighteen inches wide. Because of slight checking (that is, cracking) in these boards, I suppose they were downgraded. After surfacing the boards, I filled the checks with epoxy and sawdust. They became some of the most beautiful walnut tabletops that I have made. From this experience, I started using common number one and common number two lumber, the lowest grade, for chair seats. I found that I could cut between the knots with very little waste.

The difference in these lumber grades is in the number of knots, checks, warping, splits, and other flaws. Select is clear on both sides. FAS is clear on one side with a few knots on the other. Common number one has knots on both sides with a limit on the number of knots per foot. Common number two has the greatest number of knots. When you purchase a whole log and have it sawn, it is called "mill run." Such a log may contain all grades. If you are lucky, the grade of lumber is high. My feeling is that common number one, because of the knots, has exciting grain. If used correctly, it can make beautiful furniture.

I have four sheds where I store my lumber. Some of it is air-drying. Most of my lumber has been steamed and kiln-dried. When woodworkers get together, the conversation seems to revolve around three topics: glues, finishes, and how woods are dried. There are very strong opinions, especially on the subject of kiln-dried versus air-dried wood. Personally–this is my own opinion; I am not adamant about what others should use–I prefer using kiln-dried walnut. Yet I do have a large inventory of air-dried walnut, and I use it.

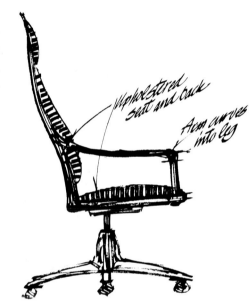

I have heard and I have read that steaming and kiln-drying walnut changes the nature, including the color, of the wood, whereas air-drying preserves its natural color. This is true. I just happen to like the gray-brown color that results from steaming and kiln-drying walnut. I do not find, however, that the quality of the wood is otherwise affected, no matter what is said. Again, this is just my opinion, but if air-drying preserves the natural color, adding a finish just as surely changes it. I have combined kiln-dried and air-dried wood in the same piece of furniture, and one cannot tell the difference when the piece is finished.

A great to-do is made about the mystique of wood. I have stated several times, both orally and in my writing, that when you cut a tree down and make boards of it, it continues to live. I should have added that it lives because people are using it. There is a lot of romantic nonsense associated with this wood mystique. Put another way, too often the mystique has been blown all out of proportion. I do not deny that there is a mystery about wood; so there is also with clay, fiber, and metal, but none of these materials has the beauty of a tree or of a board cut from it.

Some woodworkers talk about the necessity of contemplating a piece of wood and letting it tell them how it wants to be used. This is fine, but time is precious. Personally, there are so many pieces of furniture for which I have mental drawings and there are so many more pieces of wood in my future that I have no time for leisurely conversa-

tions with a single piece. My communications with wood, therefore, are very efficiently condensed. I have had so many conversations that I now use a kind of shorthand. I relate intensely to wood. The pieces that will become furniture are chosen with a mixture of common sense and love, and there is no reason for this process to be long and arduous. Though I have a continuous love affair with wood, there are other things in my life that are much more important; among them my family and my friends.

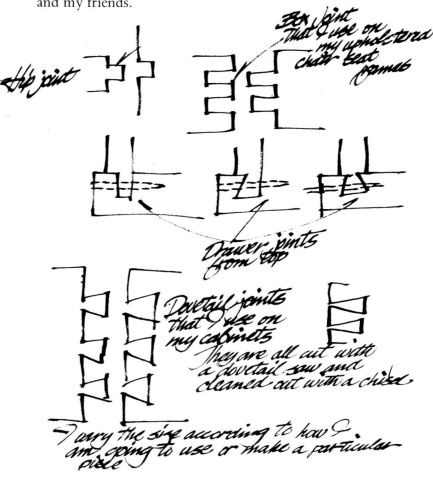

Wood moves a lot, sometimes in surprising ways. I have gotten calls from people who live nearby who are suddenly faced with antique tables that have cracked. How should they be repaired? My answer is always, "Don't touch it. Don't put oil or anything else on it. Eventually it will come back, and the gap will close up rather well." Usually in such cases the gap does close, though there will still be a visible crack. The alternative would be to remove the tabletop, resaw the boards to eliminate the crack, then glue, and clamp. But this changes the size of the tabletop unless a piece of wood is added, a step that is laborious, costly, and may or may not be effective.

The reason for mentioning the movement of antique wood is that it is so often used as an example of wood's being alive. Many people take this literally and then talk about "feeding wood" with oils, varnishes, waxes, or whatever. This is a pretty poetic idea but not necessarily a meaningful one. I understand that museums do not feed wood; they do

not keep oiling it. Once it has stabilized itself in its particular environment, it is left alone except for dusting. Wooden pieces should not be soused continuously with oil because that tends to generate expansion and contraction and other problems. Excess oil also builds up into a layer of gunk over the years and takes away from the beauty of the wood. So, while some people insist that "you have to feed wood," this is just not so.

In the case of my furniture, which is oil-finished, every piece has a minimum of six applications of oil. I recommend that my chairs be rubbed down once a year with the finish that I use. Tabletops and cabinets should be washed at least twice yearly with a damp cloth and a small amount of detergent, wiped with a water-dampened cloth, and dried. Then they should be rubbed with oil and all surplus oil removed. No matter how well a house is kept, it is surprising how much grime can adhere to large flat surfaces, like tabletops and cabinets. If such surfaces were not given a light wash first, oiling would result in rubbing the grime into the wood. This process is very much like cleaning an oil painting and bringing it back to life.

One anecdote regarding the "care and feeding" of my furniture illustrates the point. Some months after I had made a cabinet for someone in Los Angeles, I received a phone call asking if I would come look at it. No reason was specified. When I arrived everything seemed fine. Then I got closer and realized what was wrong. The housekeeper, with all good intentions, had been applying linseed oil to the piece every week, inside and out, without rubbing it down. The result was a mess, a coating of thick, tacky goo. I brought the cabinet back to my shop; it took me a week to bring it back to the way I thought it should be.

This is a good place to say something about finishes.

Before finishing but after shaping, a piece is filled (if necessary) and sanded. The filling compound is made of epoxy and fine sawdust. The sequence of sandpapers is 100 grit, 150 grit, 280 grit, and 400 wet-and-dry used dry. Then the piece is burnished with 0000 (four aught) grade steel wool.

When I first started making furniture, I used a clear synthetic lacquer, applying as many as ten coats. These were preceded by a lacquer sanding sealer. After drying, this was sanded. Then another coat of sanding sealer was applied and sanded. The clear lacquer was sprayed on, dried, and wet-sanded. This process was repeated for a total of ten coats of lacquer. The final coat was then rubbed down with pumice and finally with rotten stone. The result was beautiful, and we still have one of the pieces made then. At that time, people were very impressed with this finish, exclaiming with delight at how much it looked like plastic. I decided then and there to give up lacquer. There are many very fine commercial wood-finishing products on the market today. I do not use any of them.

After experimenting with various finishes and mixtures, I finally arrived at the double-barreled finish I use today. This is made of urethane varnish, raw tung oil, boiled linseed oil, and pure beeswax.

Some mixture of the last three ingredients has been used for centuries. It gives a warmer, more pleasing feeling than any other finish I know. The first mixture is composed of equal parts of urethane varnish (semigloss), raw tung oil, and boiled linseed oil. There is enough drier in the boiled linseed oil to activate the raw tung oil. This is applied to the raw, sanded wood three times at one-day intervals. (Urethane varnish helps in the prevention of water spotting.)

The second mixture is equal parts of raw tung oil and boiled linseed oil to which I add shredded beeswax. Because I add the beeswax by feel,

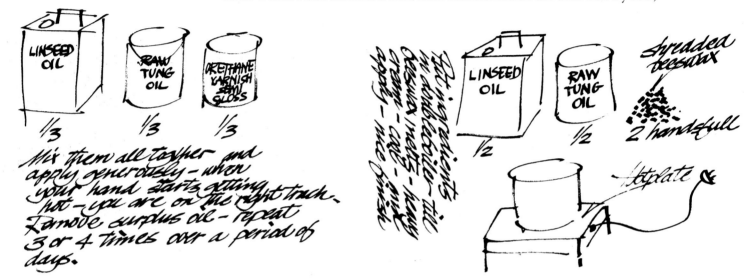

much as a cook seasons a sauce, the reader who wants to try my method will have to experiment. The final result is a mixture with the consistency of heavy cream. The oil mixture is heated to melt the beeswax. The safest way of doing this is in a double boiler on an electric hot plate. Always do this outdoors in a clear, safe area. Avoid using an open flame. Linseed oil has a very low flash point. *BE VERY CAREFUL!* Heat the oil just until the beeswax melts. The oil and wax homogenize readily. I store this mixture in a gallon can and apply it cold. It is not necessary to reheat it. It has a very long shelf life; I do not know exactly how long because I am constantly making and using it. Stir it before using.

I use a minimum of three applications, vigorously rubbing in the mixture each time. When my hand gets hot from the friction, then I know I am doing the right thing. I use both rags and my hands directly to apply the wax mixture. Rags impregnated with this mixture are very combustible. Because I subscribe to a rag service, I keep mine submerged in water in a plastic container.

One of the most important aspects of finishes, I believe, is that they invite me to touch, to caress, and to take pleasure in the wood surface. Furniture is to be used. The "Please Be Seated" title that the Museum of Fine Arts in Boston used for its exhibition of my furniture states this well. Similarly a good finish should act like a sign that says, "Please be seated."

When I started making furniture, working in a one-car garage, I owned the basic tools—a hammer, a handsaw, a jack plane, a few chisels,

a carpenter's square—but not a single power tool. Eventually my friend Harold Graham, the designer, lent me an old tilting table saw, where the table tilted and the saw remained vertical. I made quite a few pieces using that saw. I did my first large commission with only the hand tools and a saw. I acquired more hand tools as I could. Looking back, this is one of the best things that could have happened to me: I learned to work with and use hand tools. After thirty-five years, I am still learning.

The first power tool I purchased was a ten-inch table saw. I then

Nicholson cabinet maker rasps are indispensable in my work.

#54 is ½" wide and tapers to ¼" and is 8" long. —they no longer make this model. As far as I know they only make #49 and 50

Many years ago, because I could not purchase the Nicholson files I wanted, I used riffle files—

I cut them in half and put handles on them and they are really wonderful to work with— all kinds of shapes to select from

acquired a jointer, a band saw, a drill press, a lathe, and finally a small thickness planer. In acquiring all of these tools, I did not go into debt but purchased them as I was able to pay. To this day I maintain the practice of avoiding going into debt and overextending myself.

Over the years, I have upgraded all of my equipment several times. Now I have all the equipment that I need, though temptation beckons me, as it does most woodworkers, whenever a new tool is introduced. Today with all the fine tool outlets and beautiful catalogs, it is difficult not to purchase items that you really do not need.

Many years ago in Seattle, I ran across some beautiful Japanese saws and purchased one of every kind there. I have never used a single one of them but rather enjoy looking at and holding them. Later I did purchase two Japanese saws that I use in the shop. I must admit that I am guilty of buying a tool for a specific job, putting it away, and forgetting that I have it. I have several sets of Japanese chisels and gouges that I do not use because my older ones still have much life in them, and one does become accustomed to certain tools; they become very good friends.

When young woodworkers ask me what tools they should buy, I always recommend the very finest even if they only buy one at a time. I tell them, "Purchase a tool that feels good in your hand."

I have a weakness for hammers, but I find that I have never purchased a hammer whose handle felt good. I have a favorite hammer, which I reshaped to fit my hand.

After acquiring my heavy power tools, I began to purchase electric hand tools, starting with a drill and a belt sander.

In making the scooped wooden seat for my chairs, I originally used a large gouge and mallet, then finished with a scraper and sandpaper. I found this quite time-consuming; so I purchased a large body grinder (disk sander) and used 16 grit paper. This chews the wood right out to rough-shape a seat. The rough form can then be finished with smaller disk sanders and finer papers.

After purchasing a large air compressor, I started to use air tools. The repair problems are minimal compared with electric hand tools.

I am often confronted by woodworkers who have romantic ideas about hand tools versus power tools. I do not fault them one bit. What they say and feel about hand tools may very well be true. Yet to be able to make a living and produce enough work to do so, I use whatever tools will do the job most accurately and most efficiently. I think that I am an idealist, or I would not be doing what I am doing, but I am also a realist.

The most dangerous tool, either power or hand tool, is a dull tool. If a chisel, for example, is not sharp, you tend to force it. It not only makes a bad cut but requires greater effort to use. Somehow this increases the possibility for error. With power equipment, a dull band saw blade only results in bad work. One must force the work into the blade; the blade will have a tendency to drift, that is, not cut true. Again the possibility for error is compounded. The safest tool is a sharp tool.

Exhaustion equally is a woodworker's enemy. A tired mind and body can only lead to errors and accidents, especially around power machinery.

When I first started making furniture, I worked alone; yet I was able to produce as many pieces then as I do now with two helpers, perhaps even more. The designs were simpler then, and the joinery less complex.

When people ask me how long it will take to get the furniture they order, I shudder. I am fortunate that I have a great deal of work to do. This rewards me both spiritually and financially, but unfortunately it also means that I am working under pressure.

I try to be very careful how I reply to customers regarding delivery. I usually say that it will take a year or more but try not to be pinned down. There are exceptions. For example, babies do not wait, and I usually drop whatever I am doing to be sure that an order for a cradle is delivered on time.

My back orders are such now that even a year is a quick delivery time. If someone orders one piece, I usually can work it in, especially if it is a chair and I happen to have orders for chairs of the same kind. I try to finish all orders as soon as possible, but in the case of very large orders, I have to stagger my work and come back to the order repeatedly, spending time on other work as well.

At any one time I am working on four or five different orders. As I write, work is in progress on ten rocking chairs, six settees, a print rack, a dining table and fourteen chairs, and some bedroom furniture—and I am making a circular stairway that I promised my wife several years ago.

Many times I have been asked if I prefer many small jobs to a single large one. Would I consider working for one individual? I prefer to work for many different people and have no wish to put all my eggs in one basket.

The types of furniture I make are quite varied, including pieces for home, office, and church. This variety is challenging and satisfying. It does not matter how much work I have and how much pressure a client puts on me, I maintain a steady pace. Not one piece of furniture leaves my workshop that I would be ashamed of.

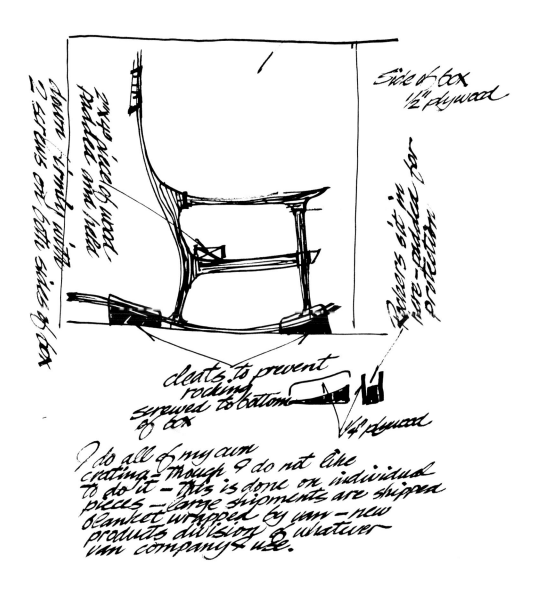

Originally most of the work I did was for people in Southern California, but today I ship my pieces all over the world. For a single piece I ship by air freight; then delivery takes only a day or two. Air freight in the long run is economical because it avoids the dangers of mishandling and breakage.

It has always been a problem to find someone to crate my pieces the way I wanted them crated; so I do it myself. This means that I make the crates also, though, frankly, I would prefer spending my time making furniture. For truck shipping I have to make heavy crates for each piece. The crates for air freight are lighter than truck crates. If I ship by van, the pieces are blanket wrapped, and I do not have to make crates. I never ship by either van or truck during the summer but wait until the temperature cools off in October. Within a hundred-mile radius of my workshop, I still deliver furniture myself.

Whatever I am working on, I get excited. It does not matter if I have done the same piece many times. I still cannot wait to get out to the shop in the morning. This is especially true when I am working on a piece that I have not done before. Work is a renewal of energy. People ask me what my favorite piece is. My favorite piece is the piece that I am working on.

I sign all of my pieces like this.
Starting each new year with
#1
No. 1 1983
Sam Maloof f.A.C.C.
©
The intials after my name
designates:
Fellow American Craft Council

The two young men who work with
me are Mike Johnson and
Mike O'Neil — put their
intials on all of my pieces
like this M6 They are burned
in with a burning pen that
Bob Stocksdale made for me.

I can find my tools easily if they are put away where they belong. Often they are not. I work in a rather cramped area *(overleaf)*. My workshop seemed very large when I built it. Now it seems intimate.

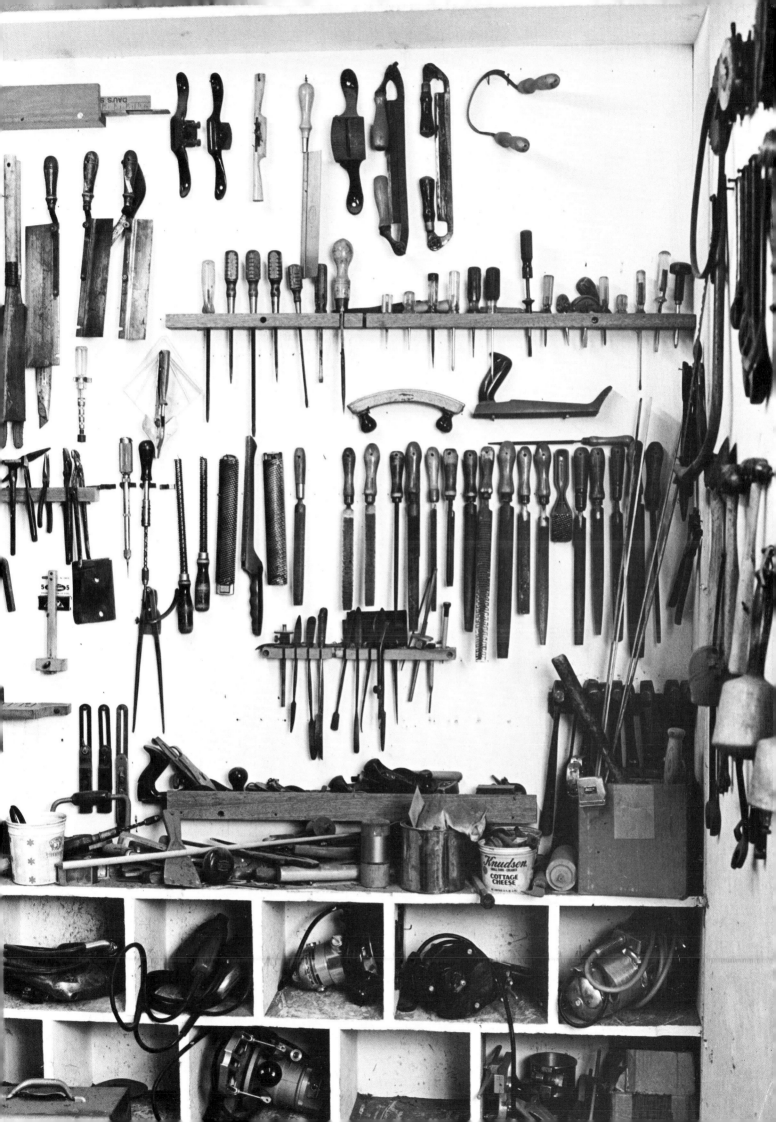

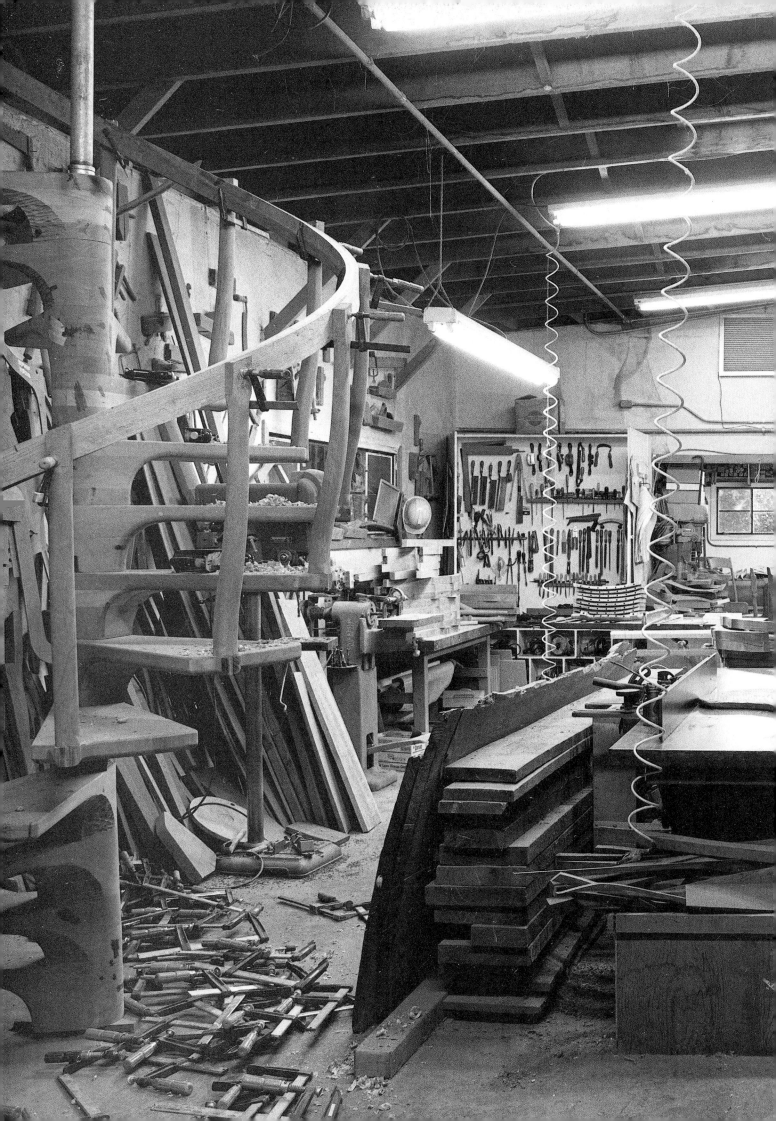

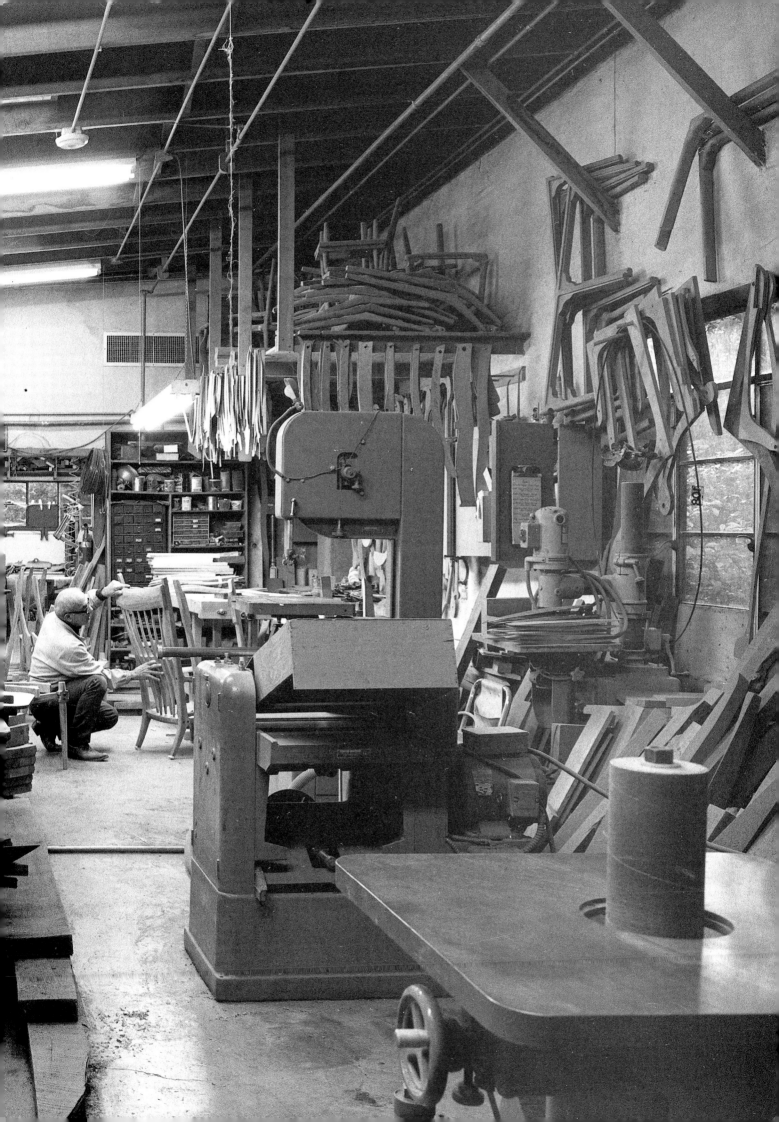

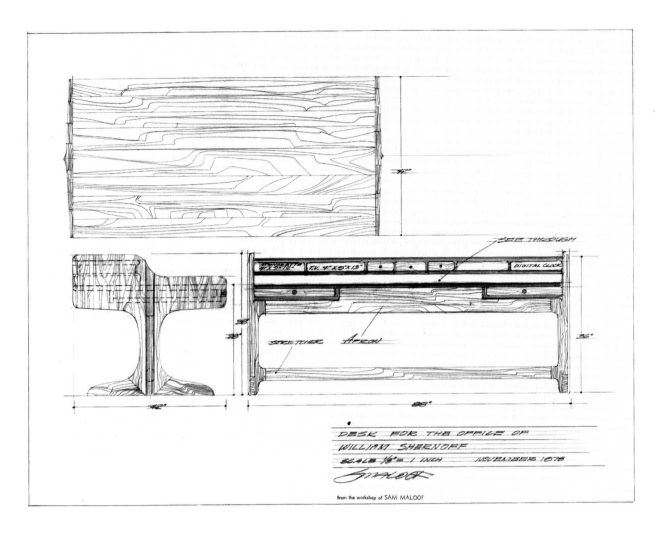

DESK FOR THE OFFICE OF
WILLIAM SHERNOFF
SCALE ⅛" = 1 INCH NOVEMBER 1976

from the workshop of SAM MALOOF

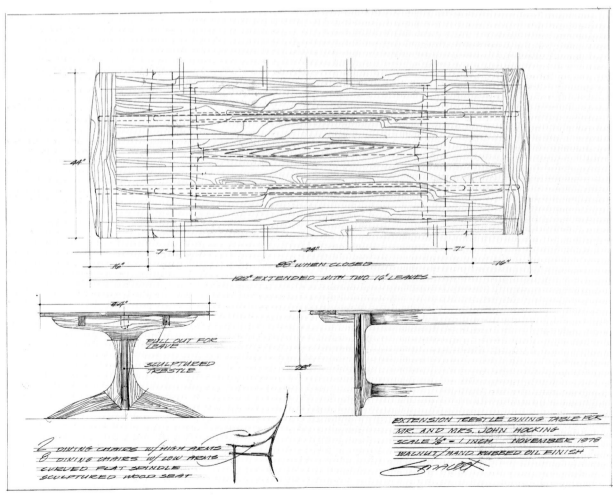

PULL OUT FOR
LEAVE

SCULPTURED
TRESTLE

2 DINING CHAIRS W/ HIGH ARMS
8 DINING CHAIRS W/ LOW ARMS
CURVED FLAT SPINDLE
SCULPTURED WOOD SEAT

EXTENSION TRESTLE DINING TABLE FOR
MR. AND MRS. JOHN HOCKING
SCALE ⅛" = 1 INCH NOVEMBER 1976
WALNUT / HAND RUBBED OIL FINISH

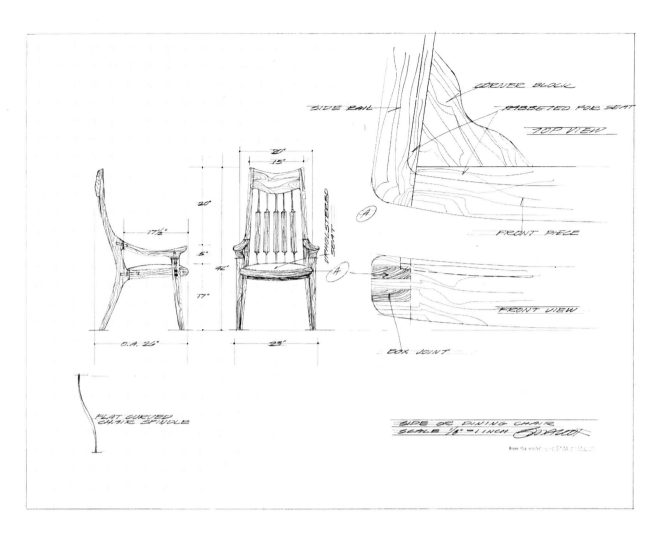

SIDE RAIL

CORNER BLOCK

RABBETED FOR SEAT

TOP VIEW

A

UPHOLSTERED SEAT

A

FRONT PIECE

FRONT VIEW

BOX JOINT

20"

15"

20"

17½"

5"

42"

17"

O.A. 26"

23"

FLAT CURVED
CHAIR SPINDLE

SIDE OF DINING CHAIR
SCALE ⅛" = 1 INCH

from the workshop of SAM MALOOF

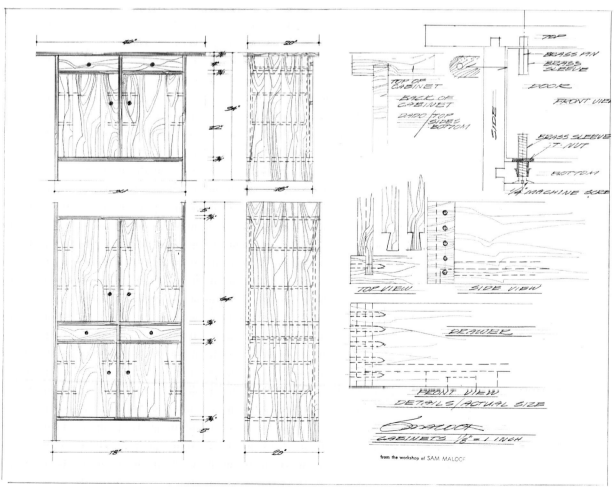

TOP

BRASS PIN
BRASS
SLEEVE

DOOR

FRONT VIEW

TOP OF
CABINET

BACK OF
CABINET

DADO TOP
SIDES
BOTTOM

SIDE

BRASS SLEEVE
T-NUT

BOTTOM

¼ MACHINE SCREW

TOP VIEW

SIDE VIEW

DRAWER

FRONT VIEW

DETAILS/ACTUAL SIZE

CABINETS ⅛" = 1 INCH

from the workshop of SAM MALOOF

42"

20"

34"

22"

30"

18"

5"

64"

18"

20"

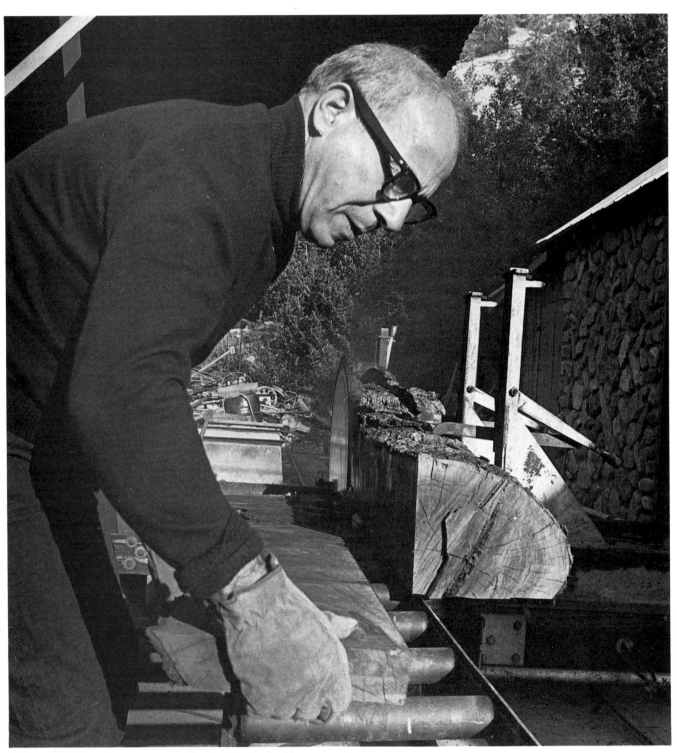

I attempted only once to cut my own lumber here at the Chapman
Sawmill. I found it to be more efficient and economical to have
my logs cut to my specifications and delivered to the shop.

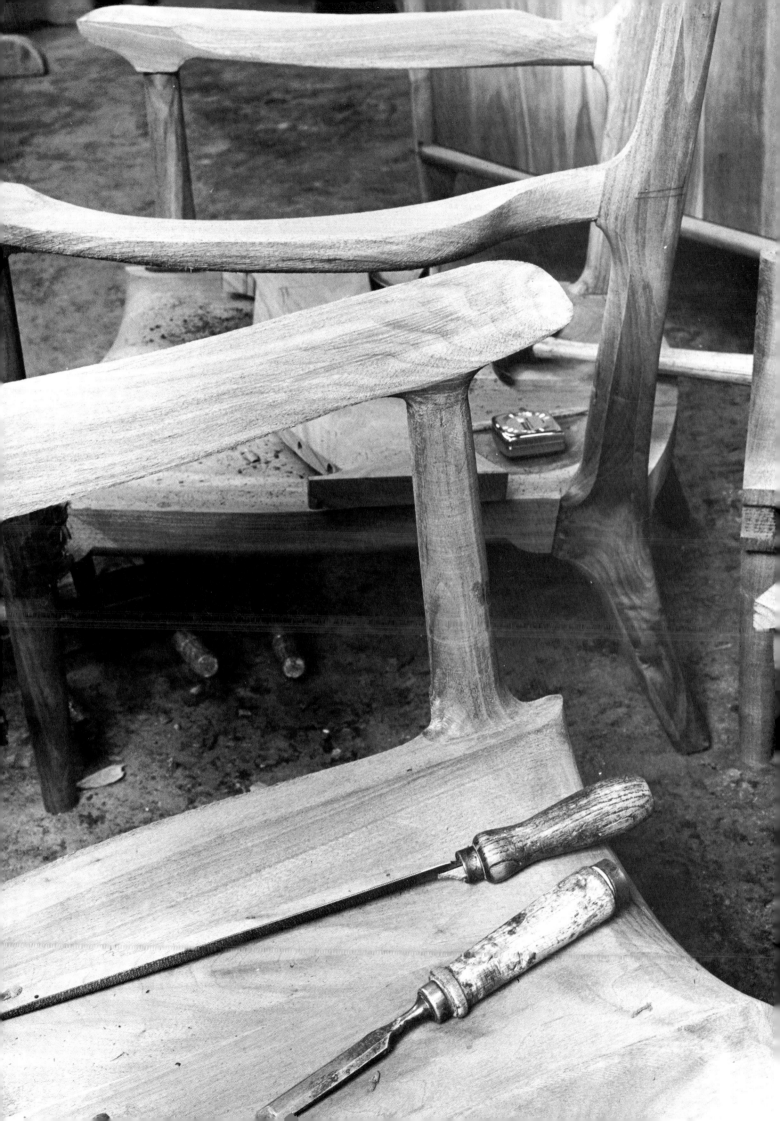

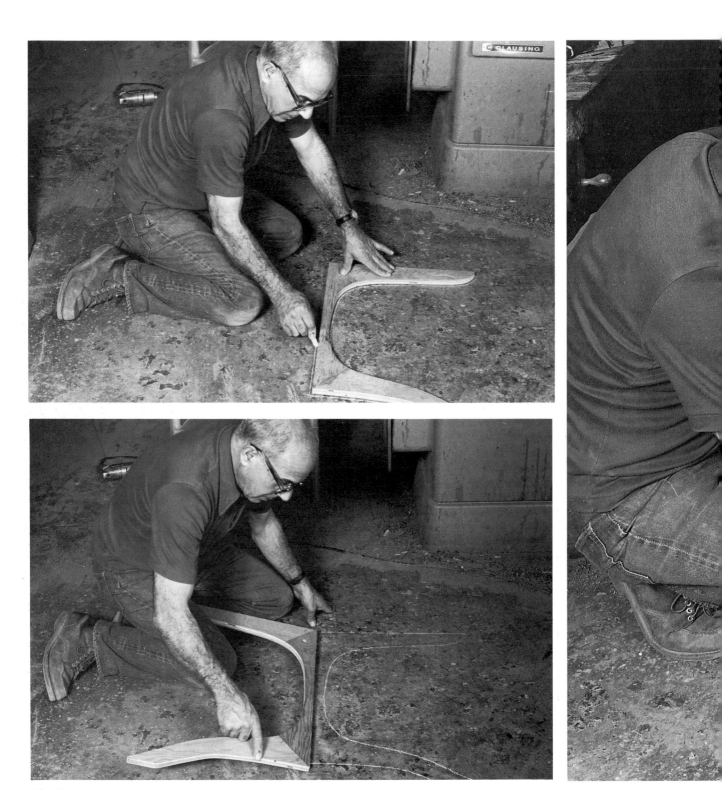

Checking out proportions of a pedestal *(top and bottom)*. I often
make proportional sketches on the floor *(right)*.

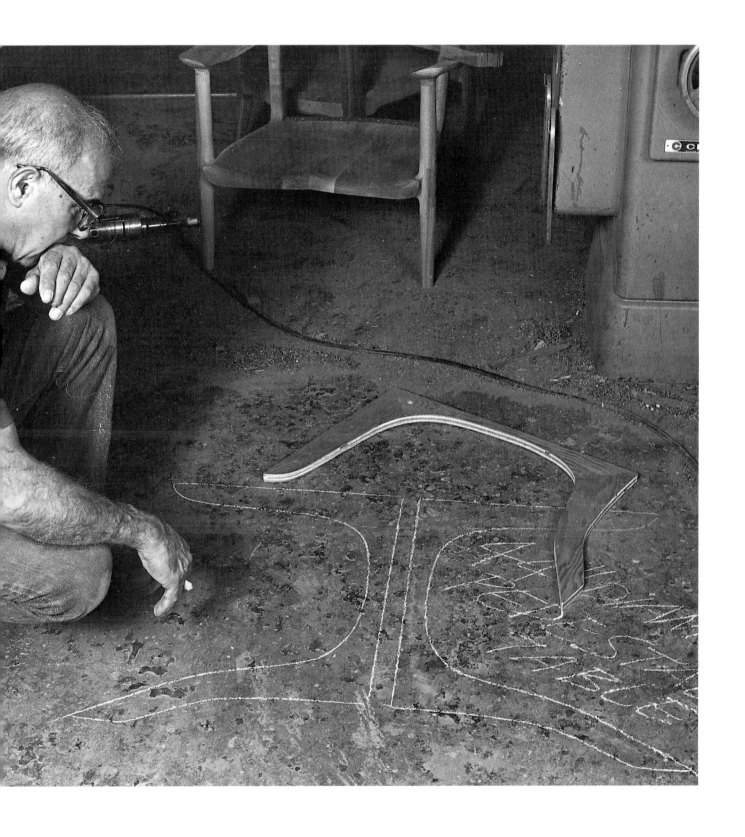

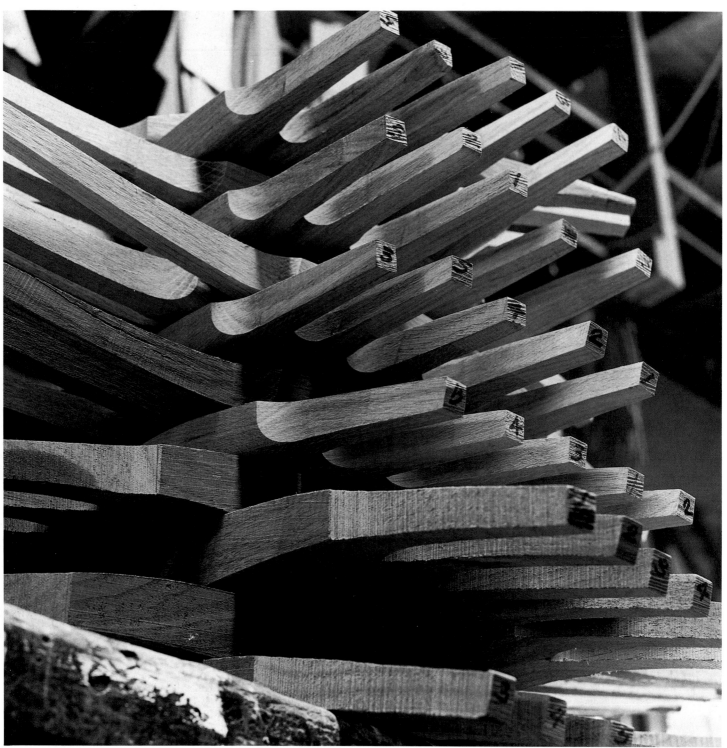

Flat, curved spindles for dining chairs prior to shaping.

Templates for the many different kinds of chairs and tables that I make. The name of the person for whom I first made a piece appears on the template pattern.

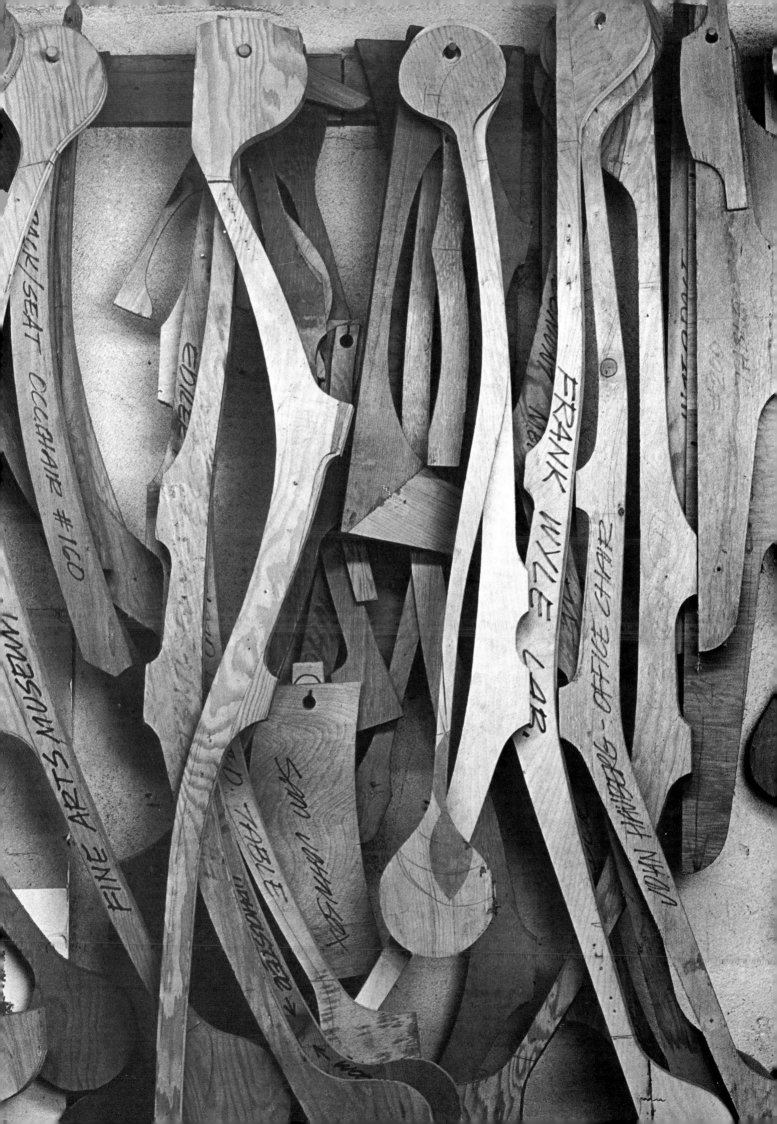

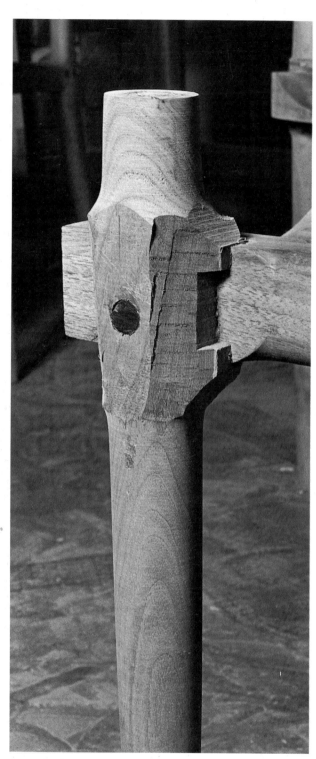

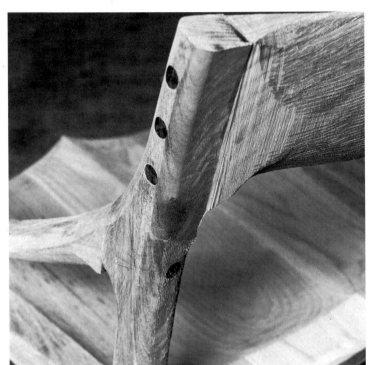

Front leg of chair *(above)* before shaping into chair
seat. This is my favorite chair *(right)*, ready
for final finishing *(see also page 141).*

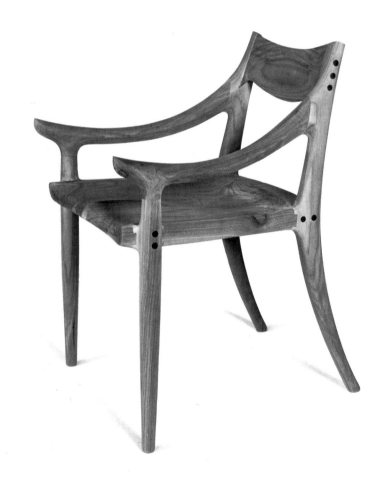

Parts of print rack in various stages
of shaping *(see pages 171-72).*

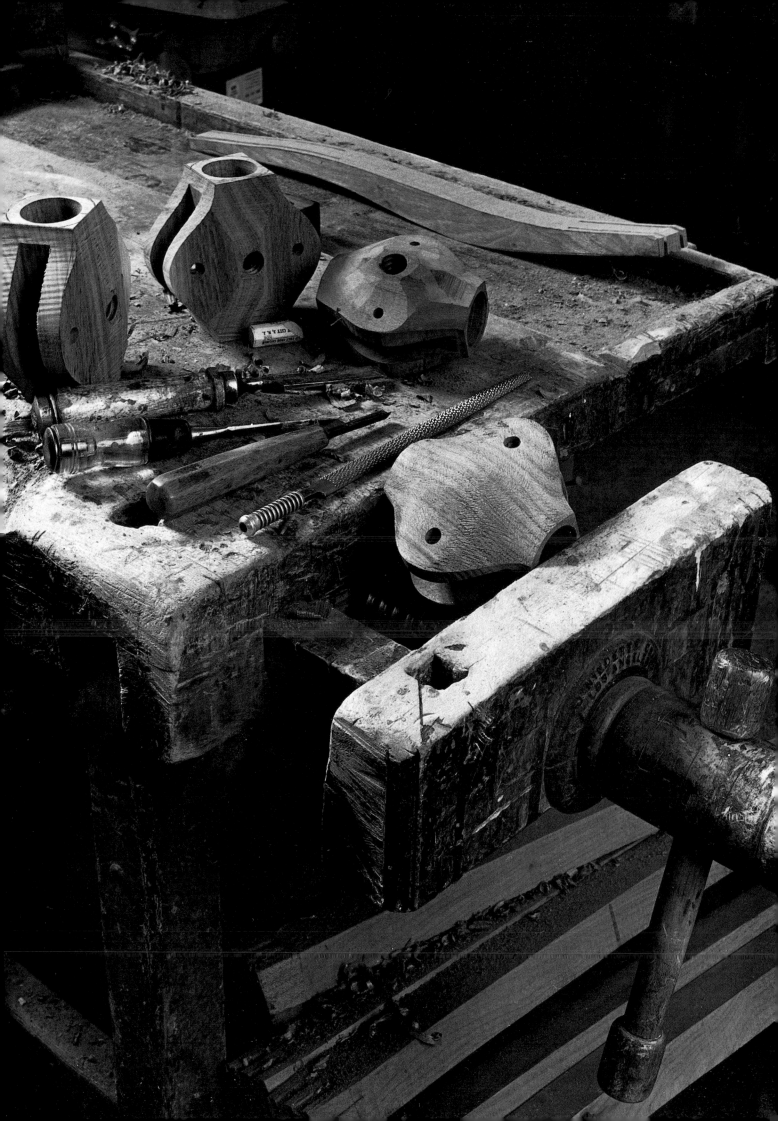

Using rasp to remove surplus wood *(top and bottom)* where front leg joins chair seat. Removing surplus wood with gouge *(right)*.

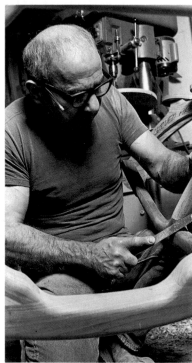

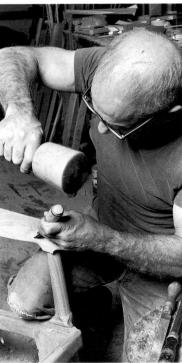

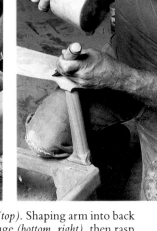

Removing surplus wood with gouge *(top)*. Shaping arm into back leg with rasp *(bottom, left)*. Using gouge *(bottom, right)*, then rasp *(right)* to remove flat area from arm.

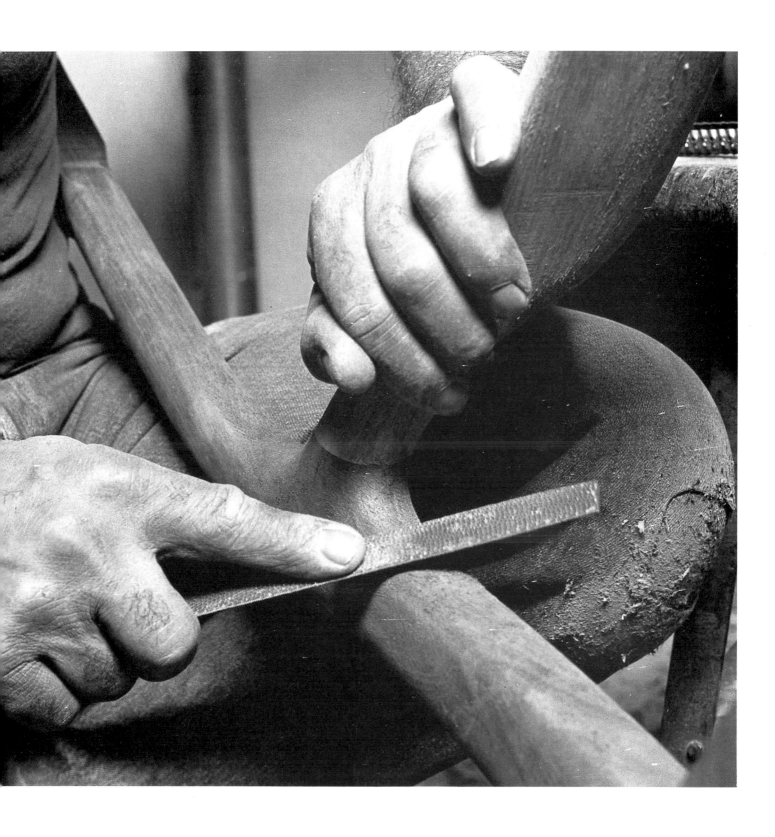

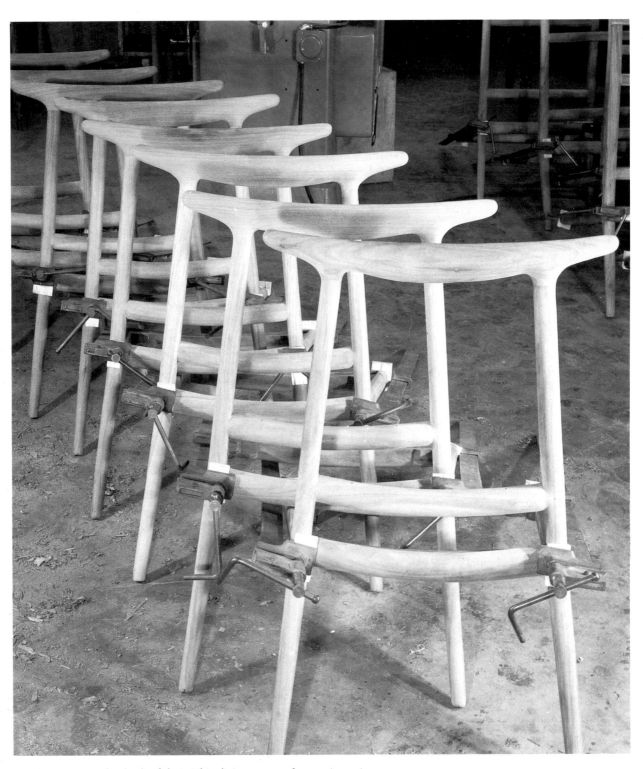

Seat frame clamped to back of chair. This chair was one of my earliest pieces.
I have changed it subtly over the years as I have many of my pieces.

Truing the flow of the arm into the back leg.

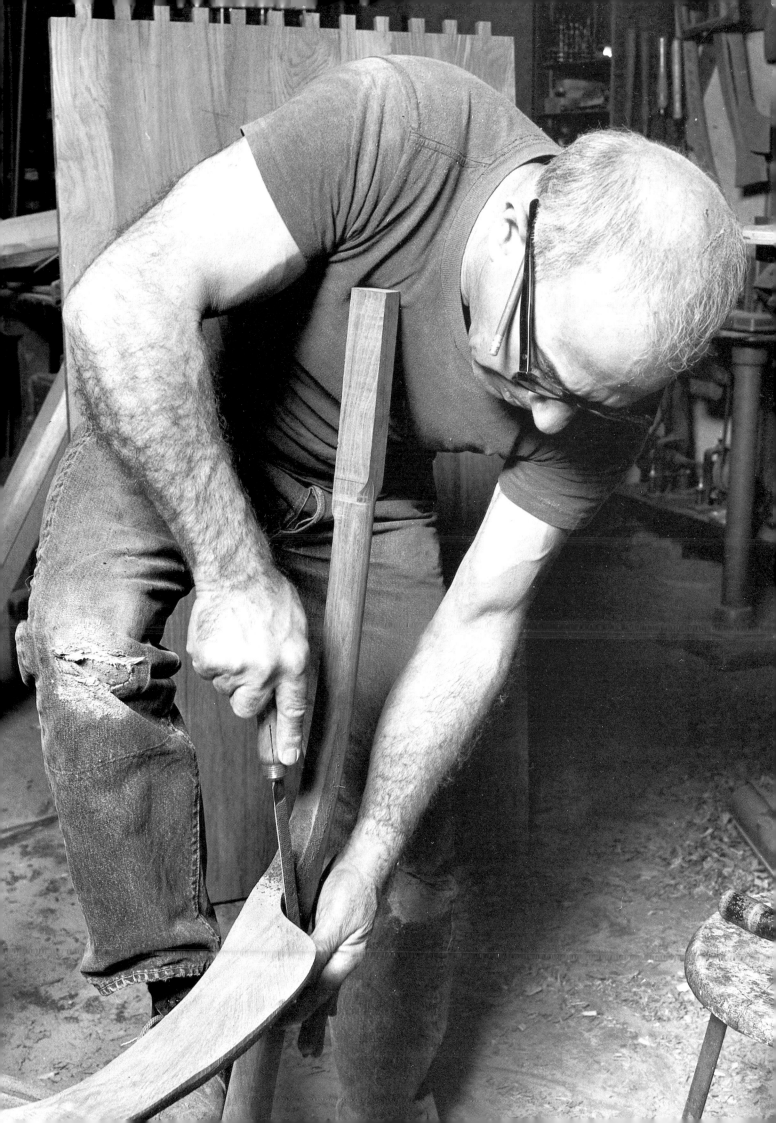

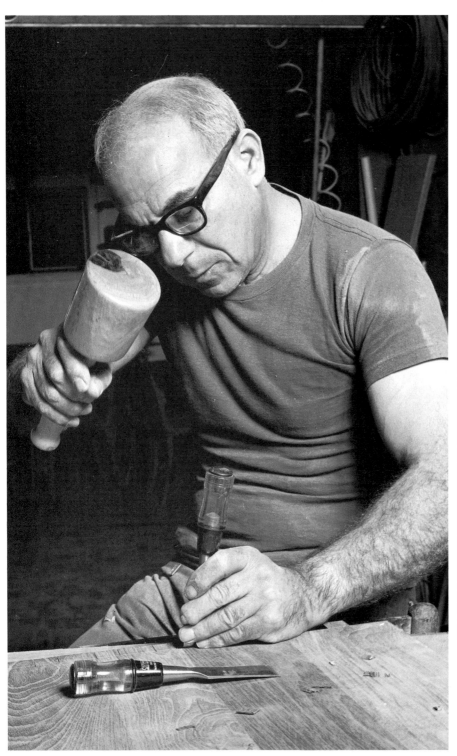

Cutting dovetails for a teak desk. All of my dovetails are made in this manner.

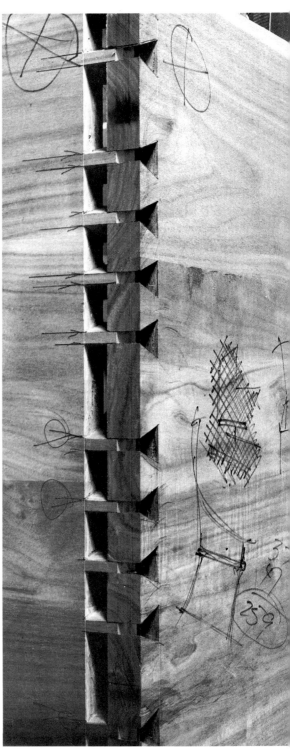

Pins and tails ready for assembly.

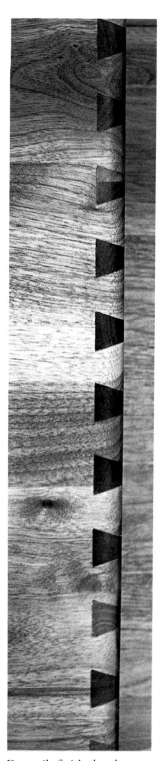

Dovetails finished and rubbed down.

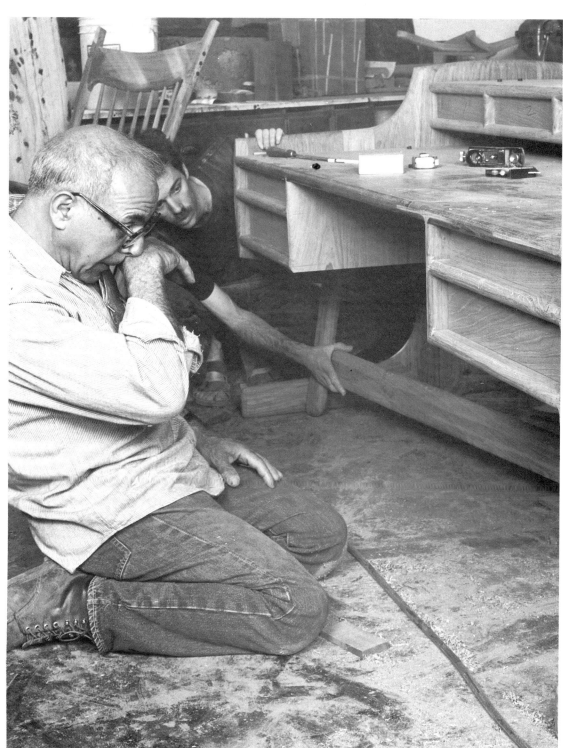

This was an interesting desk. The stretcher was an innovation.

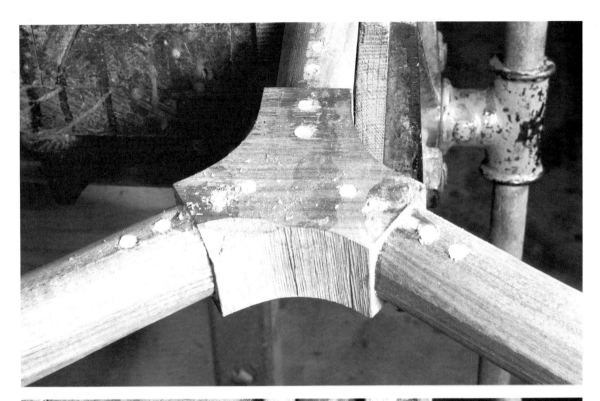

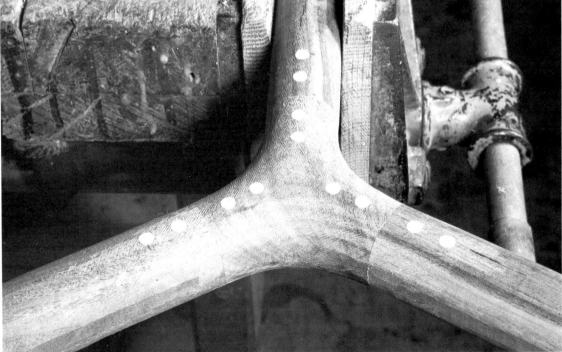

Stretcher for dining table: the small pegs go through a three-quarter-inch dowel. *(Photos: Alfreda Maloof)*

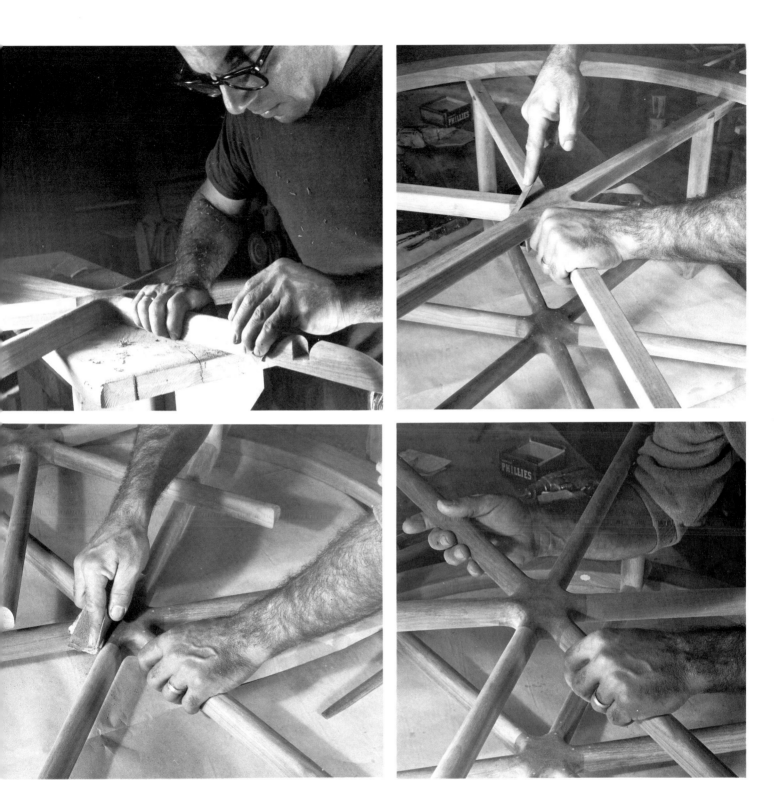

Double stretchers for large coffee table: the spokes are attached to the center hub. *(Photos: Alfreda Maloof)*

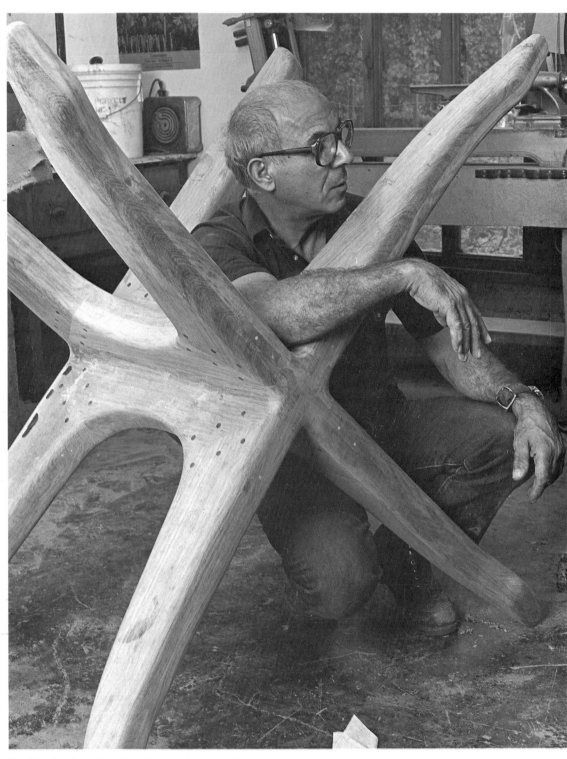

Sanding laminated pedestal for conference table.

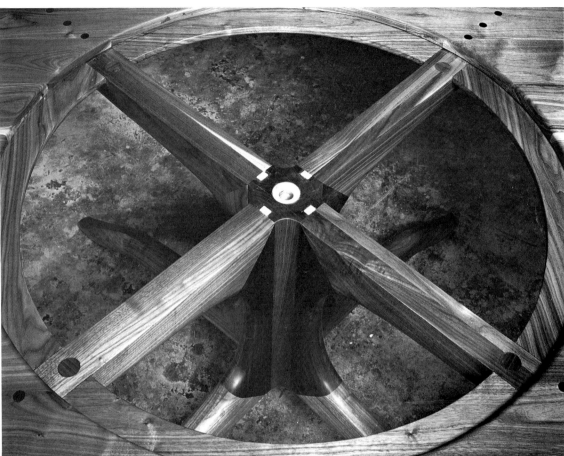

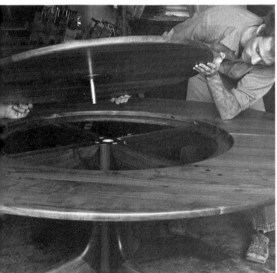

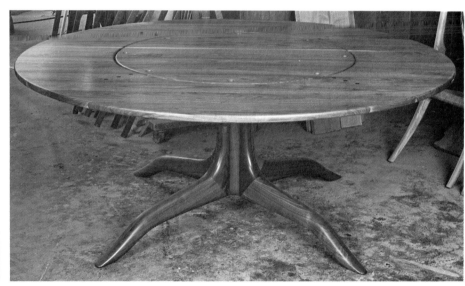

Sanding continues *(top, left; see finished conference table, pages 180-81)*. Pedestal dining table, eighty-four-inch diameter, with lazy susan: detail of pedestal and outer ring *(top, right)*; dropping lazy susan into bushing of pedestal *(bottom, left)*; finished table with finger holes for turning *(bottom, right)*.

Rack of clamps. I use many different clamps in my work. Purchasing them is one of my follies.

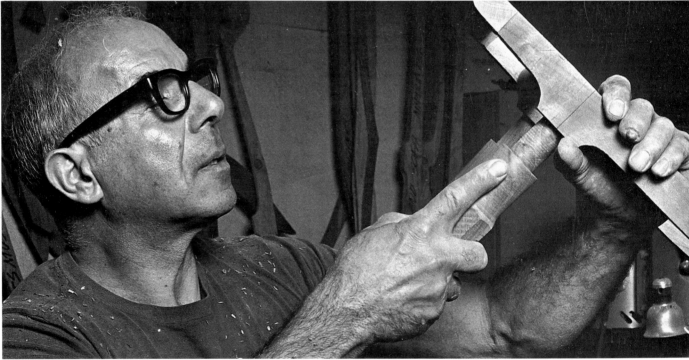

Making bench legs *(top row, left to right)*: turning leg (I do not like to turn, but once I get started, I turn rapidly); sanding leg; sawing groove for wedge; removing surplus wood opposite holes predrilled for stretcher; legs ready for assembling.

Assembling bench legs *(bottom row, left to right)*: checking for fit; attaching legs to bench seat; hammering in wedges.

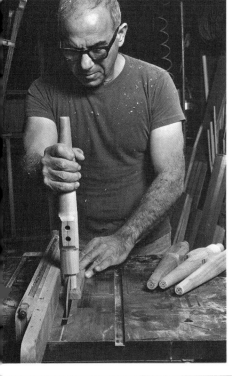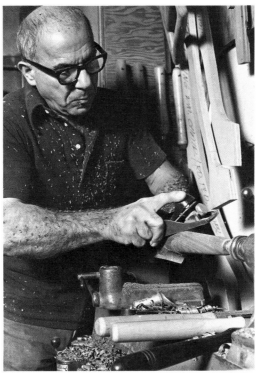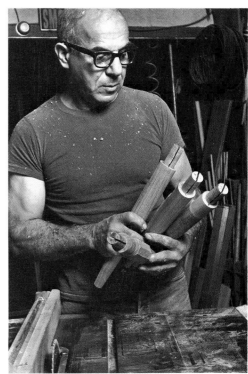

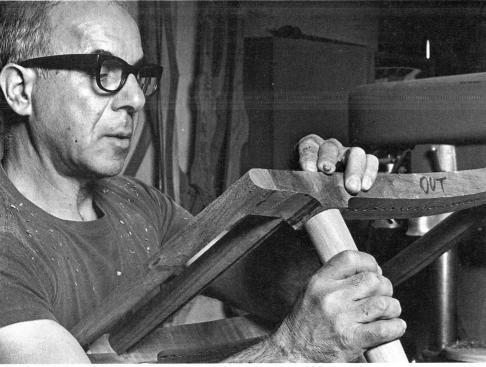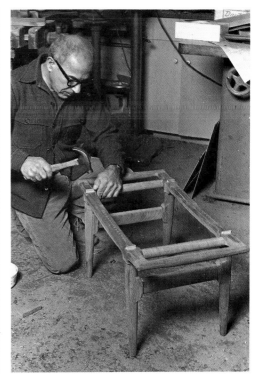

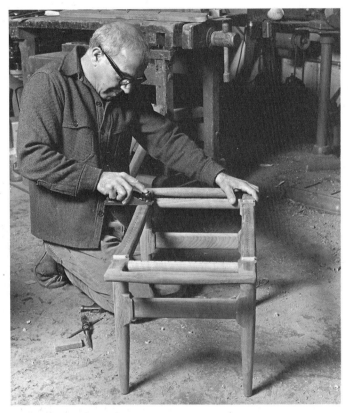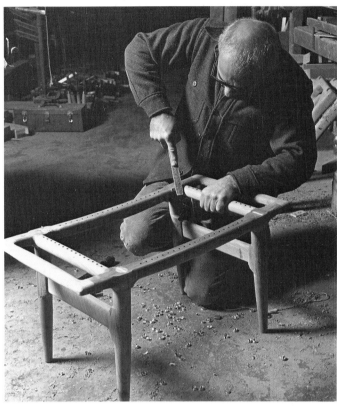

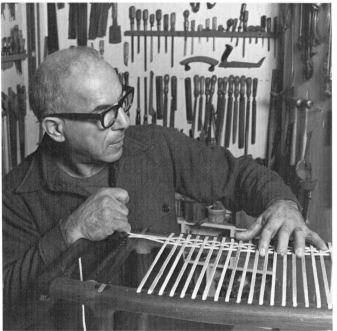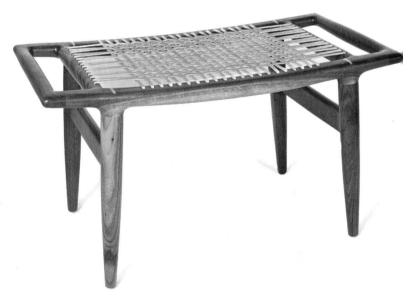

Planing spindles even with top of bench seat *(top, left)*. Shaping seat *(top, right)*: the stretchers below will also be shaped to blend into the legs. Weaving rawhide leather for seat *(bottom, left)*: my grandson Aaron has taken over this work (for how long I do not know); the older he gets, the wiser he gets, and the greater his demands for payment. The finished piece *(bottom, right)*: since these photographs were taken I have made some changes in the bench *(see page 168)*.

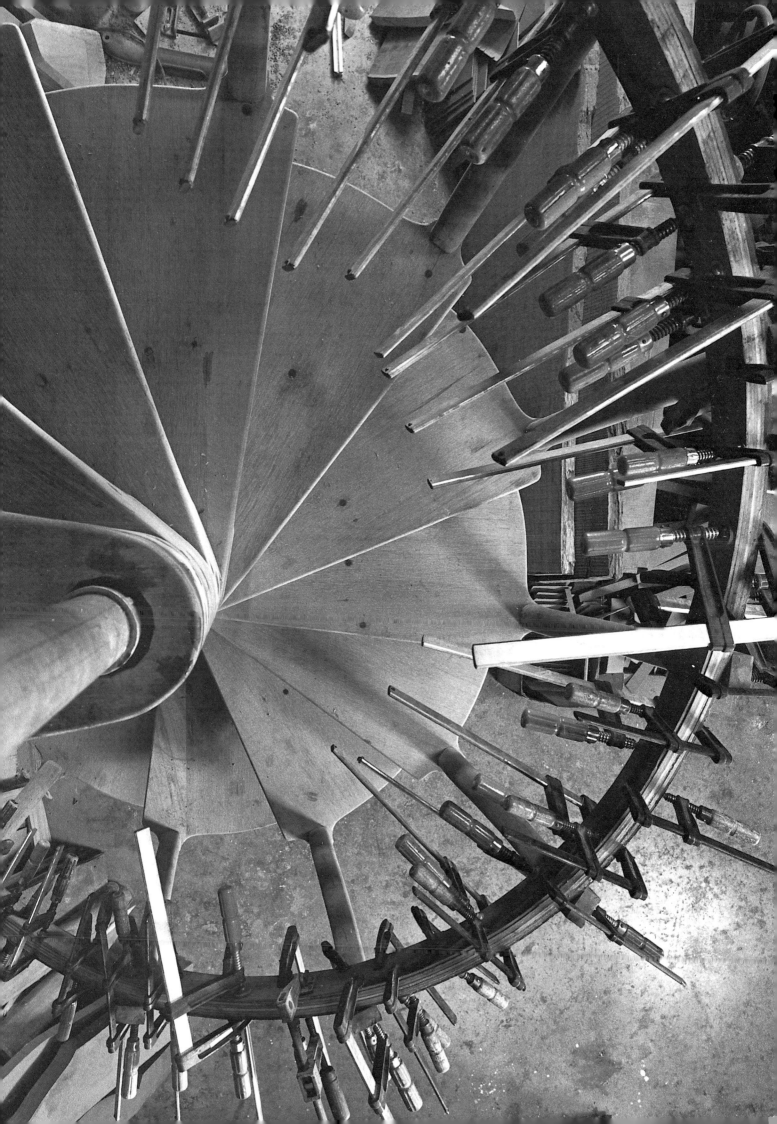

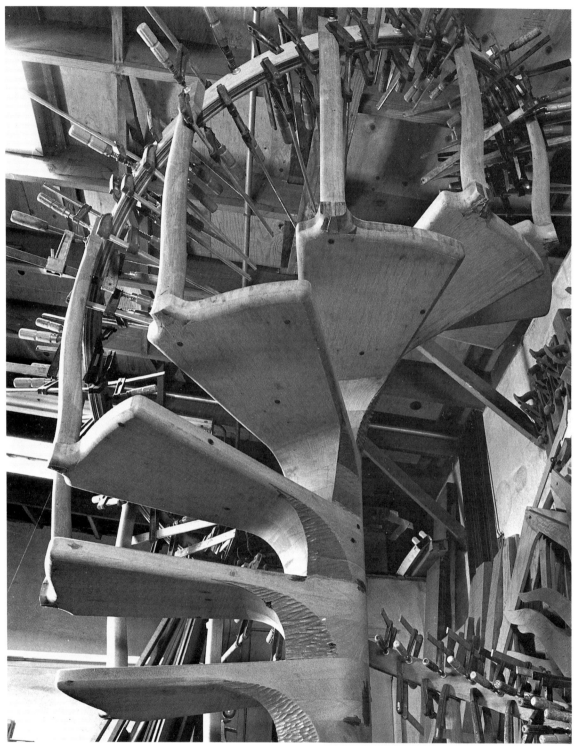

This spiral staircase *(above, opposite, and preceding page)* was started some years ago but was not completed until 1983. I made it of scrap wood that was used in crating Taiwanese motorboats. The railing is made of six laminates—I used approximately one hundred clamps in assembling it. Once I made up my mind, it did not take too long to build.

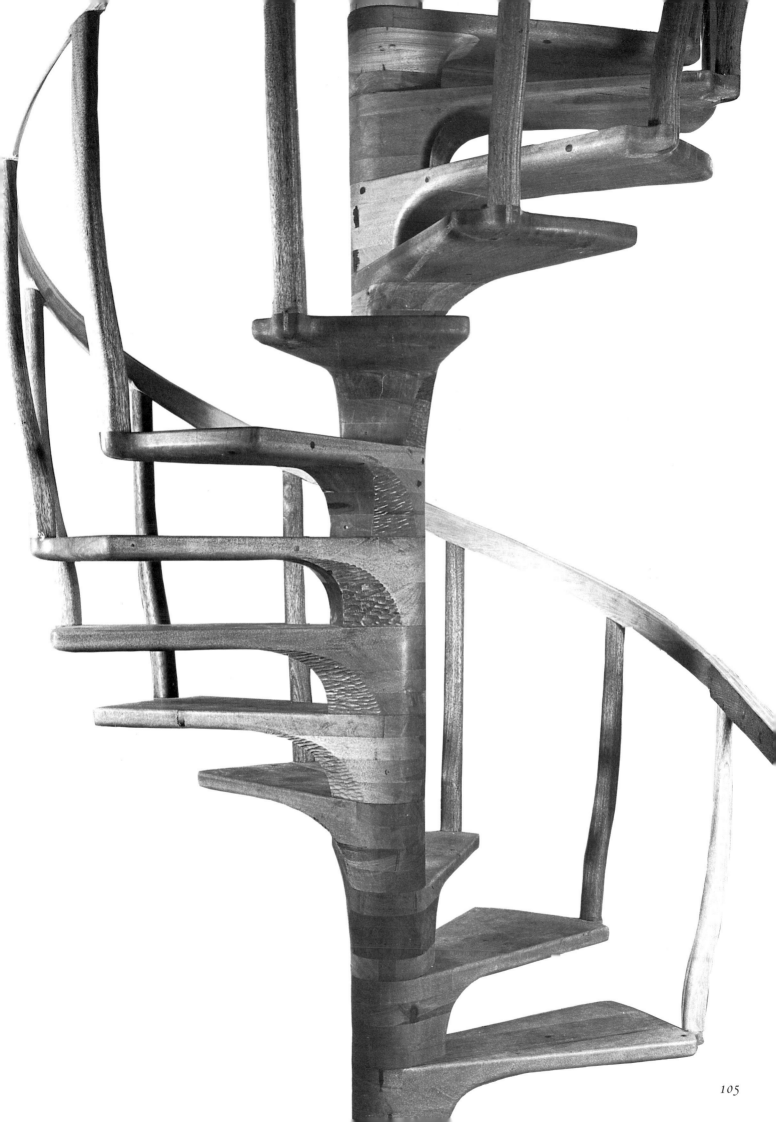

Making a rocking chair

Of all the pieces in the furniture repertoire, chairs are the most difficult to make, but I find them a challenge and do make many of them. To explain how I go about building a rocking chair, I have chosen the most commonly ordered of my twelve designs.

The wood that I use for the seat, arms, legs, and crest of the rocking chair is eight-quarters (two inches) thick. For the rockers and spindles, the wood is six-quarters (one and one-half inches) thick. Because the wood for the seat, arms, front legs, and crest is sawed into small pieces, there is nò reason to use prime wood for them; so I use common number one and common number two. These grades differ from the higher grades by having more knots per board foot. My rockers are laminated for strength, while the curved, flat spindles are shaped on the band saw, not steam bent or laminated.

The seats of all my seating pieces are made first. I select wood for color and grain *(1)*, using three to seven pieces for each seat. Though I stock wood wide enough (twenty inches) to make solid seats, I am concerned that seats made of a single piece of wood would warp or crack. All of my seats are doweled with one-half-by-three-inch dowels. Contrary to what some woodworkers say, dowels act not only as levelers but add strength as well.

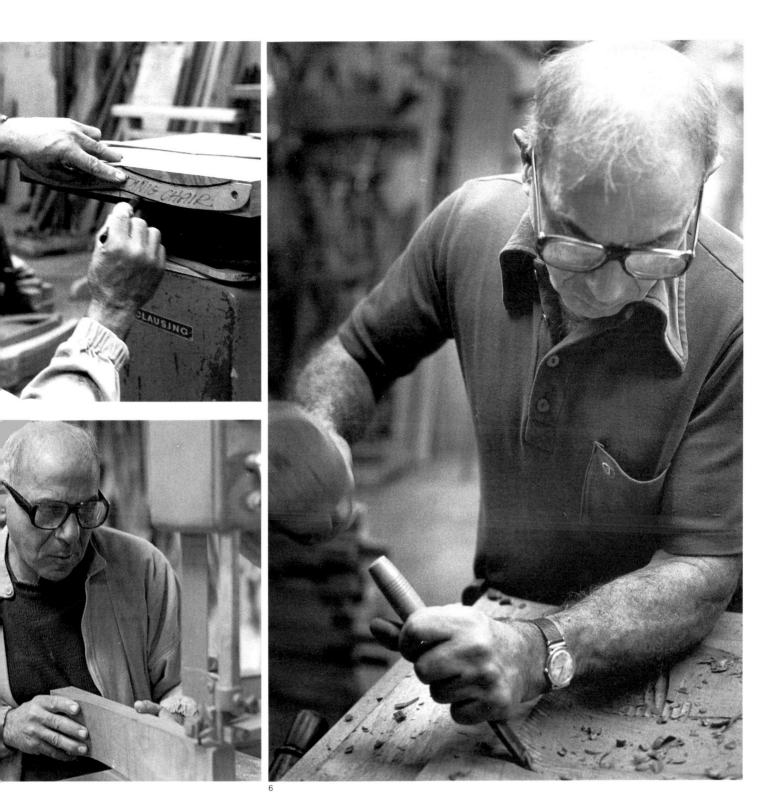

6

After matching the grain and color of the wood and laying it out for the seat *(2)*, I trace my pattern *(3)*. I drill holes on the boring machine for the dowels *(4)*, then I scoop out the rough form of the seat freehand on the band saw *(5)* prior to gluing. The glue having set, I refine the shape of the seat by gouging it to the pattern line *(6)*.

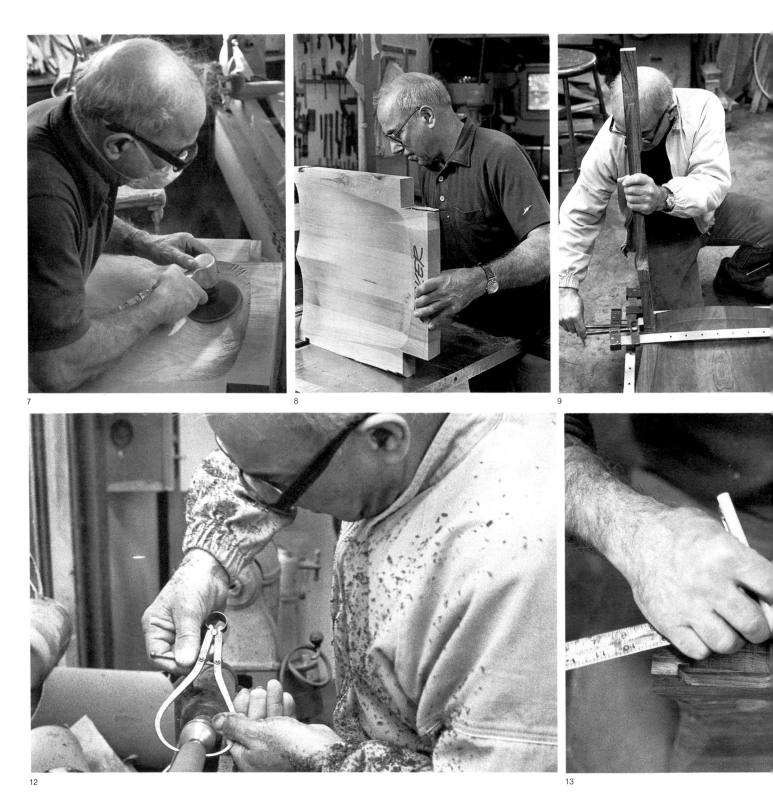

7

8

9

12

13

After gouging, I use the disk sander (7), starting with 16 grit, then, going through five different grits, finishing with 400. The seat is then ready for dadoing (notching) and routing where the front legs will be attached (8). The back legs are glued and clamped to the seat frame at this point (9), and the front legs are dadoed where they are to fit into the seat (10). I remove excess wood from the front legs with the band saw (11) prior to turning them on the lathe (12) and marking them for drilling (13). Again I remove excess wood, this time by planing (14).

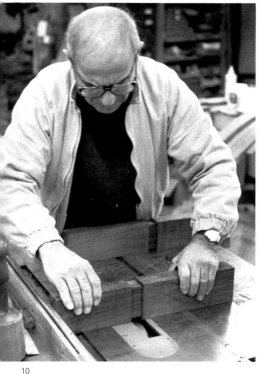

10

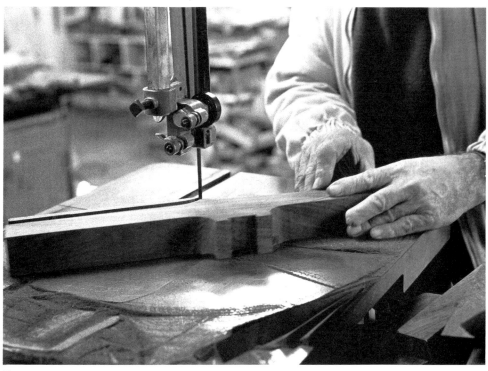

11

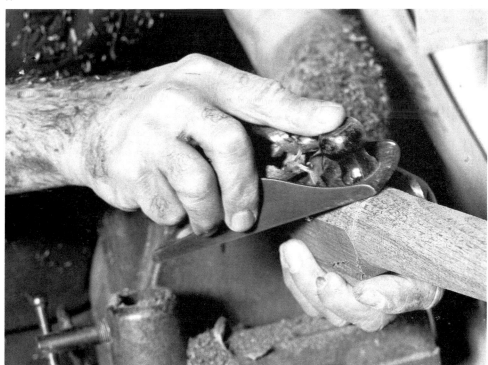

14

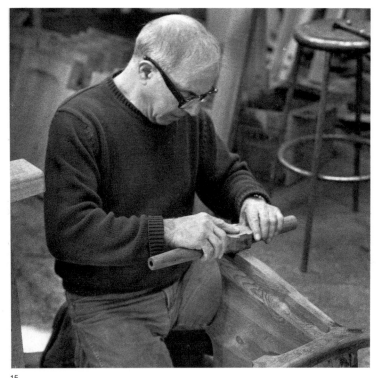

15

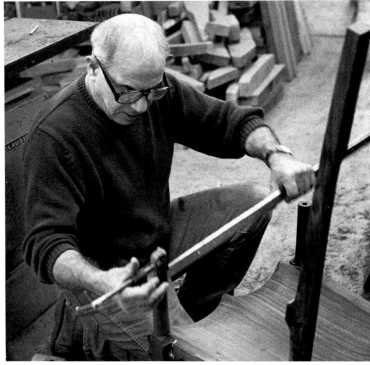

16

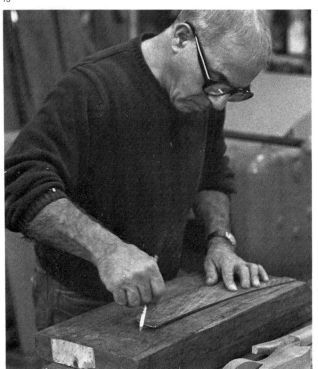

19

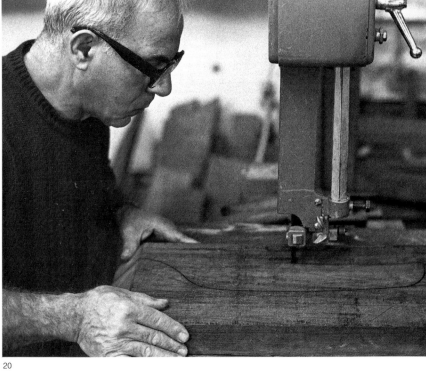

20

When the front legs are ready to be attached (15), I clamp them (16) and form them into the seat frame (17), shaping them with a pattern maker's rasp (18). (Here Mike Johnson, left, and Mike O'Neil, the two young men who work with me, observe the assembly of the front legs and seat frame.)

Other parts of the chair are cut, shaped, and sanded while the seat and leg assemblies dry. The arms are laid out and shaped freehand on the band saw (19, 20, 21). It takes me about fifteen minutes to complete two arms. I do not recommend using a band saw in this manner however: it is dangerous. In fact, if I had had formal woodworking training or known better, I probably would not have evolved this method myself.

Final shaping of the arm is done with a rasp (22).

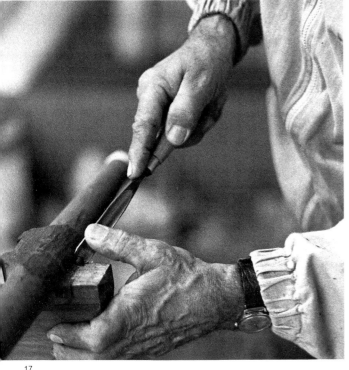

17

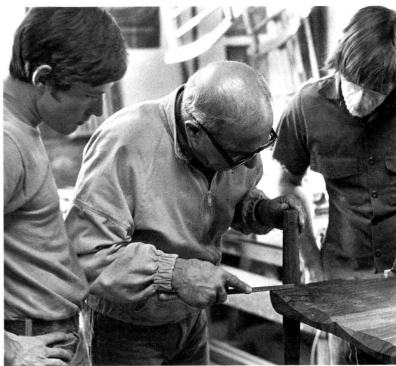

18

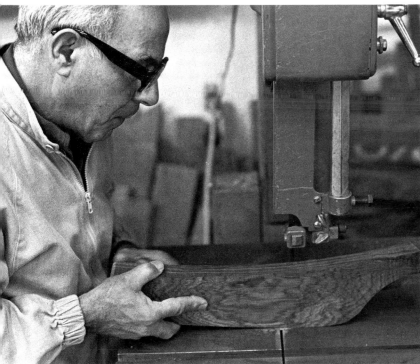

21

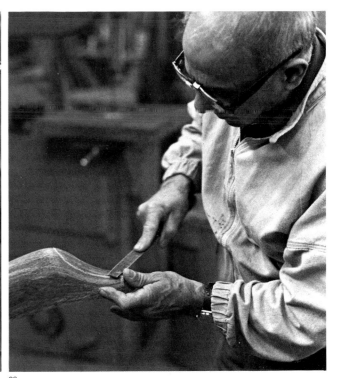

22

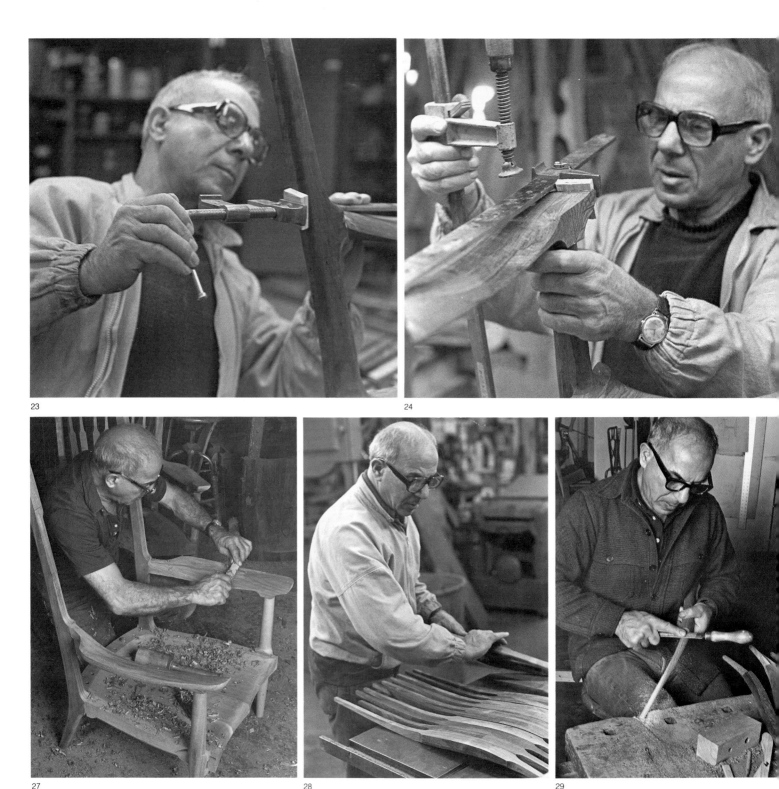

23

24

27

28

29

Once shaped, the arms are fitted to the back legs *(23)*, then clamped to the front legs *(24)*. Excess wood is gouged out *(25)*, and the piece is shaped with a rasp *(26)* and spokeshaver *(25)*.

Work on the spindles begins with the matching of wood for grain and color *(28)*. Each spindle must be shaped with a rasp *(29)* and sanded *(30)*. I use a block of wood into which I have drilled two holes, one five-sixteenths of an inch and the other one-half inch, to check the diameter of each spindle *(31)*, then sand them with 400 grit sandpaper.

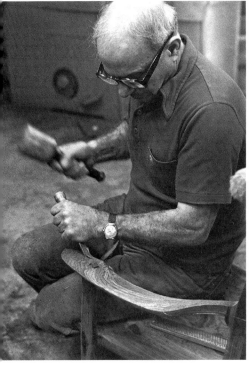

26

31

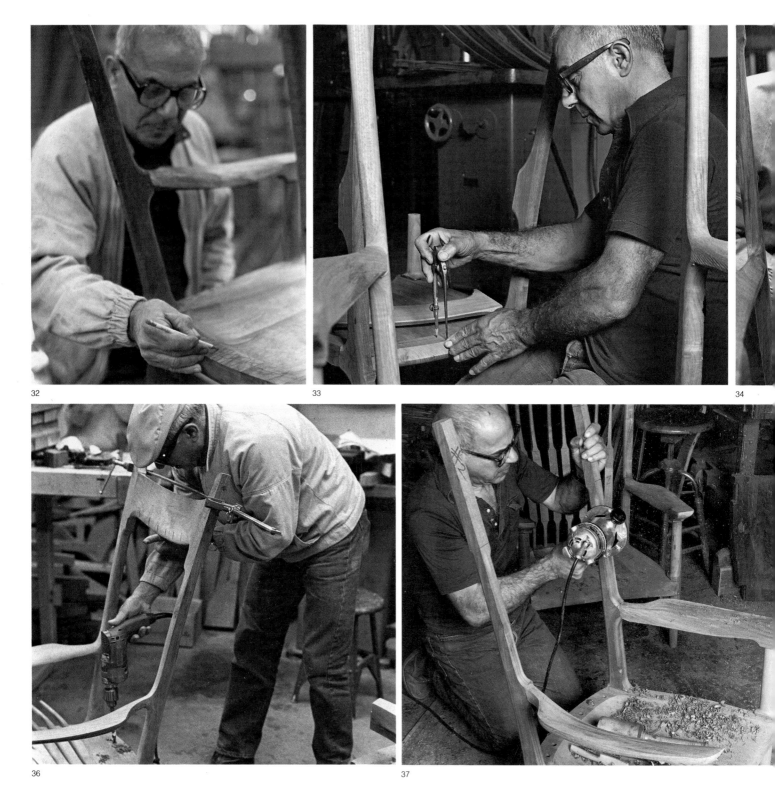

32

33

34

36

37

Before the spindles can be attached to the seat, the position of the holes must be measured and marked (32, 33, 34). The cant of the corresponding holes must be marked in the crest rail as well (35). The holes themselves are drilled freehand (36). I just eyeball them, much as I do everything I work on. Someone in a workshop once said to me, "Sam, you must have crosshairs in your eyes. If a woodworker does not have them, what can he do?" and a voice in the group called out, "Have them tattooed."

Before attaching the spindles, I route the insides of the back legs (37) and sand them. Then I check the fit of the spindles (38). Each one must be marked for length before final cutting, rounding, and sanding (to three-eighths-inch diameter, 39).

114

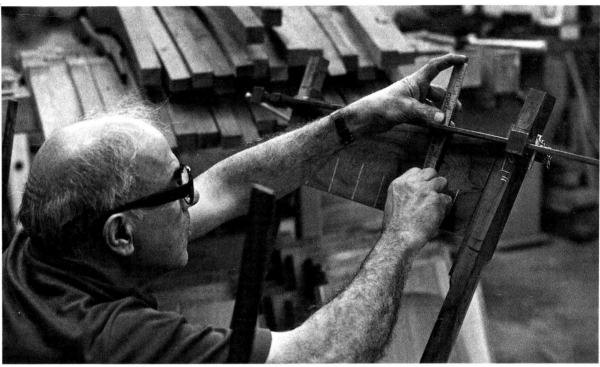

35

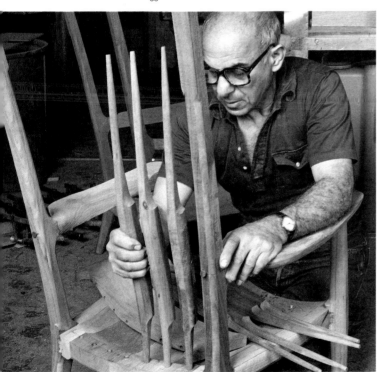

38

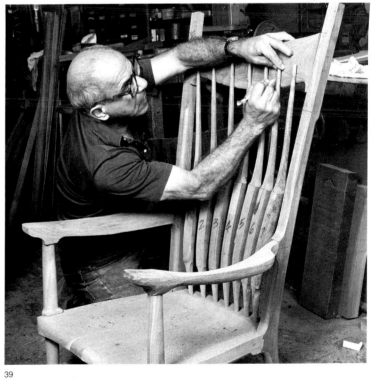

39

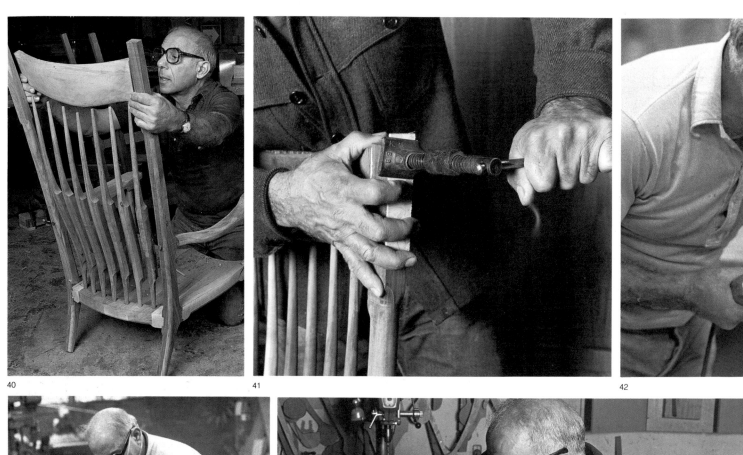

40

41

42

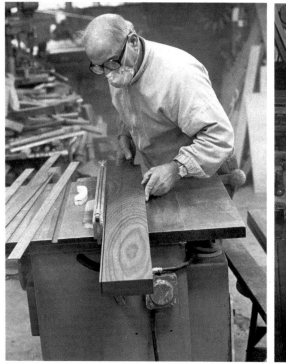

43

44

The crest rail is the next piece to be fitted *(40)*. Having glued the spindles into the seat, I attach the crest to the spindles and then to the back legs *(41)*. The final attachment is done with screws *(42)*. Before the rockers are attached, the entire chair is completely shaped and sanded. The rockers are made of strips of wood that are sawed, or "ripped" *(43)*, glued *(44)*, clamped *(45)*, and allowed to dry *(46)*.

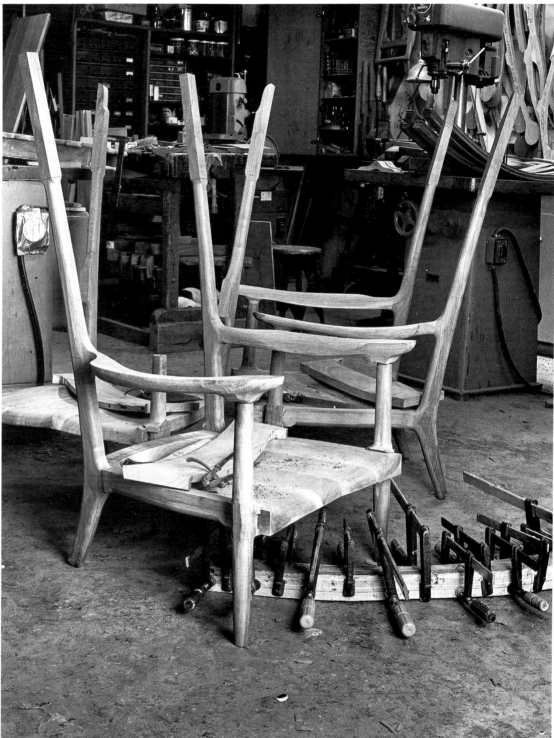

45

46

117

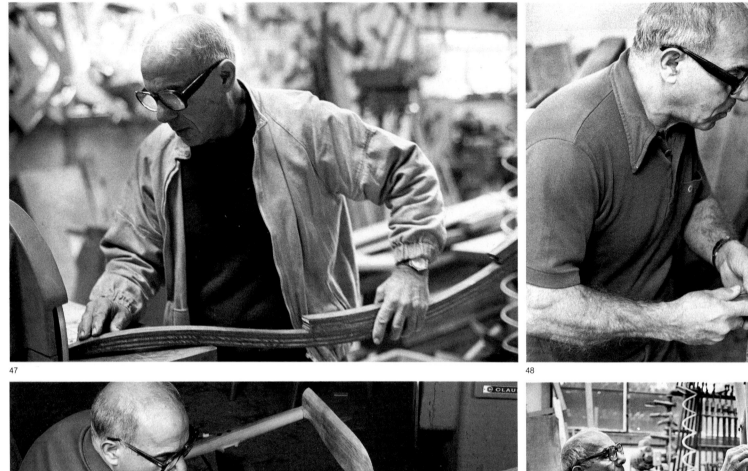

47

48

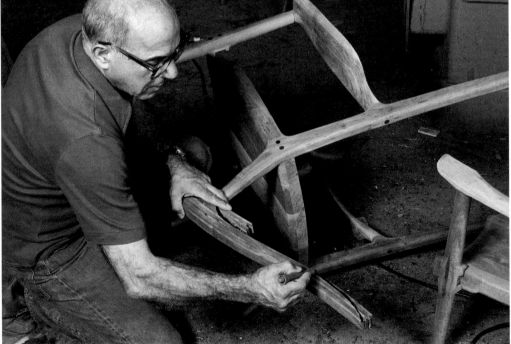

50

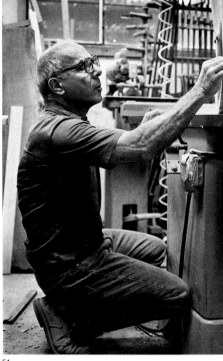

51

As many as a dozen clamps hold the compound laminates in place as the rockers dry *(47)*. The rockers are then shaped and sanded *(48, 49, 50)* and readied for attachment to the legs *(51)*. First, however, each rocker is individually balanced *(52)*; experience has taught me that rockers differ because of the density of the wood and other factors. The rockers are clamped in place *(53)*, shaped into the legs *(54)*, and sanded again.

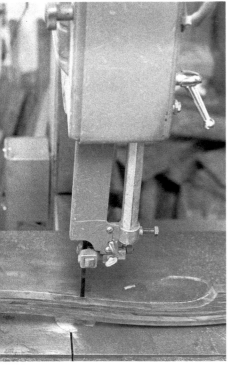

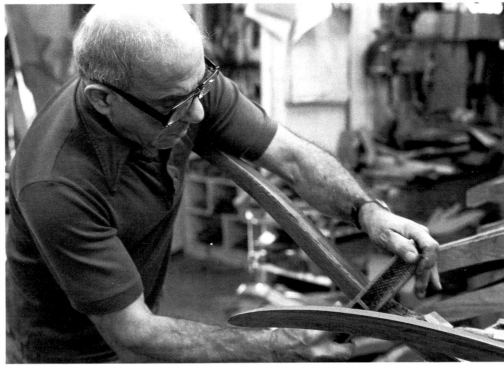

49

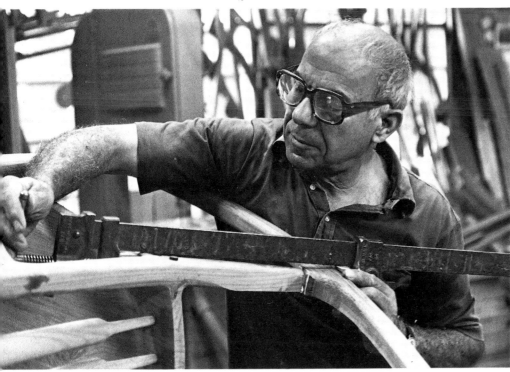

52

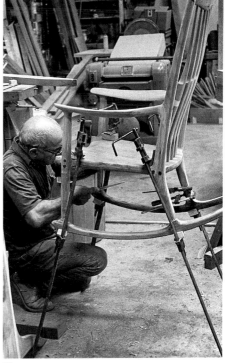

53

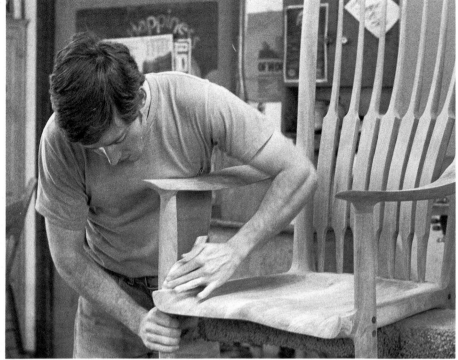

54

55

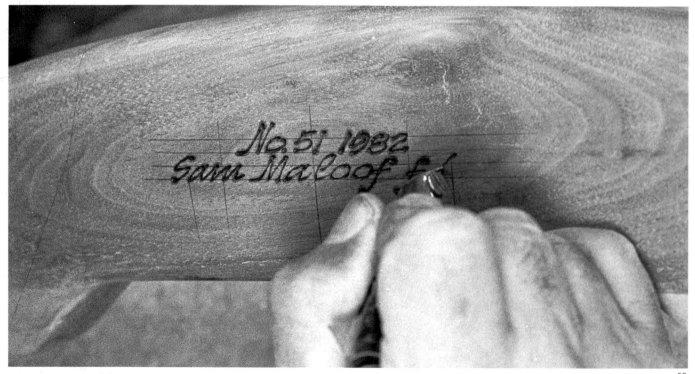

56

Before applying a finish, I go over the chair with 400 grit sandpaper and burnish it with 0000 steel wool.

I use two finishes on every piece of furniture. The first consists of one-third urethane (semigloss), one-third raw tung oil, and one-third boiled linseed oil. I use the raw tung oil because it does not jell; it has an indefinite shelf life. The boiled linseed oil has enough drier in it to activate the raw tung oil.

I apply this mixture to the piece very generously, rubbing hard (when my hand starts getting hot, I know I am doing it correctly). Then I remove all the excess and let the chair sit overnight—and sometimes longer. This process is repeated three or four times.

I make a second mixture, leaving out the urethane. Into this I grate a couple of handfuls of shredded beeswax per gallon can of the oil mixture, heating it in a double boiler on top of a hot plate until the beeswax melts. This mixture homogenizes and has the consistency of heavy cream. (I do this out of doors, away from buildings.)

I apply this in the same manner as the first finish. (By the way, I never let my oily rags lie around the shop, since the oils are highly combustible. I keep my rags in an outdoor container filled with water.)

And that is the way I make a rocking chair.

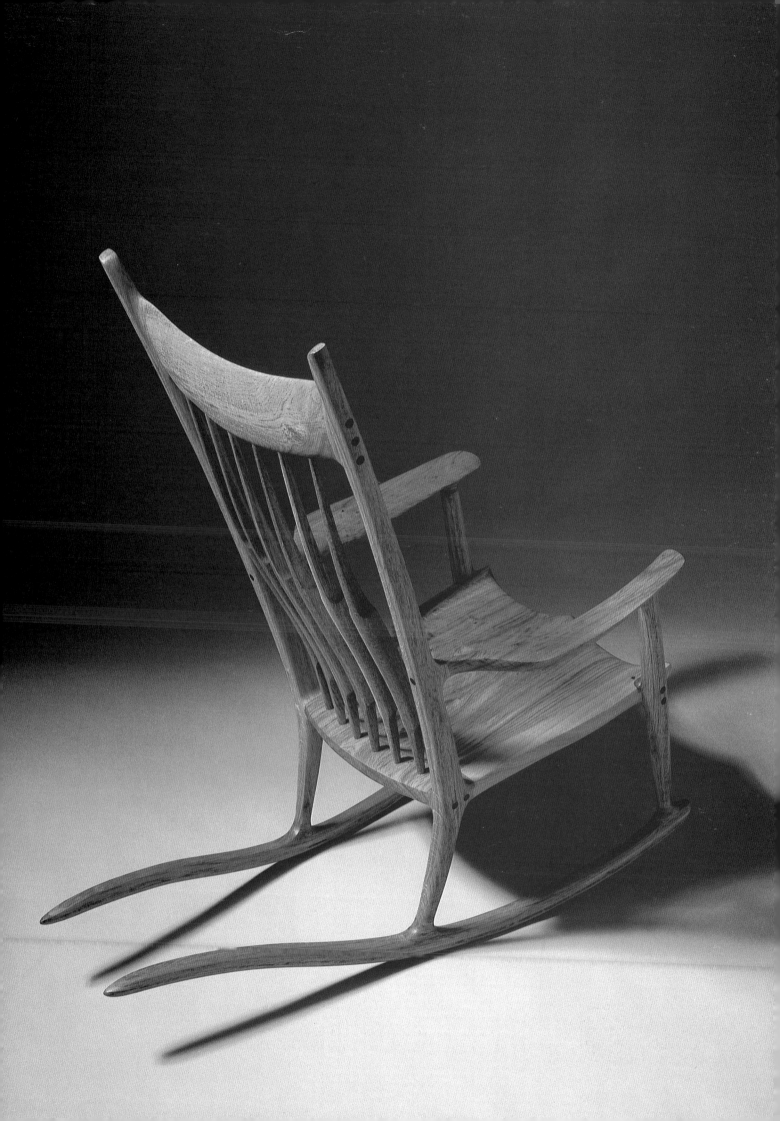

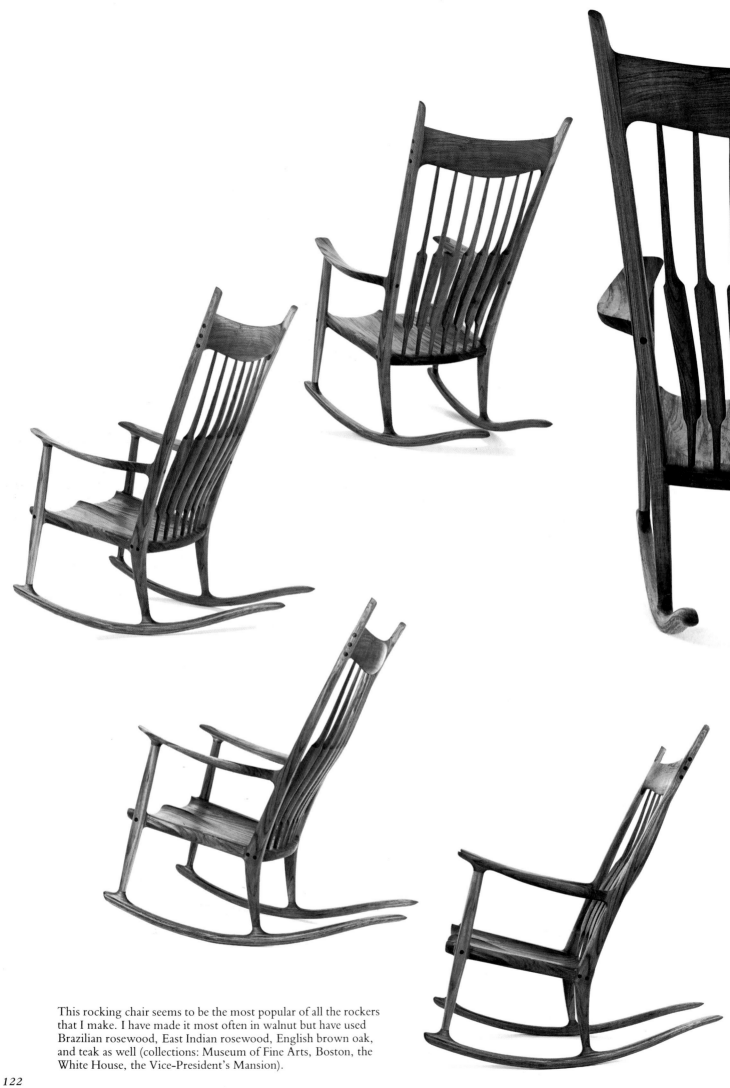

This rocking chair seems to be the most popular of all the rockers that I make. I have made it most often in walnut but have used Brazilian rosewood, East Indian rosewood, English brown oak, and teak as well (collections: Museum of Fine Arts, Boston, the White House, the Vice-President's Mansion).

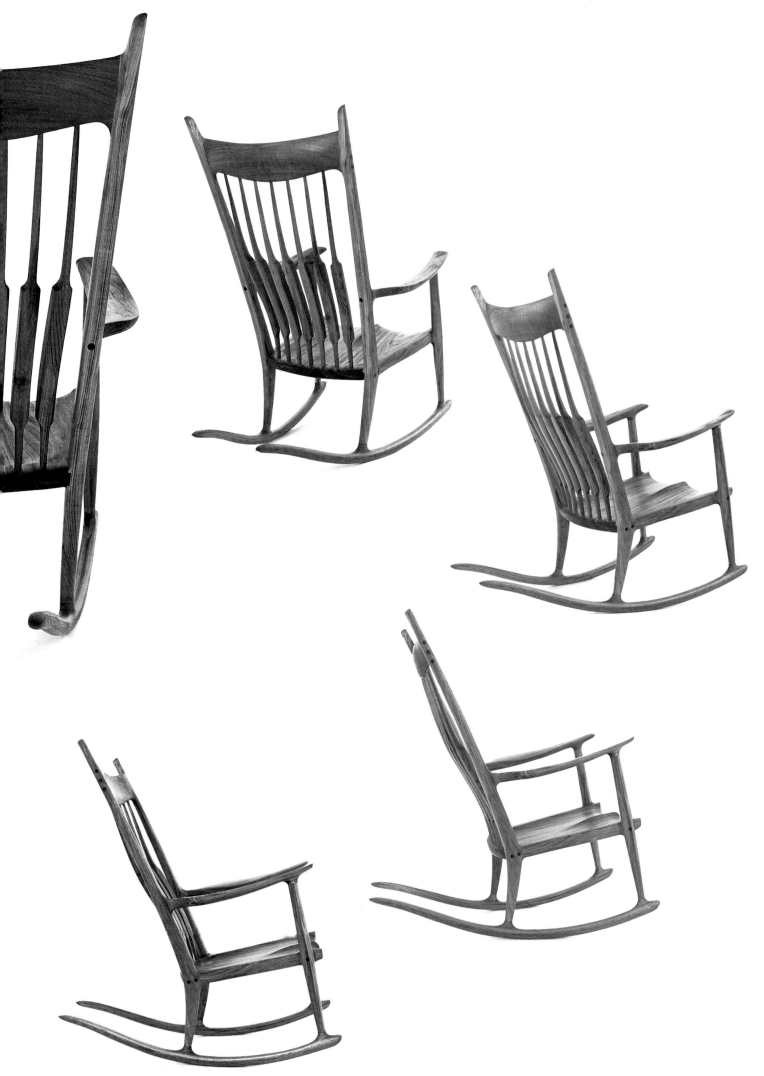

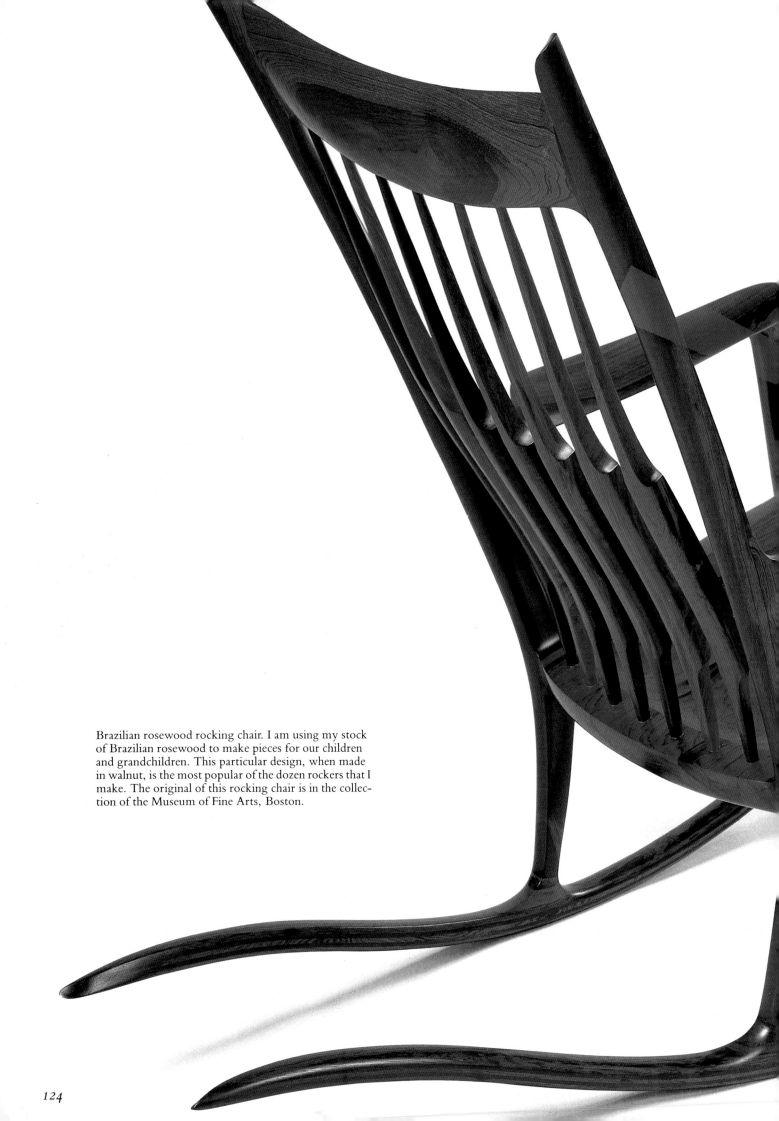

Brazilian rosewood rocking chair. I am using my stock
of Brazilian rosewood to make pieces for our children
and grandchildren. This particular design, when made
in walnut, is the most popular of the dozen rockers that I
make. The original of this rocking chair is in the collec-
tion of the Museum of Fine Arts, Boston.

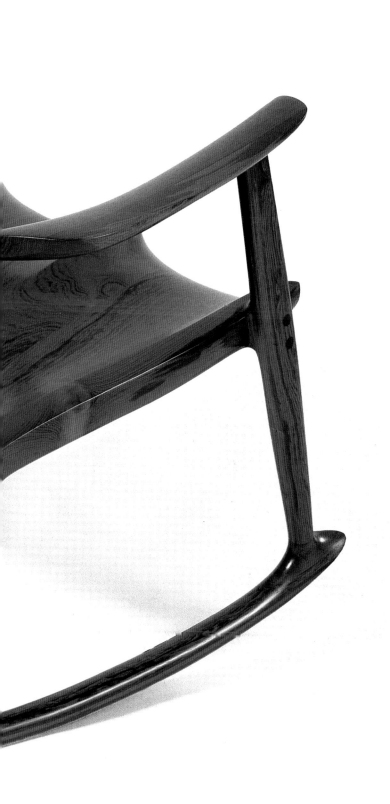

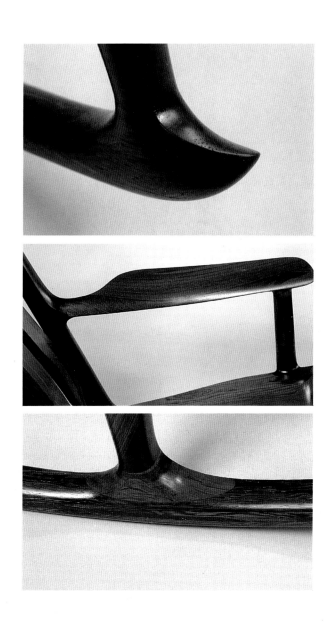

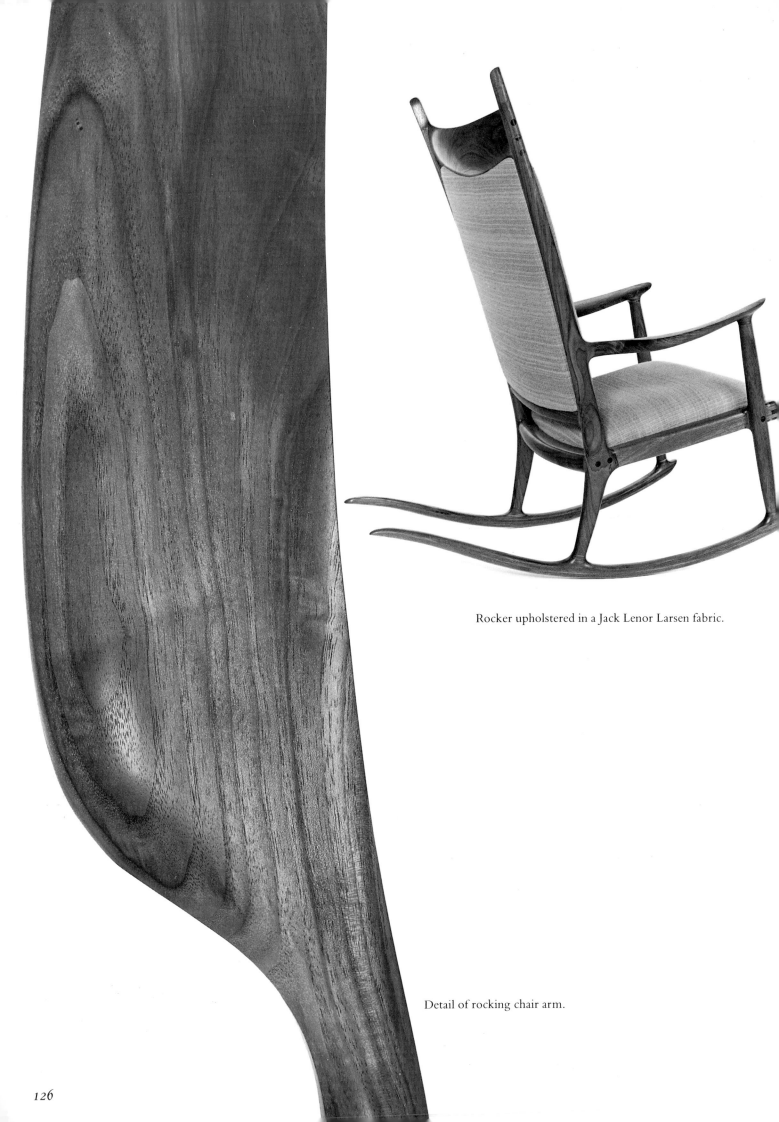

Rocker upholstered in a Jack Lenor Larsen fabric.

Detail of rocking chair arm.

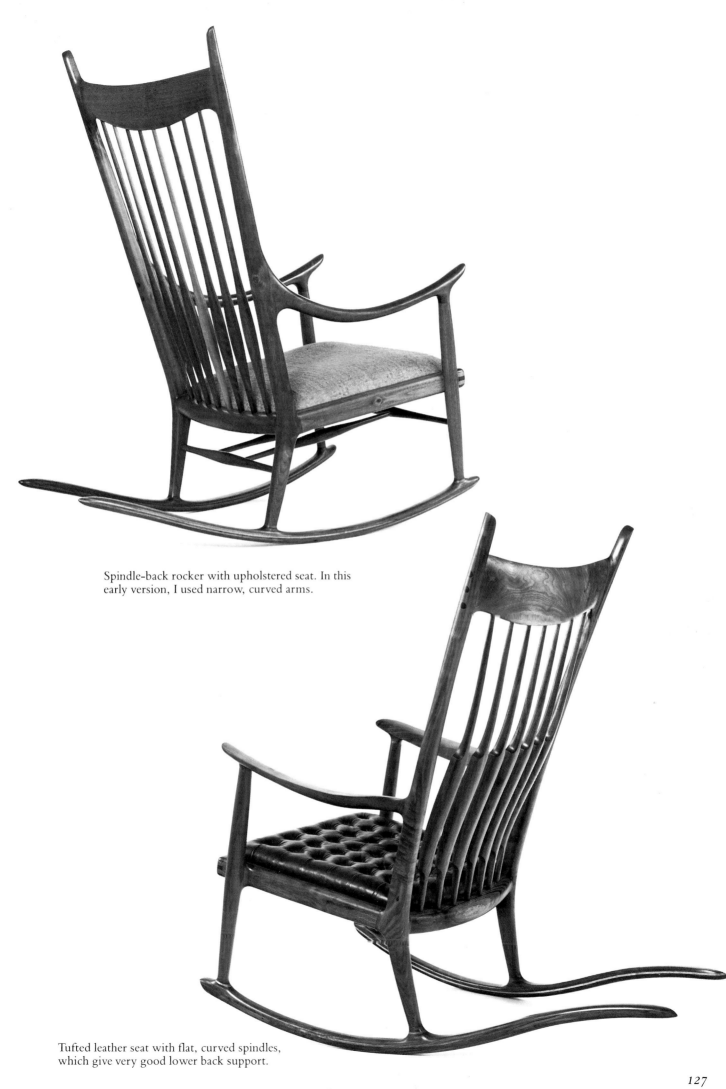

Spindle-back rocker with upholstered seat. In this
early version, I used narrow, curved arms.

Tufted leather seat with flat, curved spindles,
which give very good lower back support.

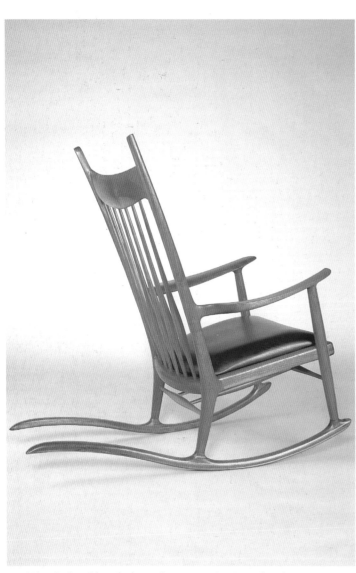

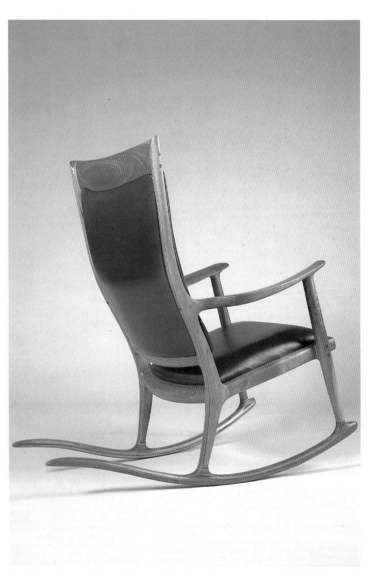

Rocking chair with upholstered seat; note laminated rockers.

Rocking chair with upholstered back and seat.

Inside detail of chair *(see also page 141)*.

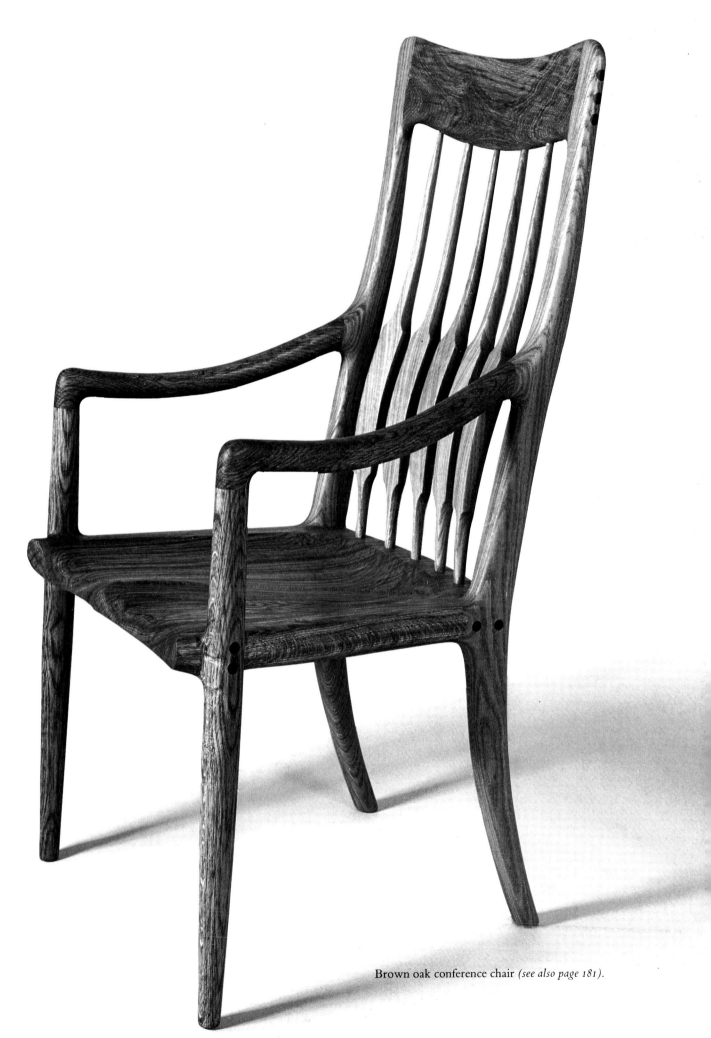

Brown oak conference chair *(see also page 181)*.

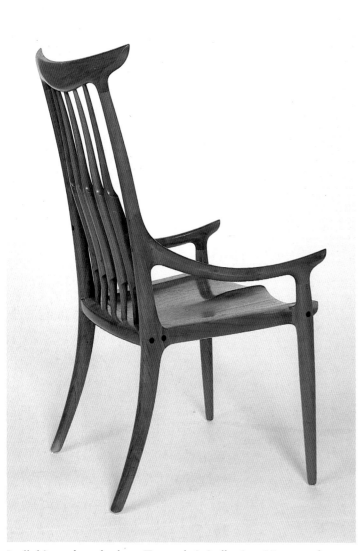

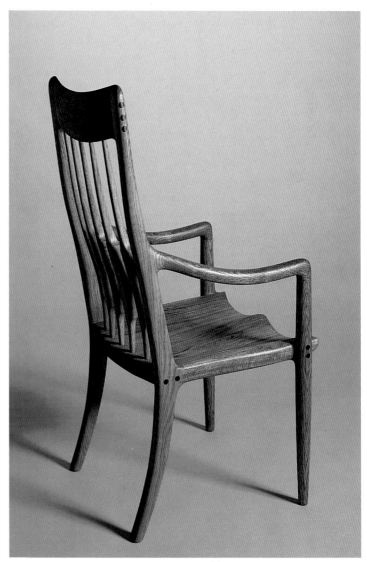

I call this my horn back, or Texas, chair (collection: Museum of Fine Arts, Boston). I also make this as an upholstered chair.

English brown oak conference chair: I made a group of ten of these for a conference room.

Curved slat back dining chair with curved arms.

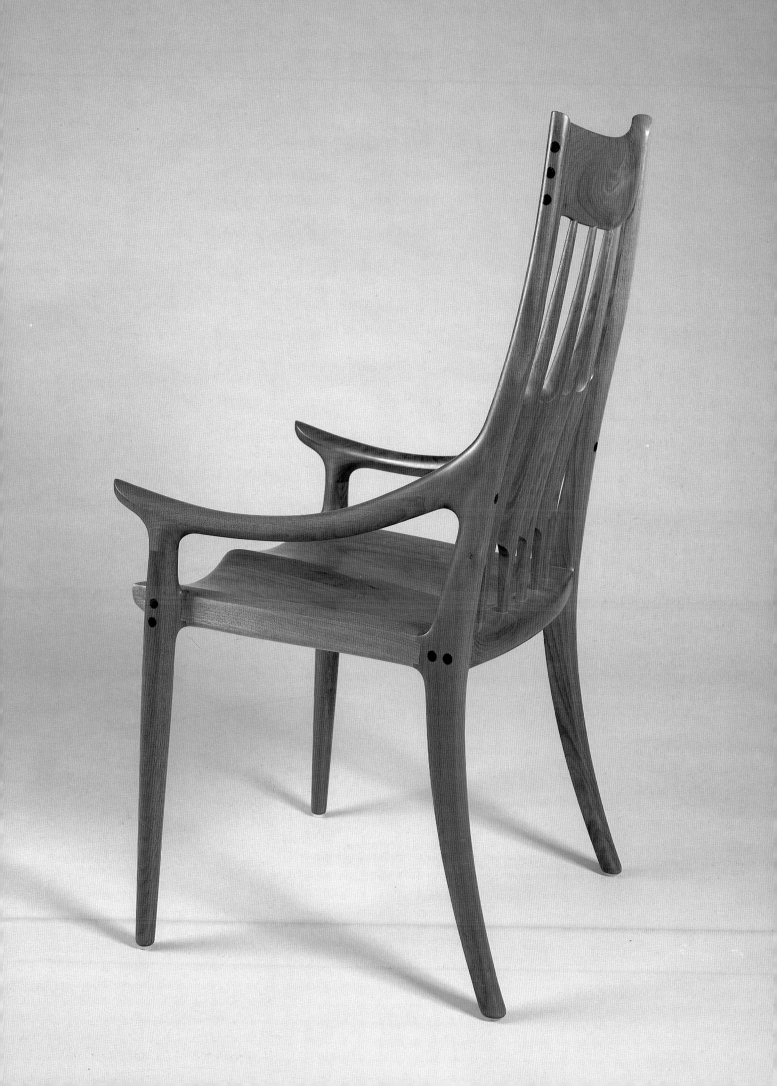

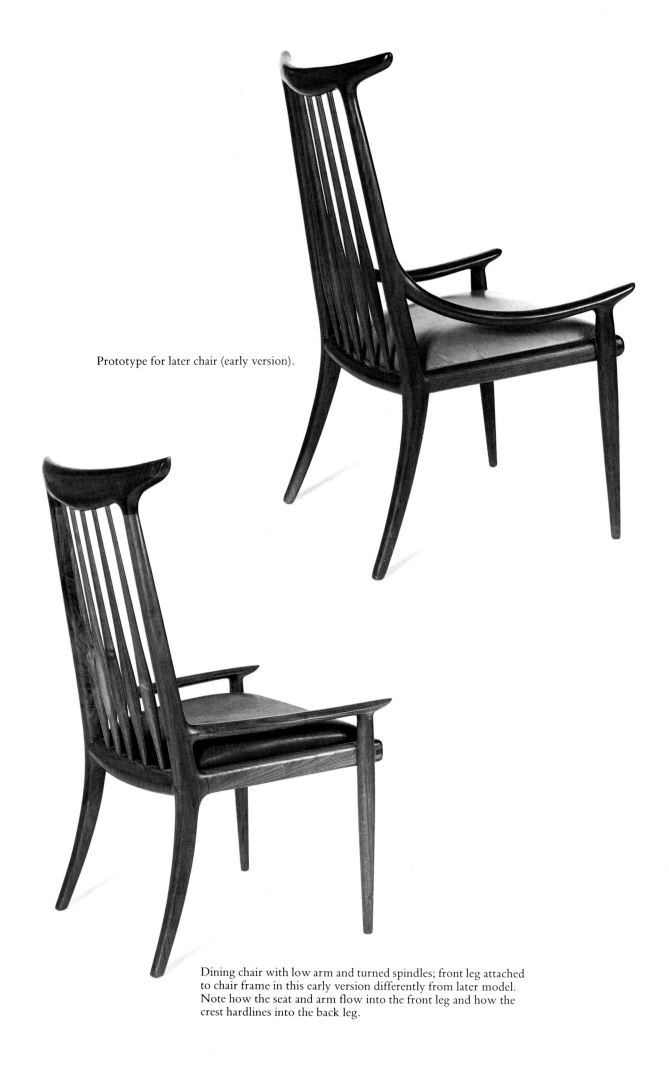

Prototype for later chair (early version).

Dining chair with low arm and turned spindles; front leg attached to chair frame in this early version differently from later model. Note how the seat and arm flow into the front leg and how the crest hardlines into the back leg.

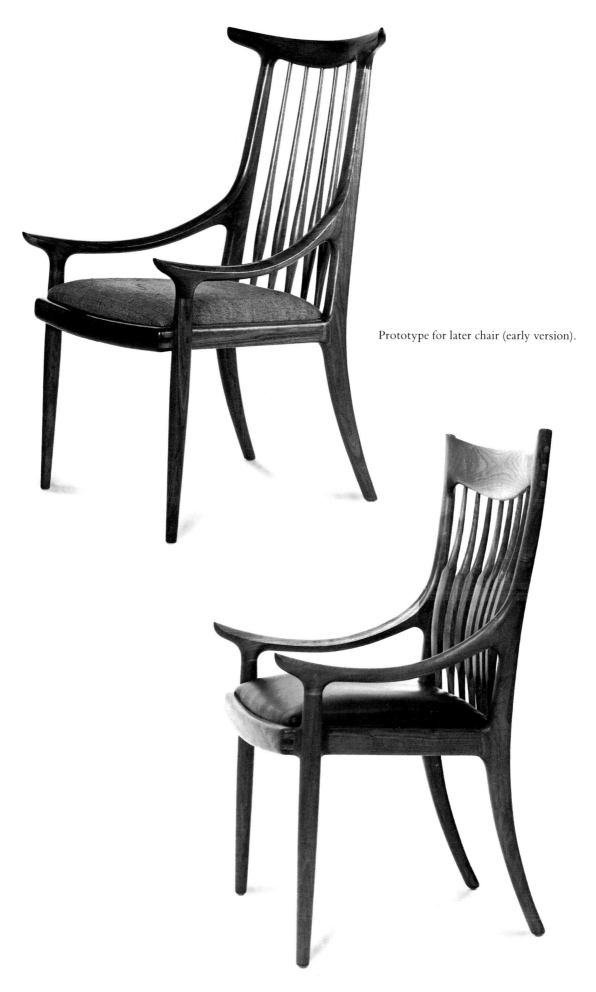

Prototype for later chair (early version).

This chair is similar to the one above, except it is wider and the
back legs flair out. It can be used as an occasional chair (collection:
Museum of Fine Arts, Boston).

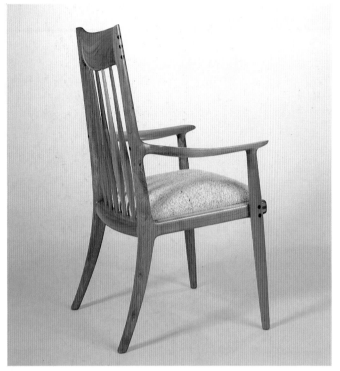

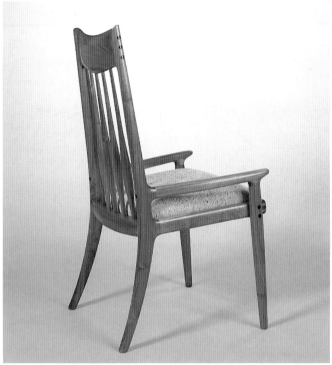

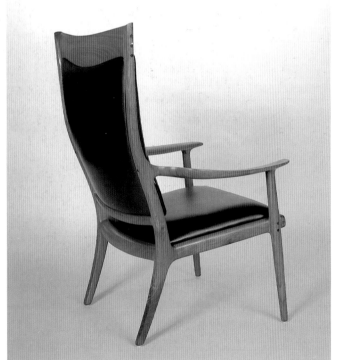

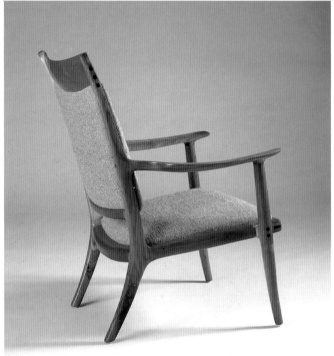

Upholstered dining chair with turned spindles *(top)*.

High-back occasional chair in walnut, upholstered in black leather *(bottom)*.

The low arm on this chair *(top)*, not really an arm at all, takes the place of a stretcher below the seat. It functions as a handle to lower oneself into the chair, move the chair back and forth, and raise oneself from a seated position.

All the joinery is exposed in this occasional chair *(bottom)*. The cushions, upholstered in Jack Lenor Larsen fabric, are held in place by suction.

High-back occasional chair, upholstered in Jack Lenor Larsen fabric; slightly different design from the chair on the opposite page *(bottom, left)*.

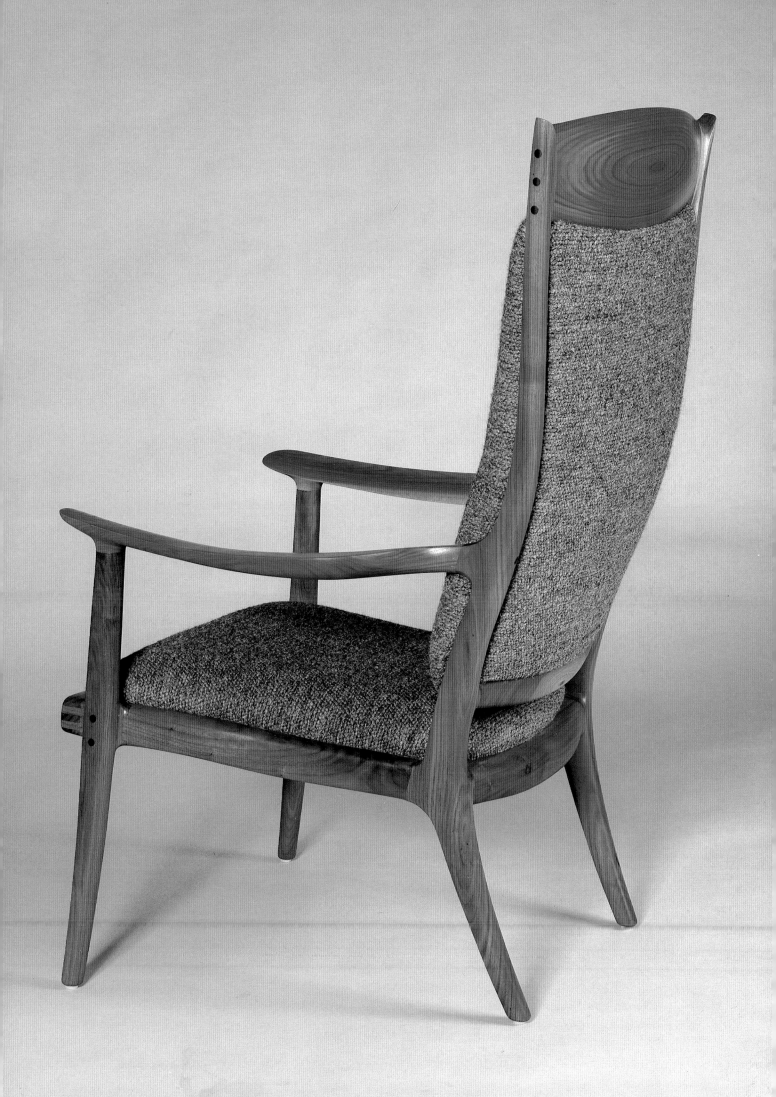

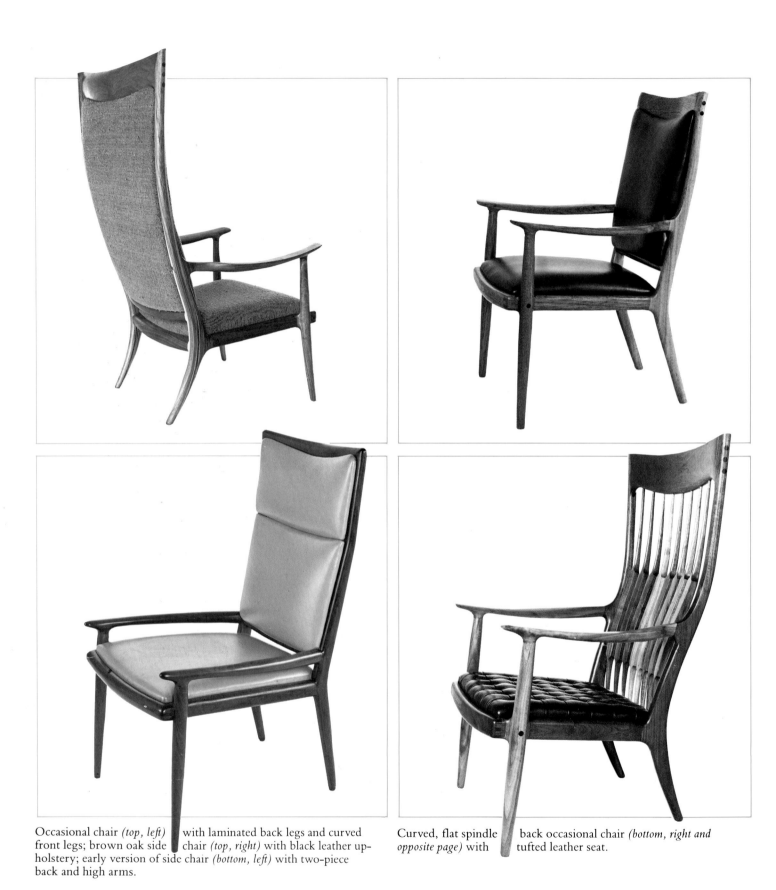

Occasional chair *(top, left)* with laminated back legs and curved front legs; brown oak side chair *(top, right)* with black leather upholstery; early version of side chair *(bottom, left)* with two-piece back and high arms.

Curved, flat spindle back occasional chair *(bottom, right and opposite page)* with tufted leather seat.

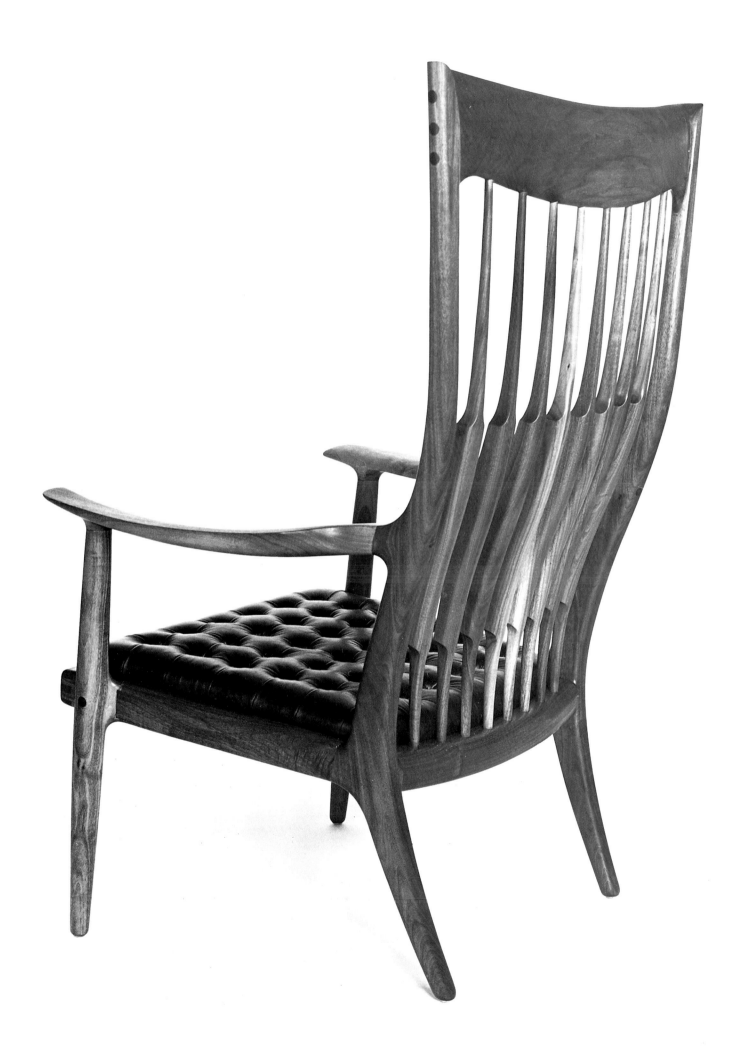

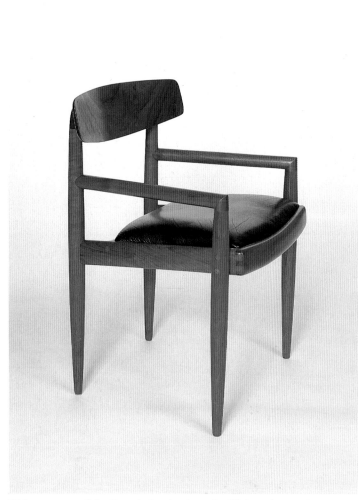

This was one of the first chairs that I made. We have been using the original four for thirty years.

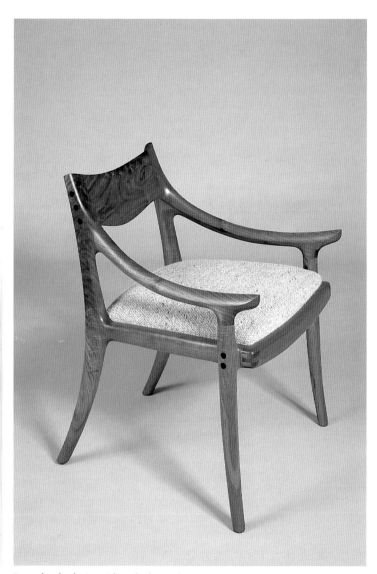

Low-back chair with upholstered seat.

If I picked favorites among my pieces, this chair would be near the top of my list (collection: Museum of Fine Arts, Boston). It gives very good lower back support.

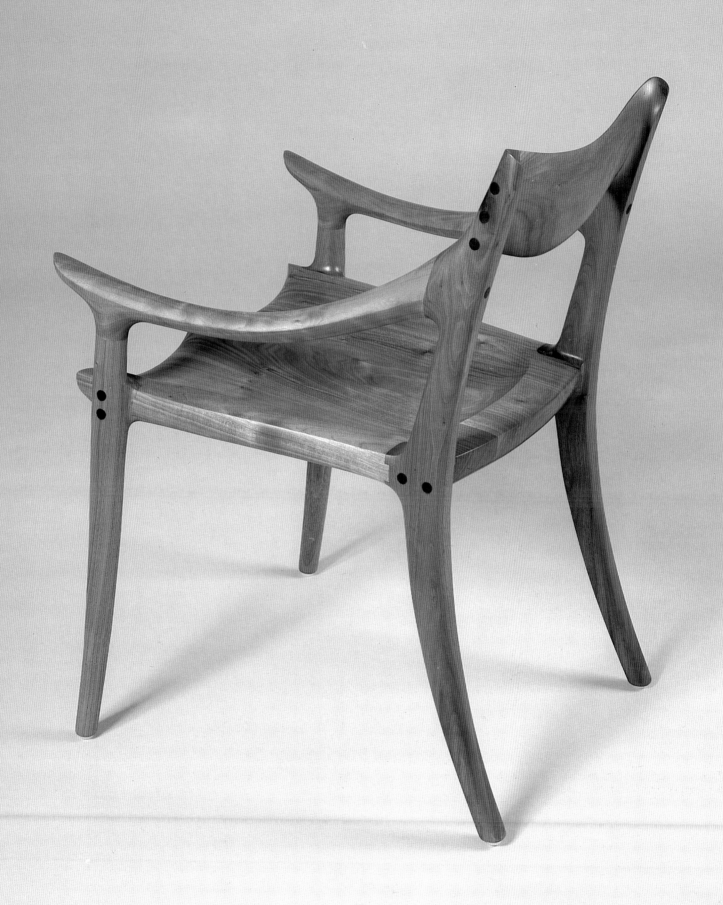

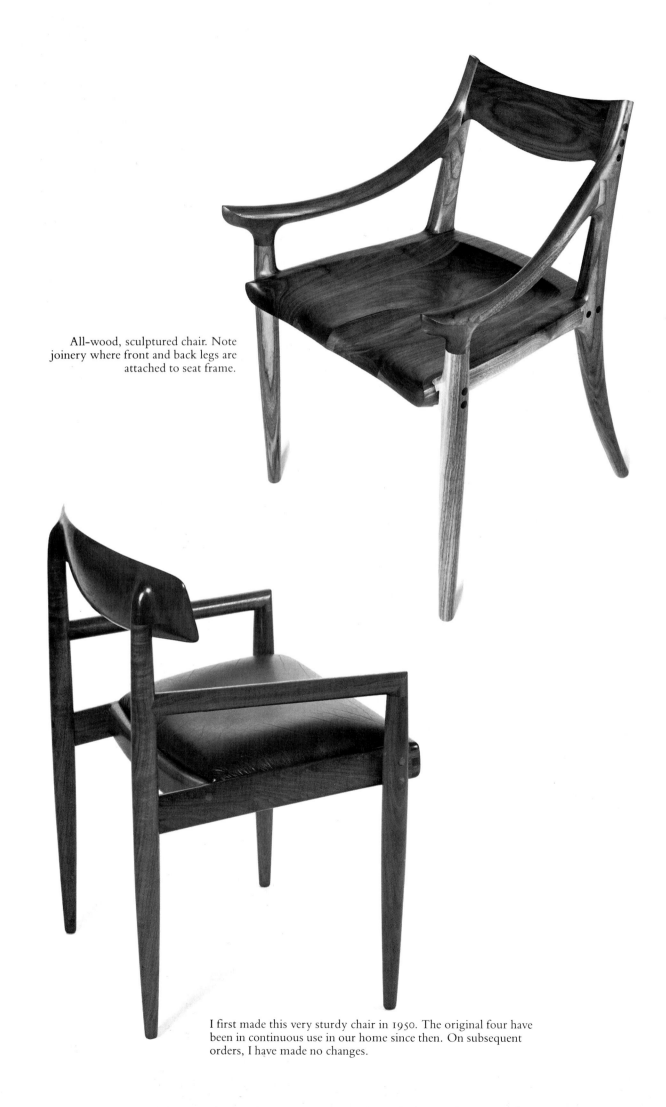

All-wood, sculptured chair. Note joinery where front and back legs are attached to seat frame.

I first made this very sturdy chair in 1950. The original four have been in continuous use in our home since then. On subsequent orders, I have made no changes.

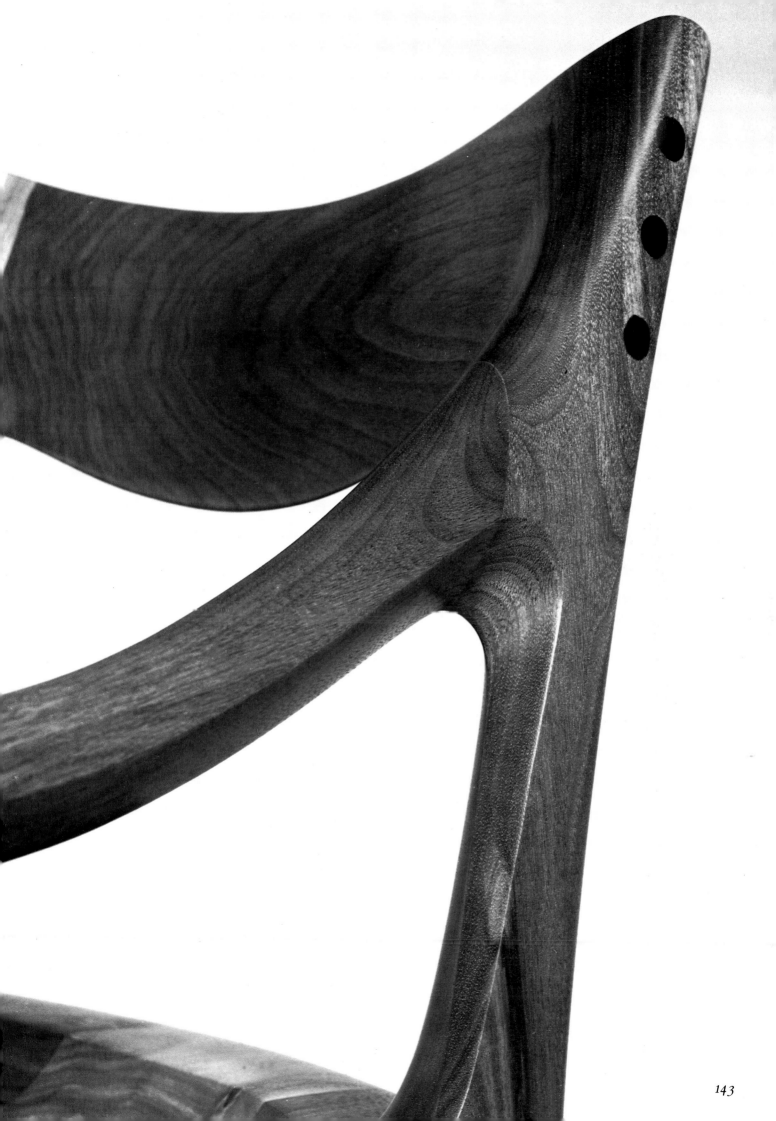

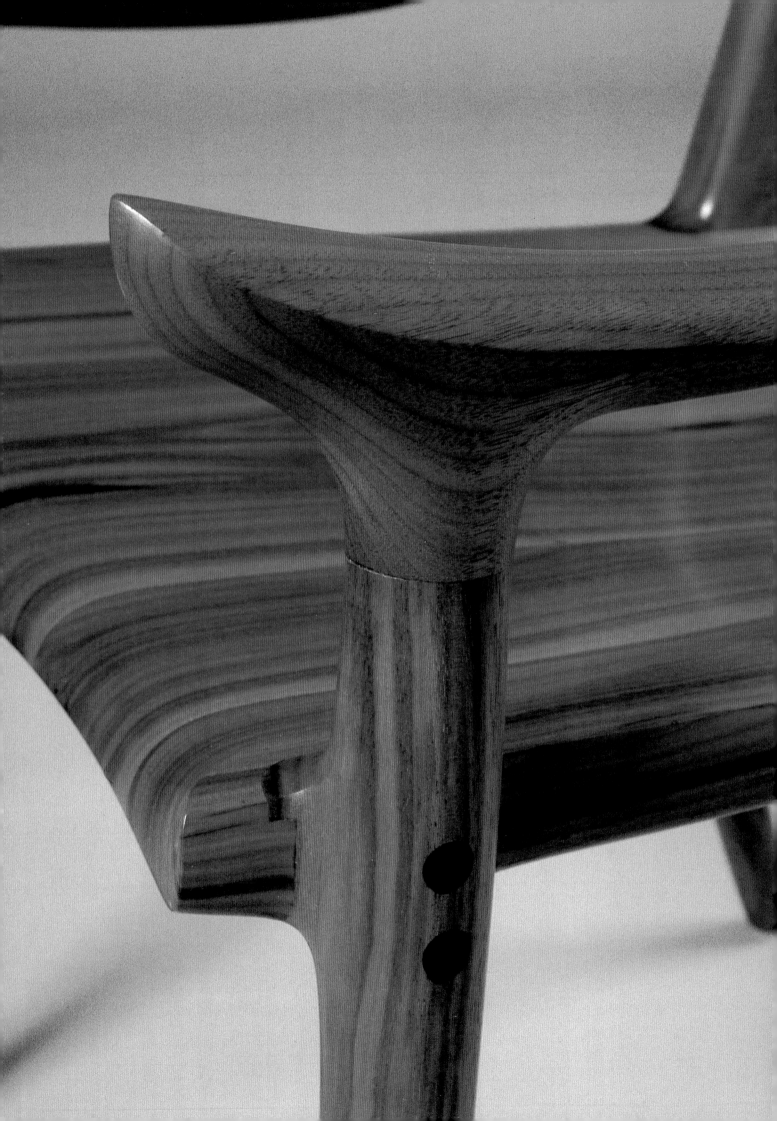

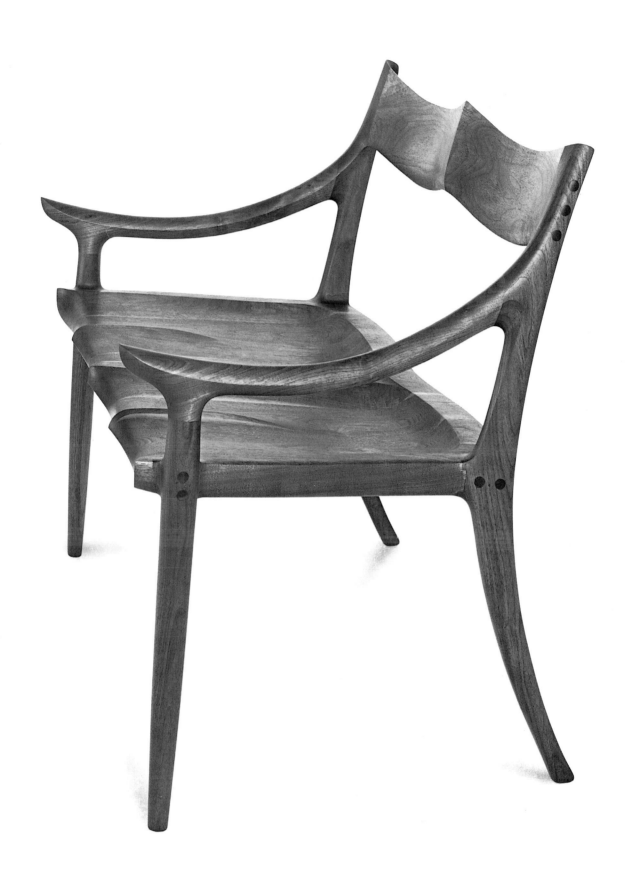

Settee: the original was made for the Museum of Fine Arts, Boston. The St. Louis Art Museum also has one in its collection.

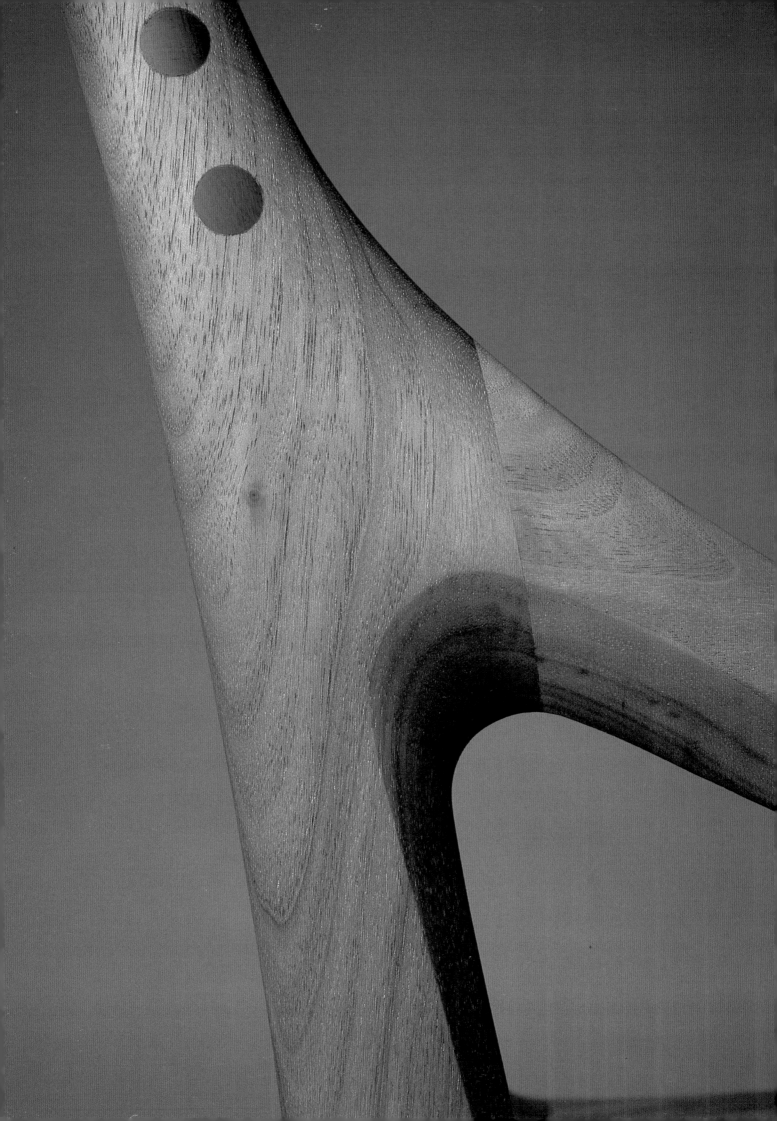

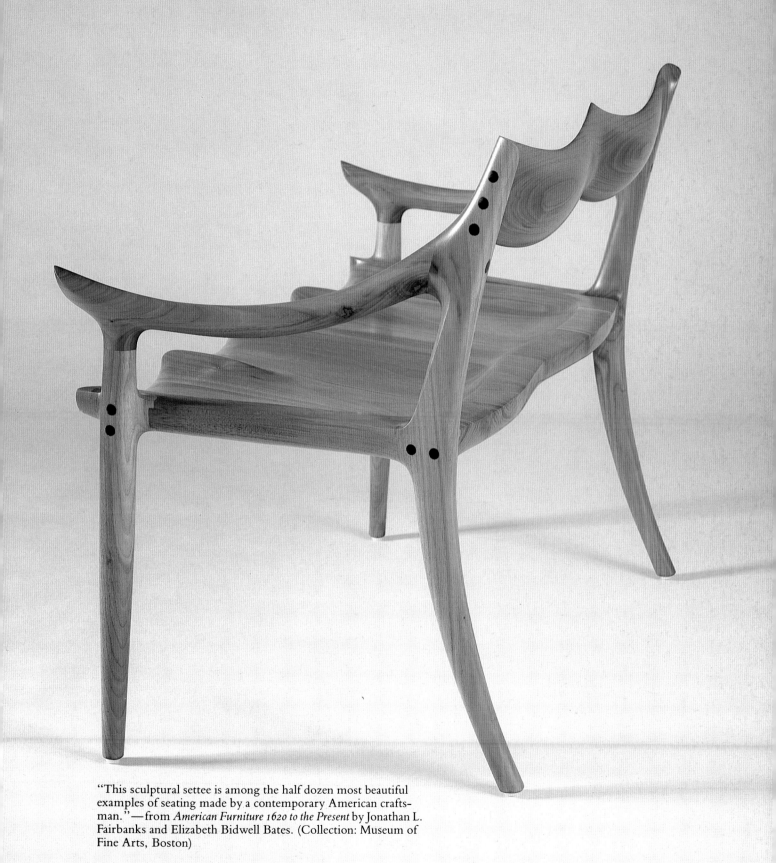

"This sculptural settee is among the half dozen most beautiful examples of seating made by a contemporary American craftsman."—from *American Furniture 1620 to the Present* by Jonathan L. Fairbanks and Elizabeth Bidwell Bates. (Collection: Museum of Fine Arts, Boston)

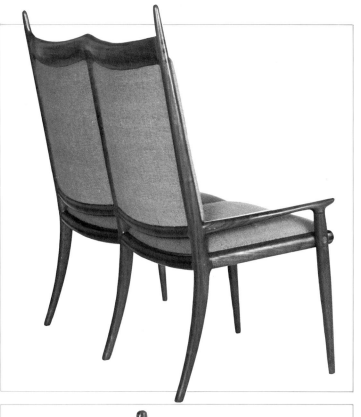

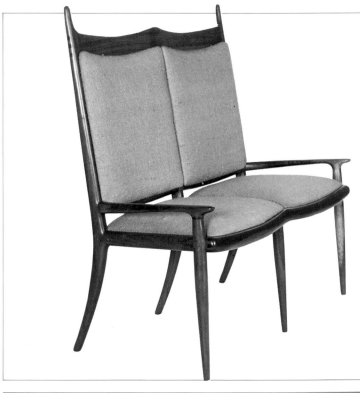

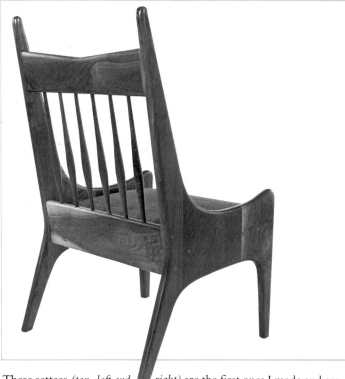

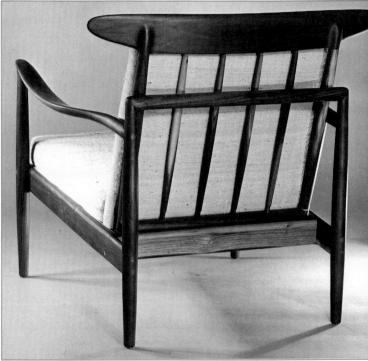

These settees *(top, left and right)* are the first ones I made and are used in our home. This chair *(bottom, left)* was made as a chancel chair for a church. The crest on this chair *(bottom, right)* was an early version of a theme I have continued to use.

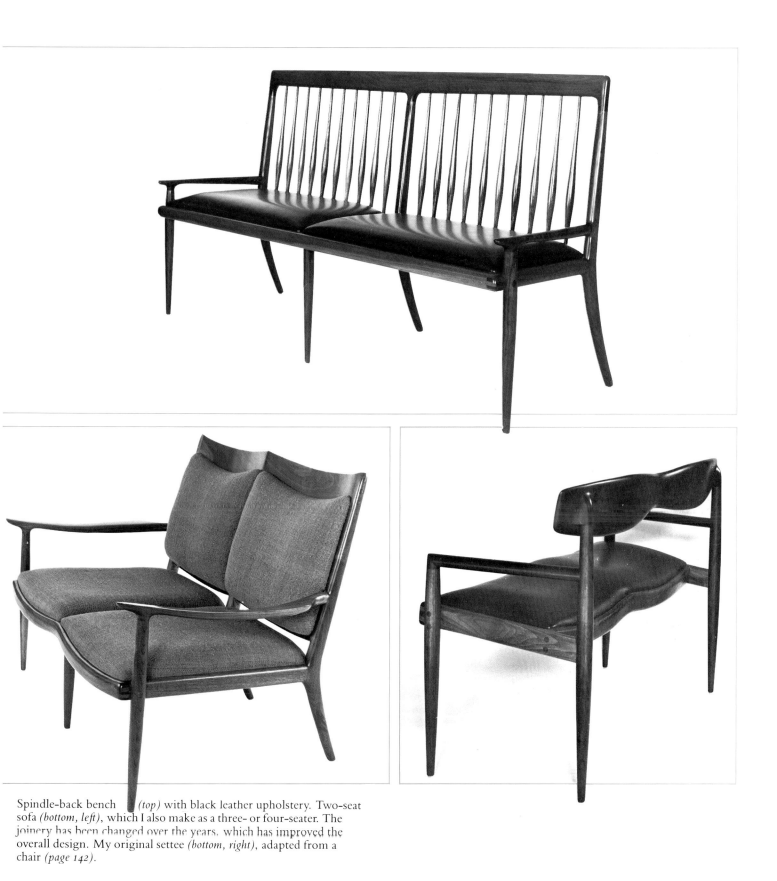

Spindle-back bench (top) with black leather upholstery. Two-seat sofa (bottom, left), which I also make as a three- or four-seater. The joinery has been changed over the years, which has improved the overall design. My original settee (bottom, right), adapted from a chair (page 142).

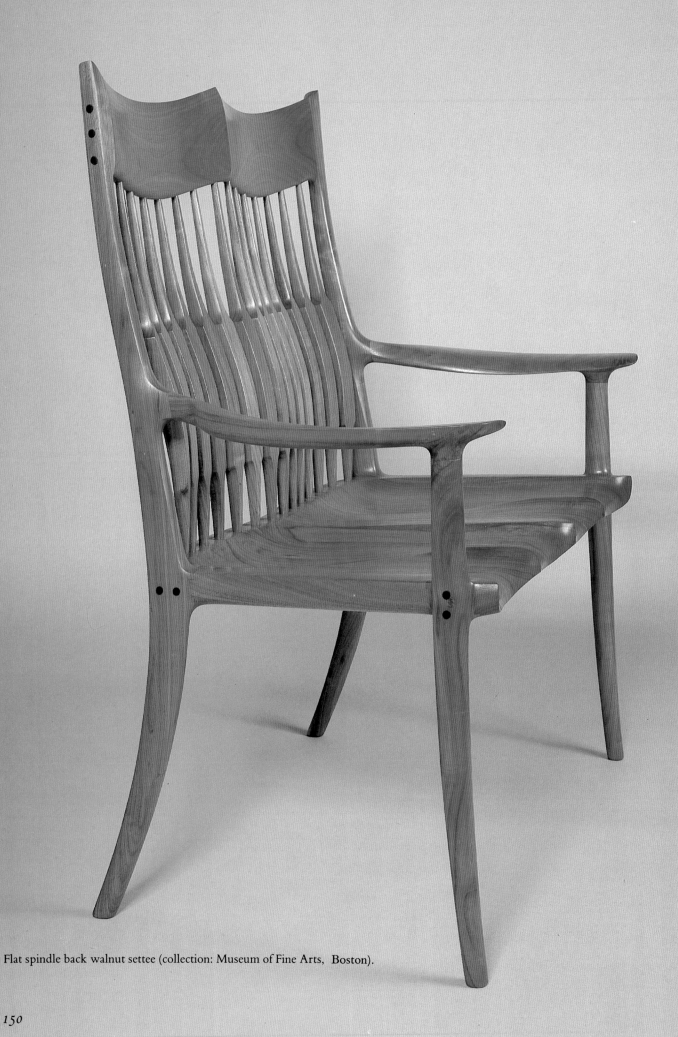

Flat spindle back walnut settee (collection: Museum of Fine Arts, Boston).

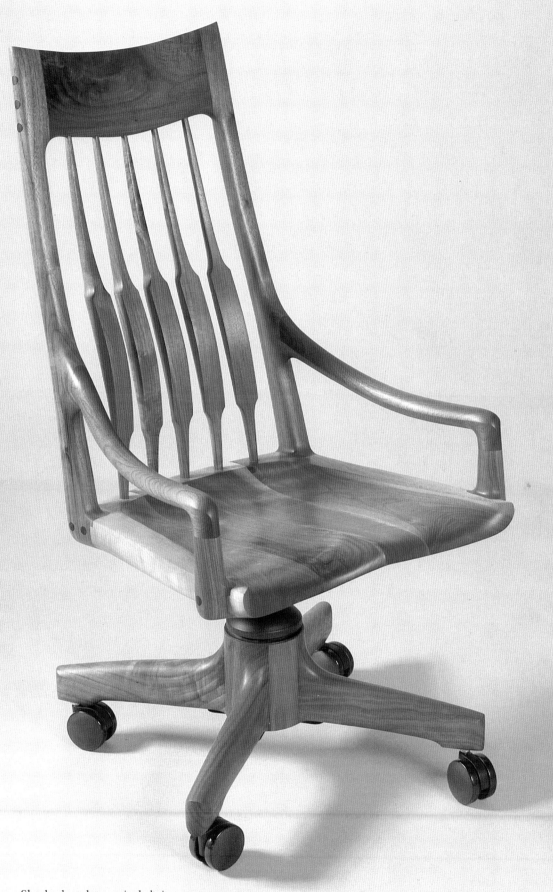

Slat-back walnut swivel chair.

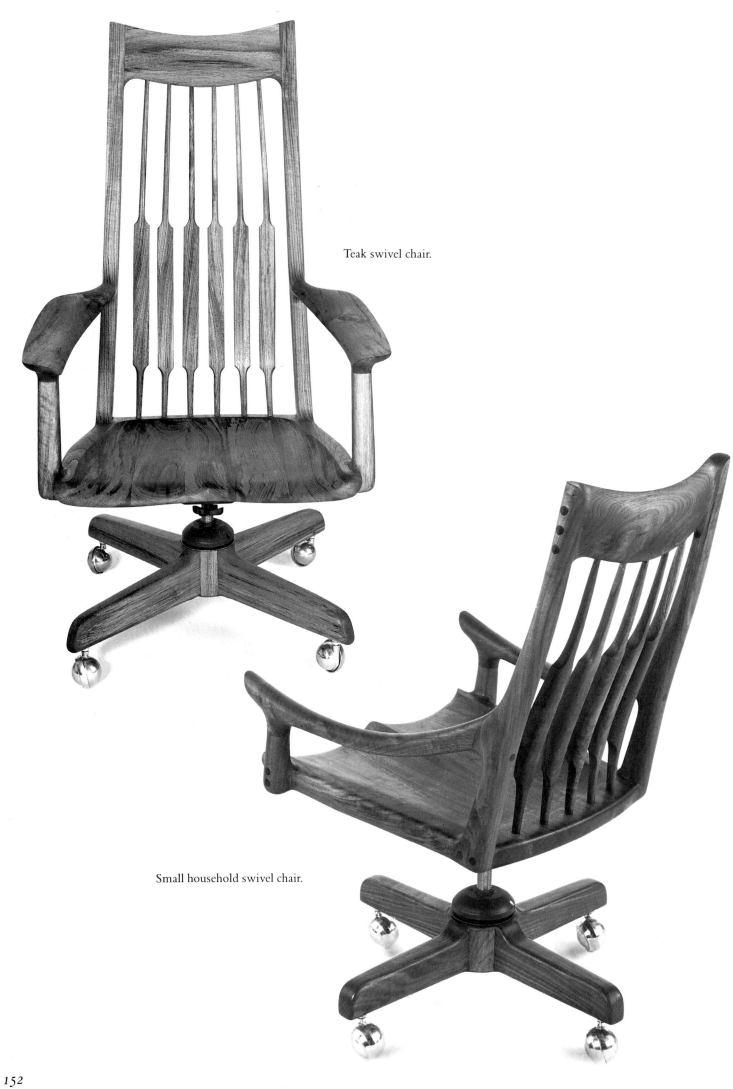

Teak swivel chair.

Small household swivel chair.

Table top (forty-eight-inch diameter)
made of black walnut.

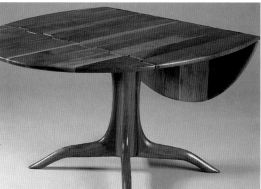

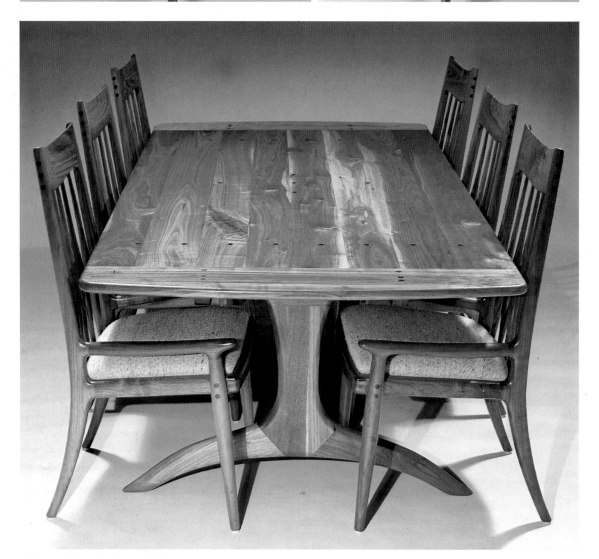

This oval, drop-leaf, wood-hinged pedestal table with sculpted base *(top, left and right)* seats six people. The extension trestle table *(bottom)* seats eight people when closed, twelve people when extended. The spindle-back chairs (turned on a lathe) have upholstered seats. Table and support arm shown from underside *(opposite)*.

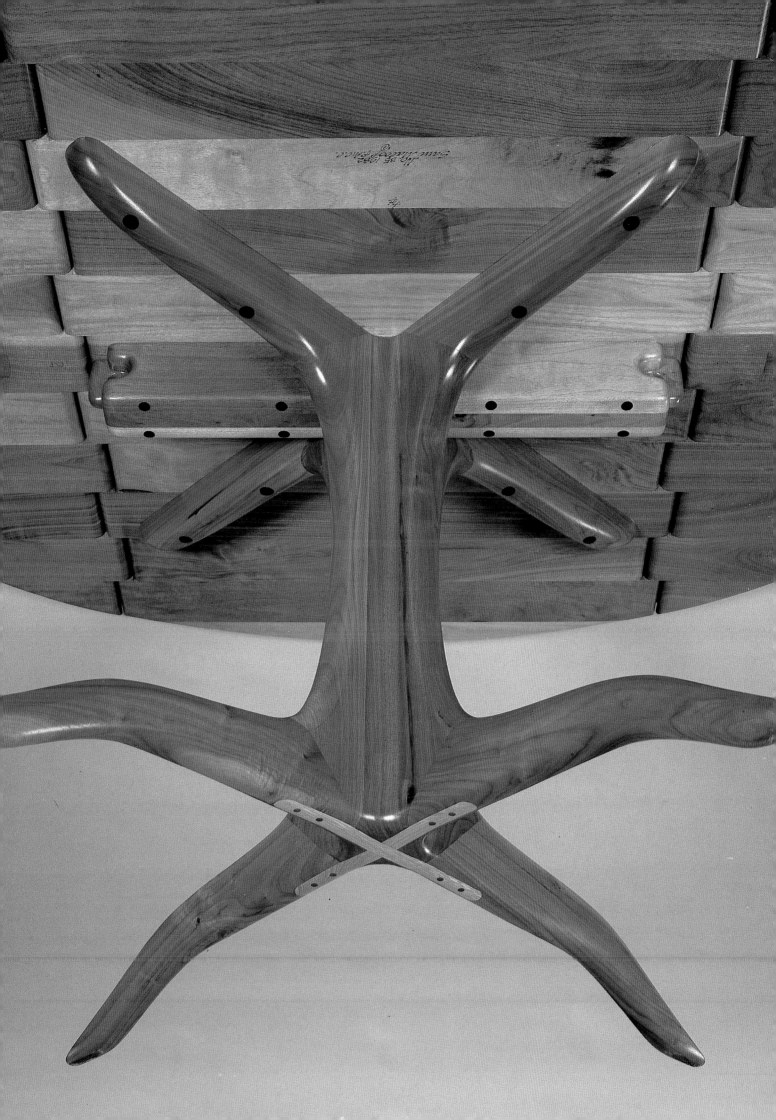

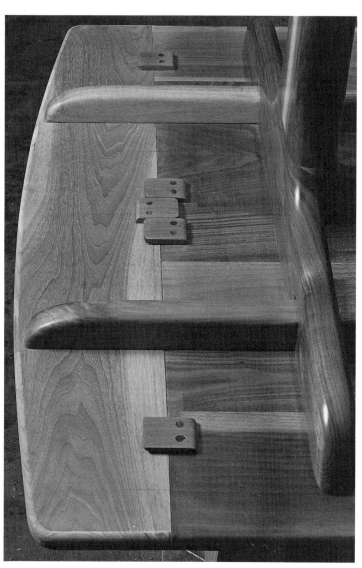

Underside of extension dining table closed *(left)*; same table opened to accept leaf *(right)*.

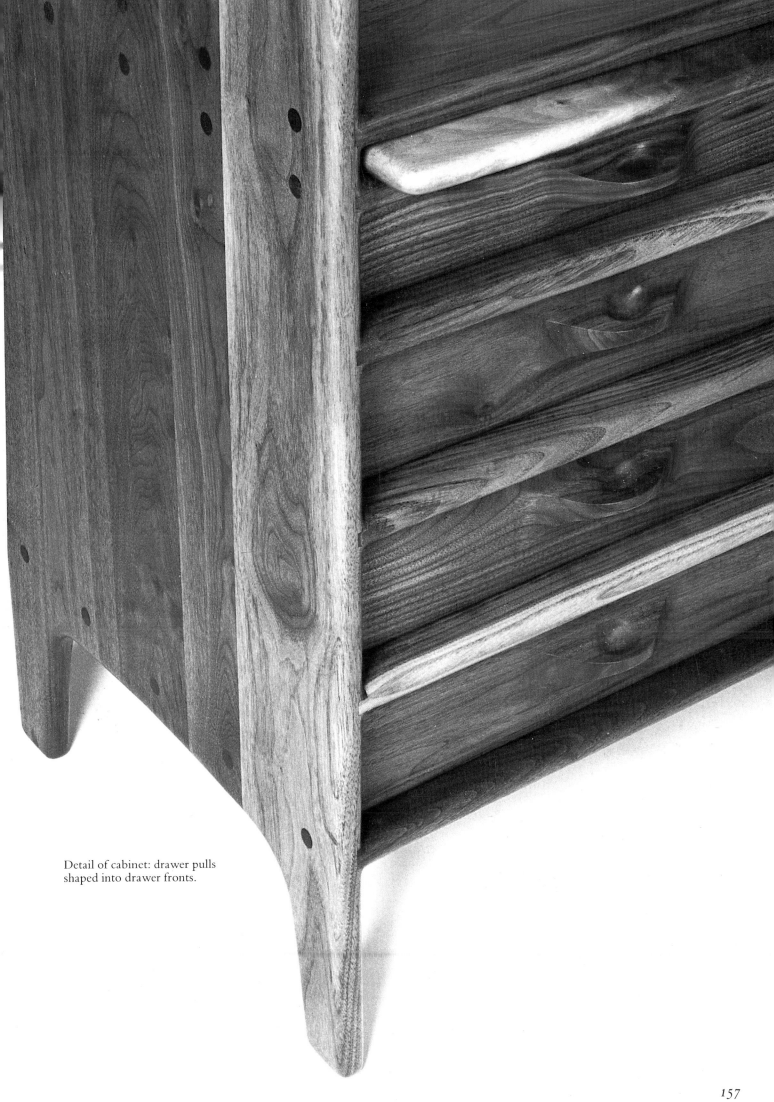

Detail of cabinet: drawer pulls
shaped into drawer fronts.

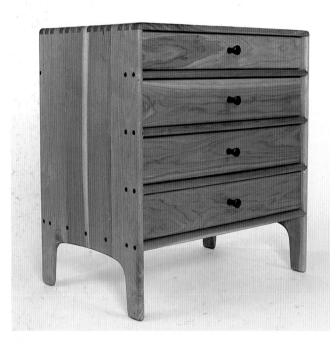

Brown oak credenza, twenty-two by thirty-six by eighty-four inches *(top, left)*; brown oak cabinet with dovetails *(top, right)*; walnut chest *(bottom, left)*; brown oak cabinet with dovetails *(bottom, right)*.

Brazilian rosewood desk with
wood-hinged, drop-leaf writing surface

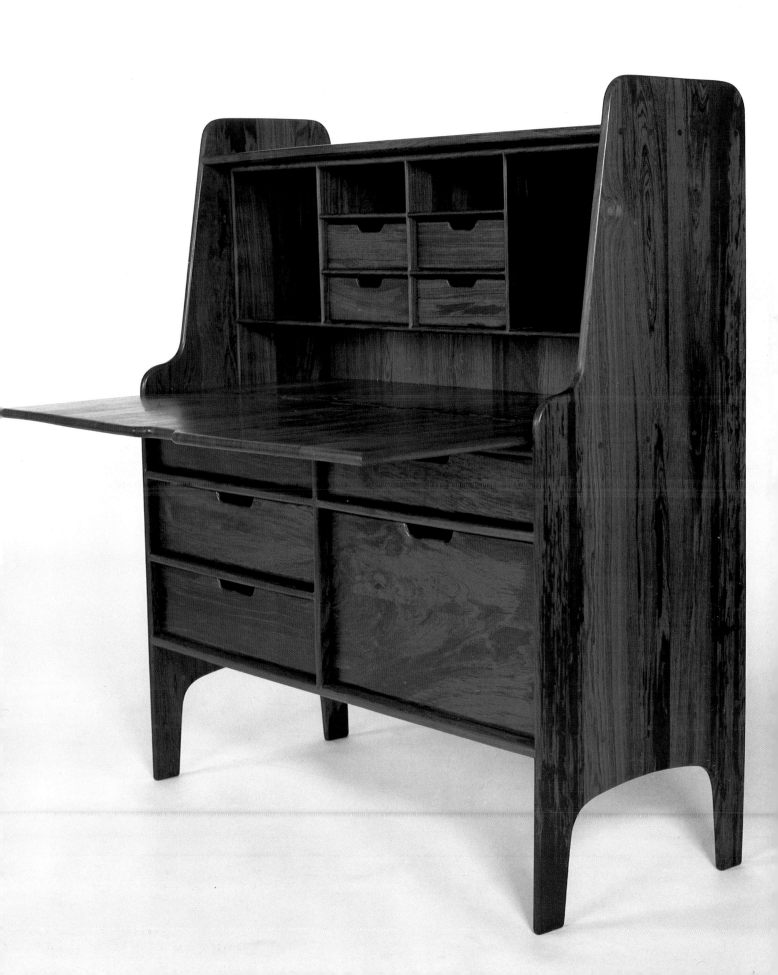

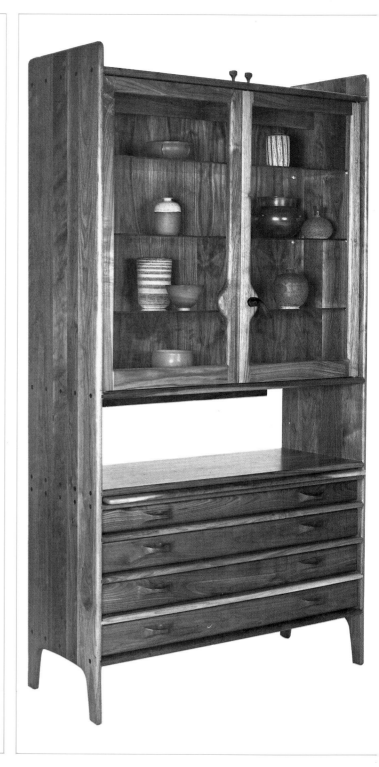

Cabinets with drawers and glass doors.

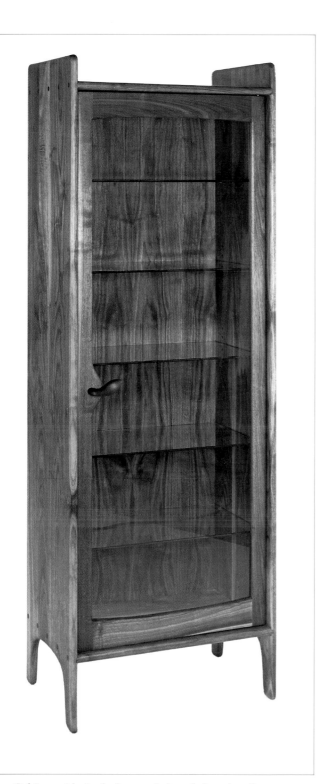

Cabinet with single door and glass shelves; handle made of ebony.

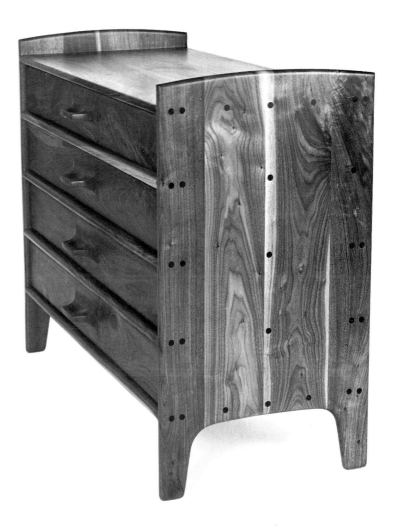

Chest of drawers. All of my cabinets and chests are finished in back so that they can be used away from walls.

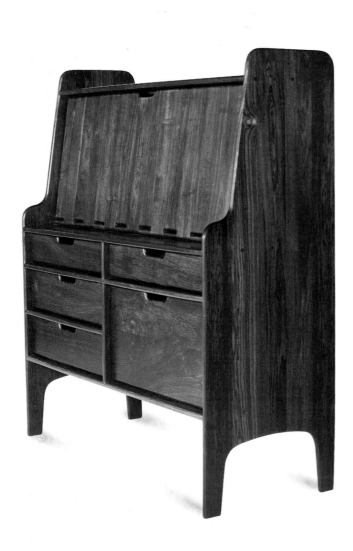

Brazilian rosewood desk *(above)* with wood-hinged, drop-leaf writing surface *(see page 159)*; desk hutch *(right)*: writing surface has wooden hinges and lower doors inset for knee space.

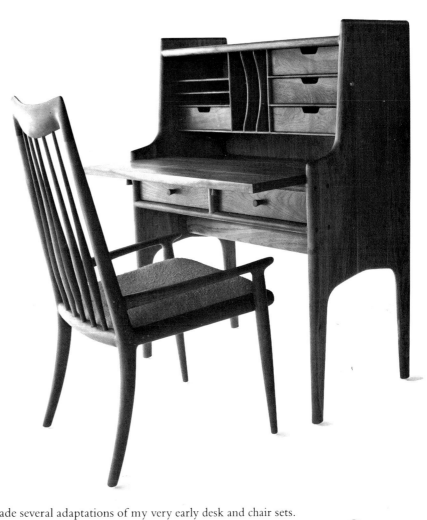

I have made several adaptations of my very early desk and chair sets.

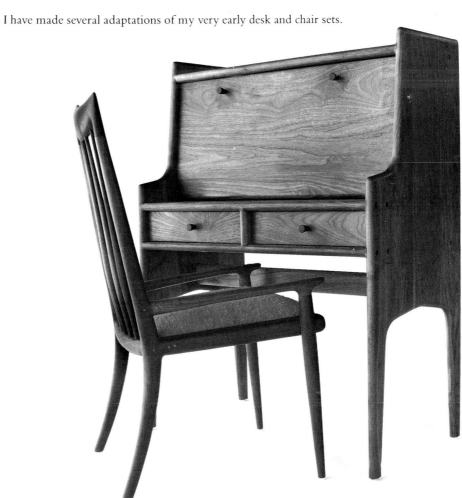

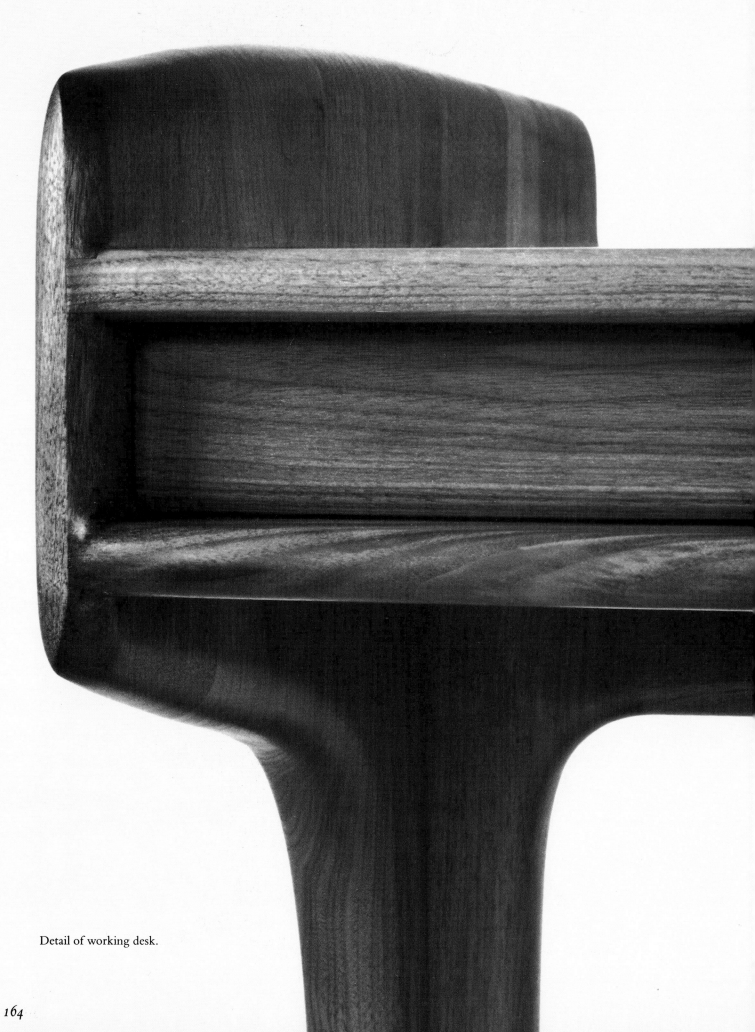

Detail of working desk.

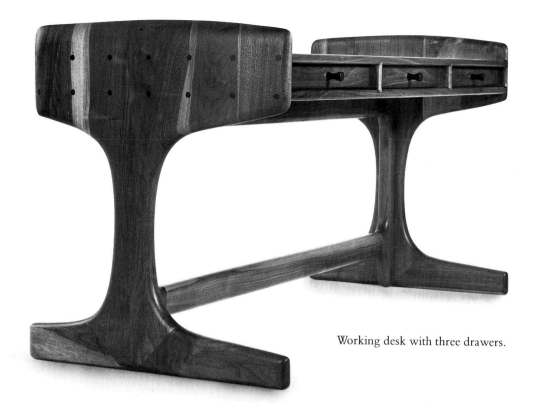

Working desk with three drawers.

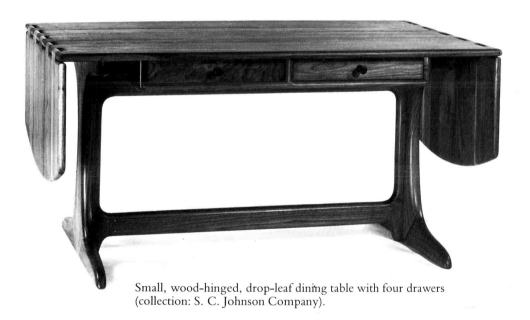

Small, wood-hinged, drop-leaf dining table with four drawers
(collection: S. C. Johnson Company).

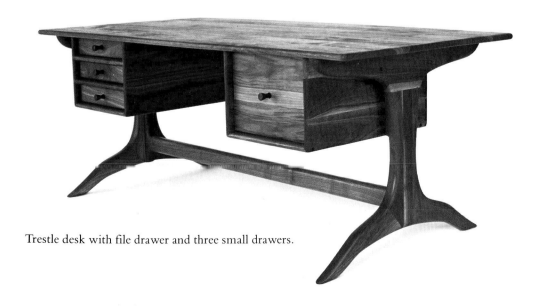

Trestle desk with file drawer and three small drawers.

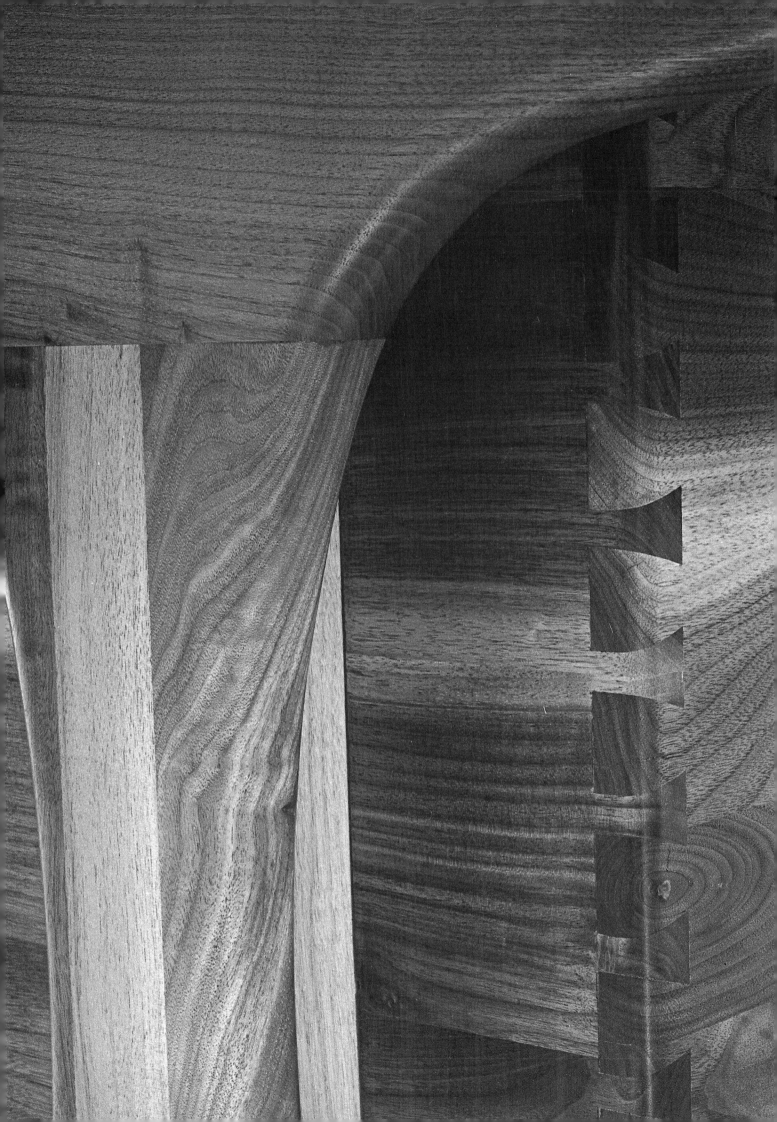

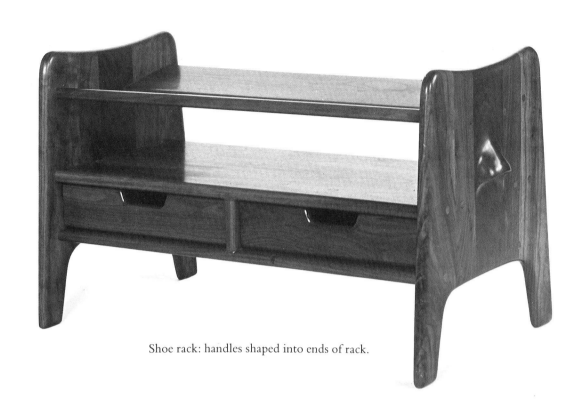

Shoe rack: handles shaped into ends of rack.

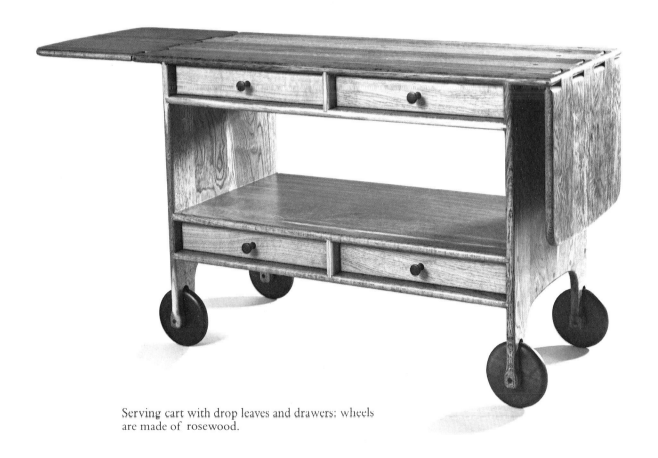

Serving cart with drop leaves and drawers; wheels are made of rosewood.

Detail of trestle desk: leg and dovetails (see preceding page).

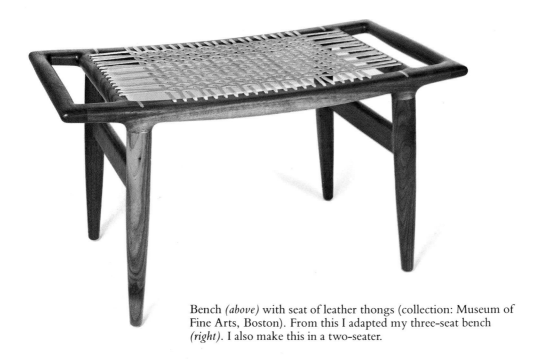

Bench *(above)* with seat of leather thongs (collection: Museum of Fine Arts, Boston). From this I adapted my three-seat bench *(right)*. I also make this in a two-seater.

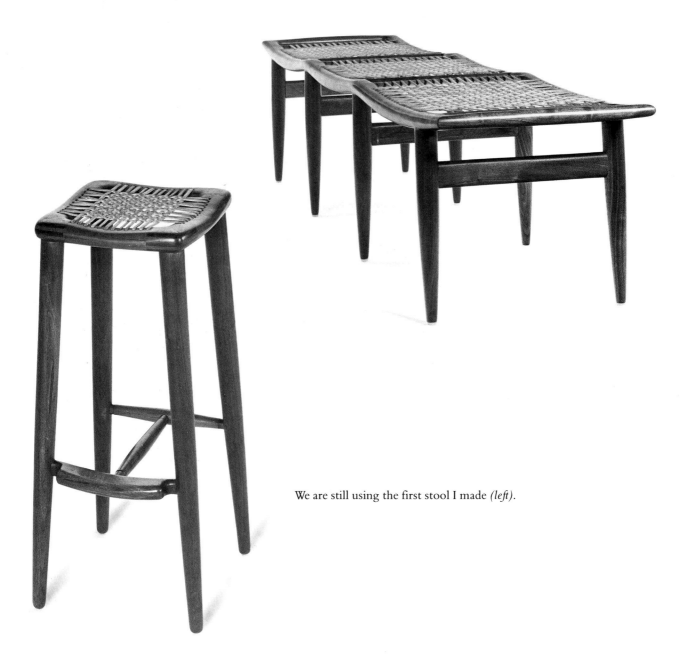

We are still using the first stool I made *(left)*.

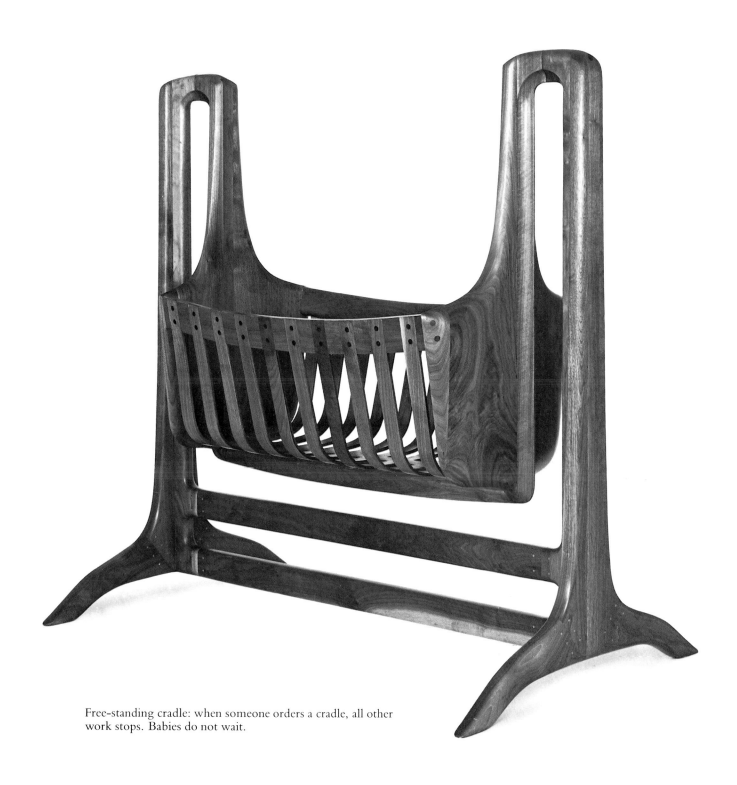

Free-standing cradle: when someone orders a cradle, all other work stops. Babies do not wait.

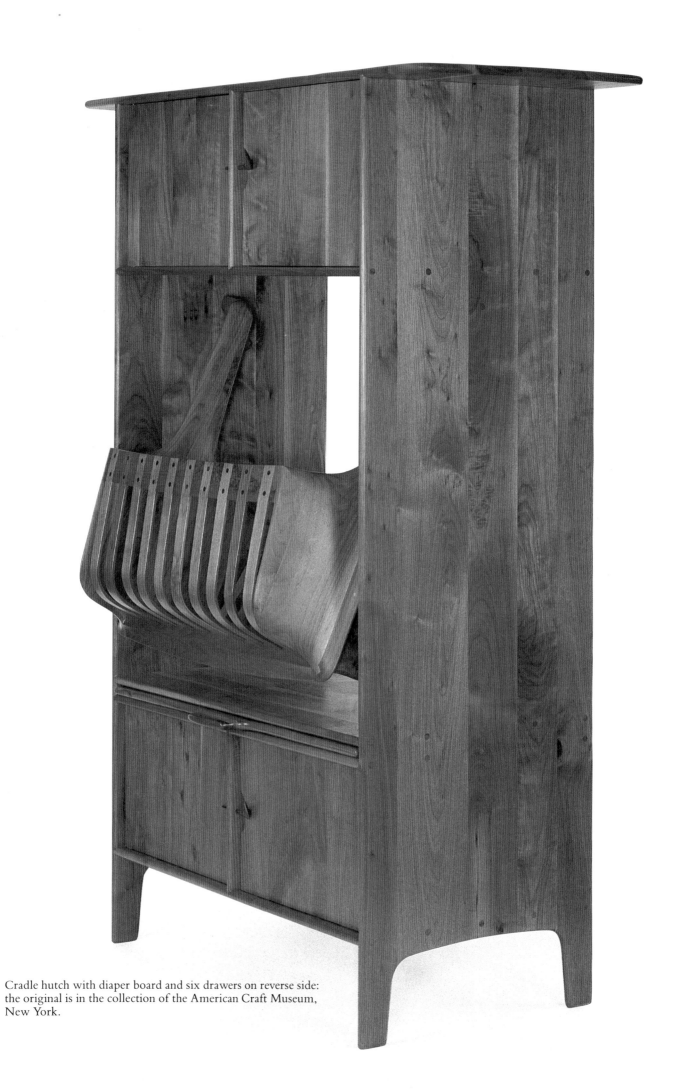

Cradle hutch with diaper board and six drawers on reverse side:
the original is in the collection of the American Craft Museum,
New York.

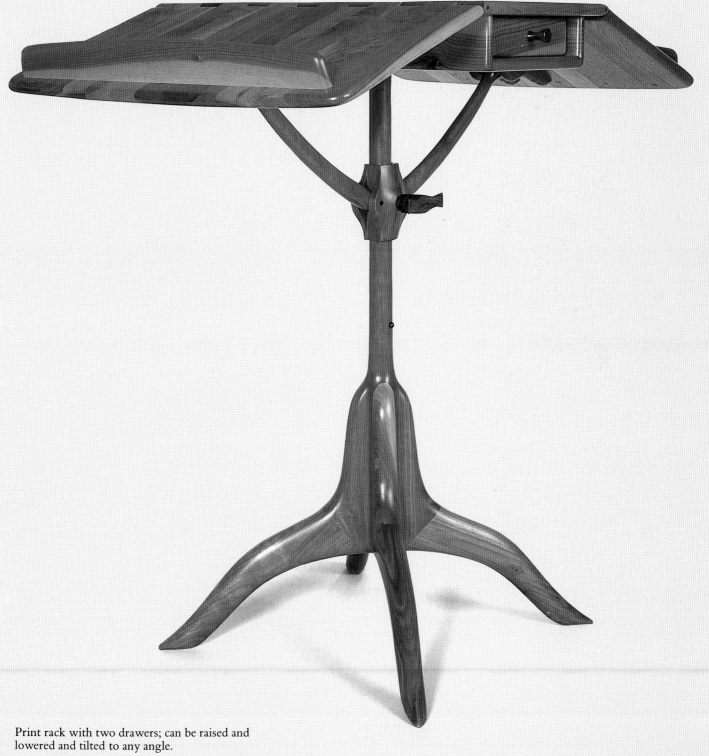

Print rack with two drawers; can be raised and
lowered and tilted to any angle.

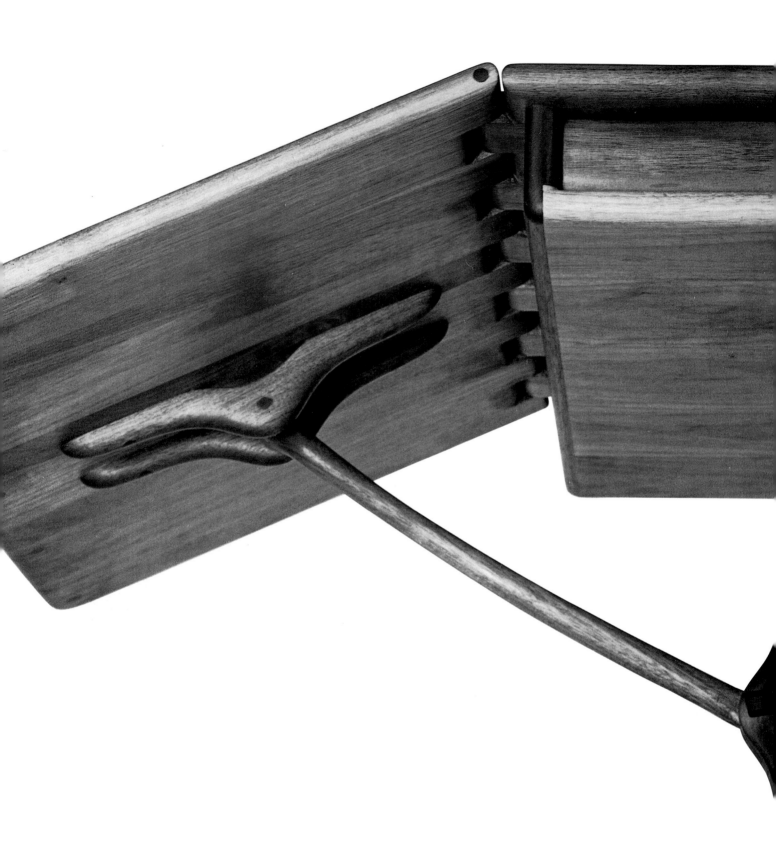

Underside of wood-hinged print rack, showing mechanism for
raising and lowering leaves.

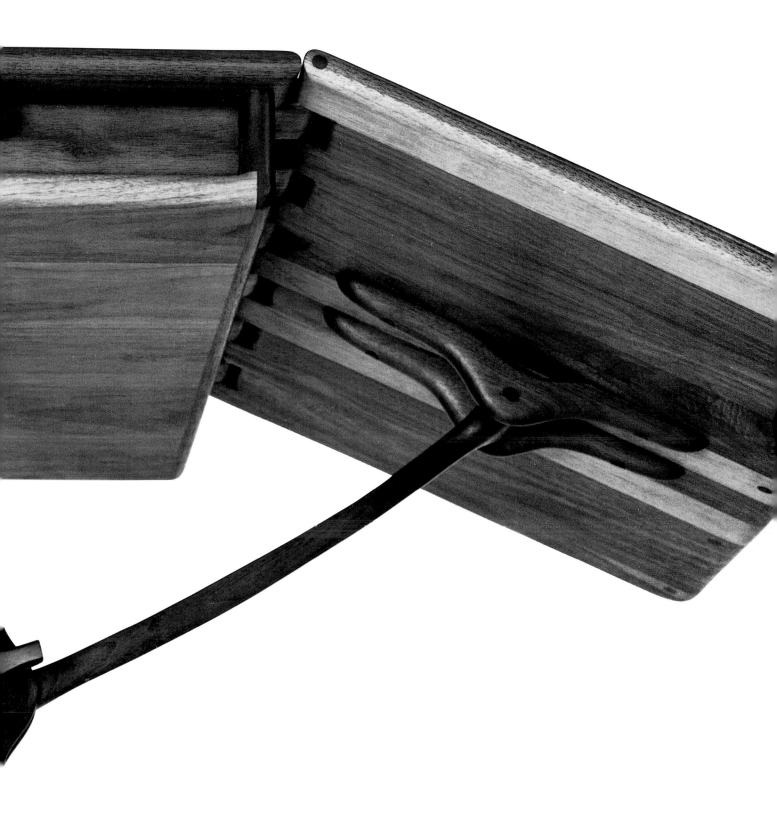

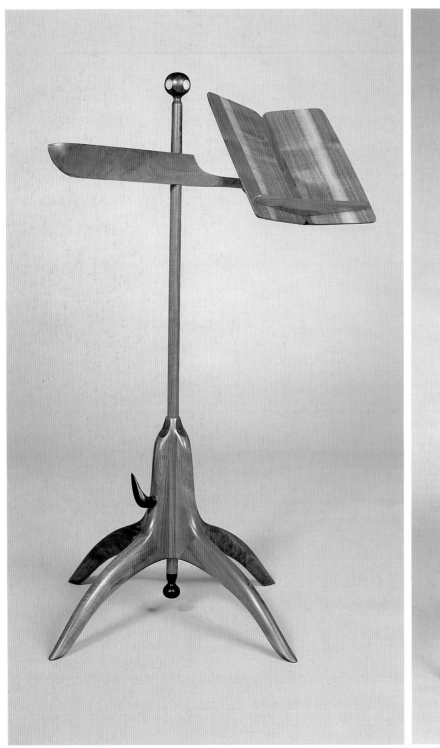

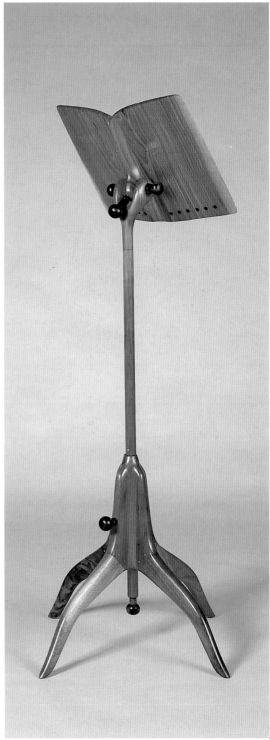

Walnut adjustable music rack.

I enjoyed experimenting with this single music rack *(above)*; detail *(opposite)*.

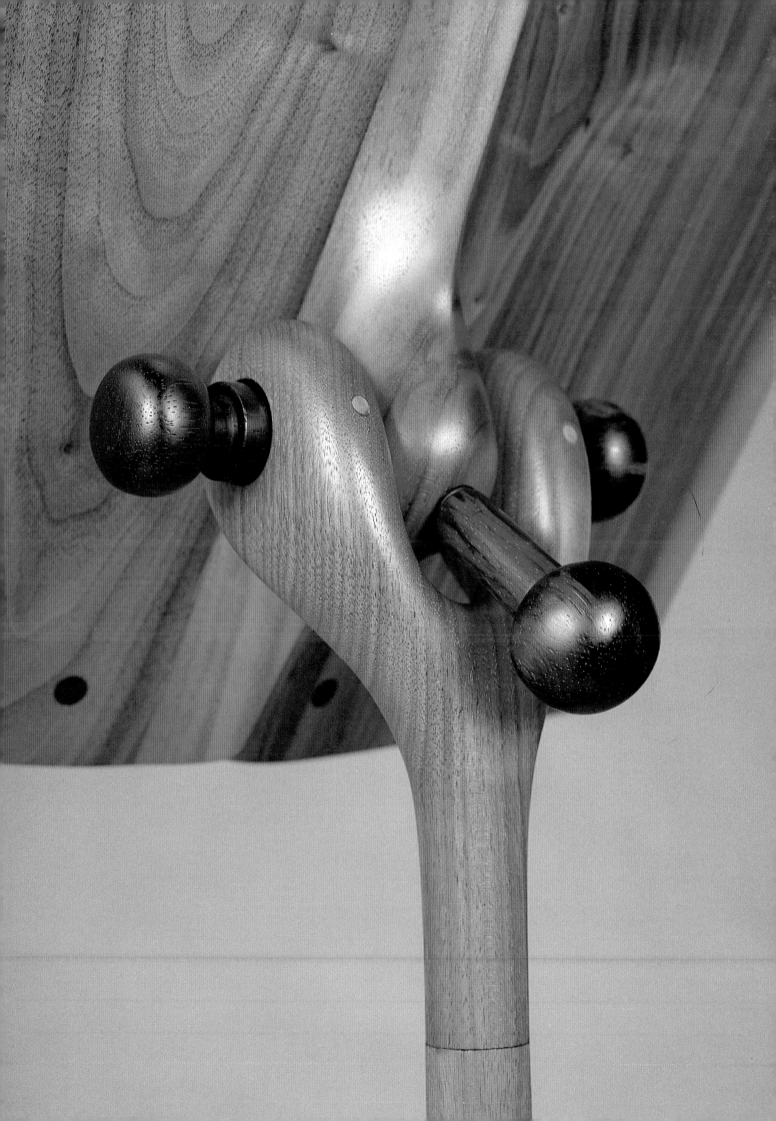

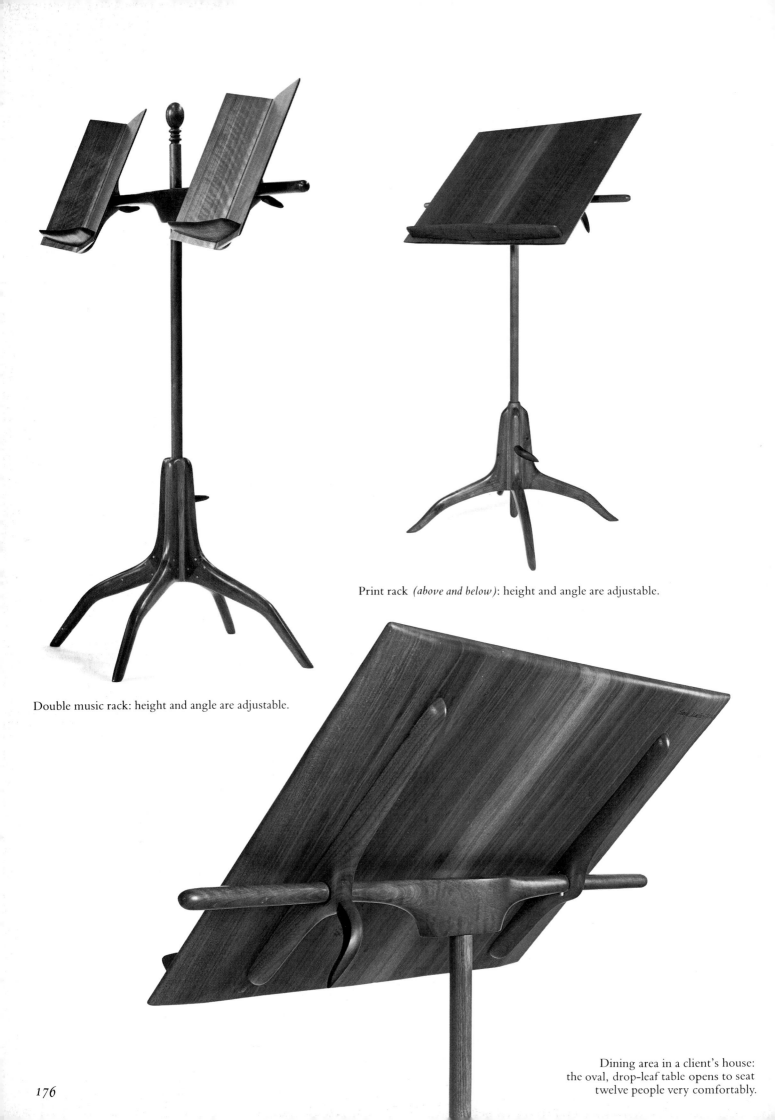

Double music rack: height and angle are adjustable.

Print rack *(above and below)*: height and angle are adjustable.

Dining area in a client's house:
the oval, drop-leaf table opens to seat
twelve people very comfortably.

Cork and walnut coffee table (sixty-inch diameter) with lazy susan.

Four-trestle, twenty-by-six-foot conference table and chairs.
Tabletop is a full two inches thick; it took eighteen men to carry it
up a circular stairway—that was the top only.

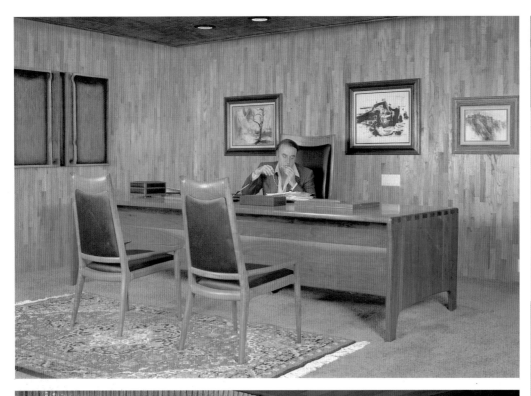

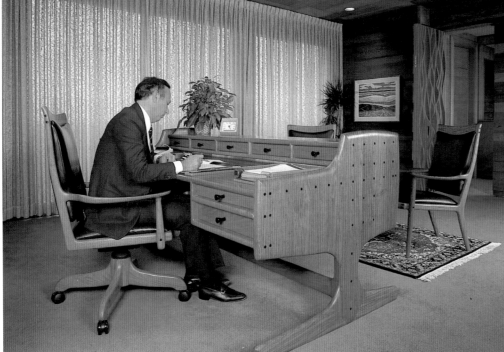

Ten-foot, walnut executive desk *(top)* with two banks of drawers and dovetails at both ends; eight-foot, English brown oak executive desk *(bottom)*; single-pedestal conference table and chairs *(right)*, all of English brown oak *(see also p. 132, right)*.

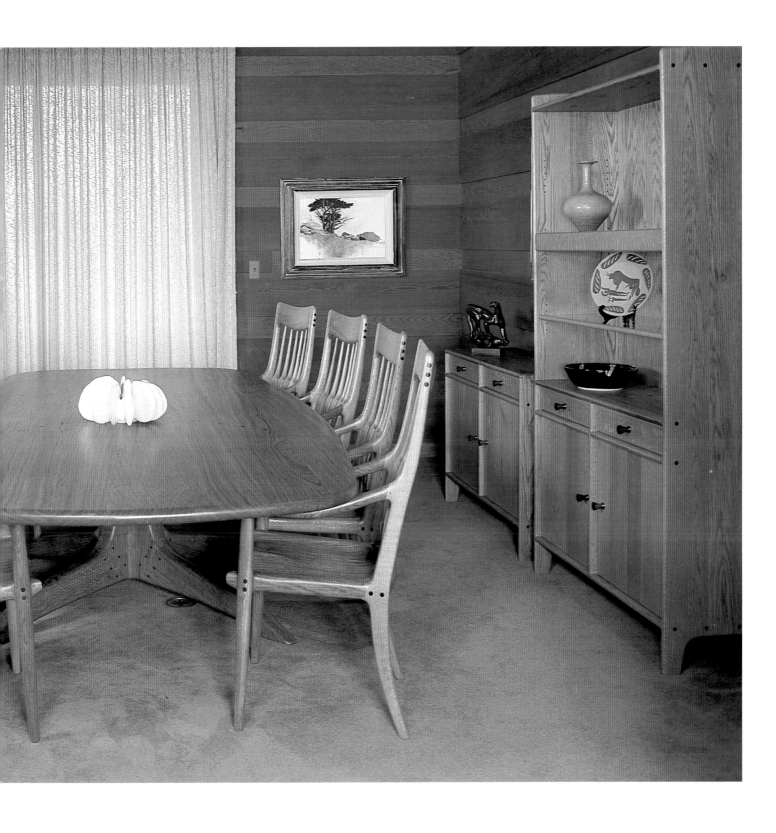

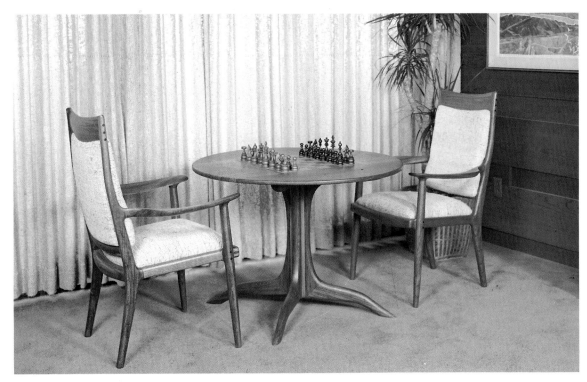

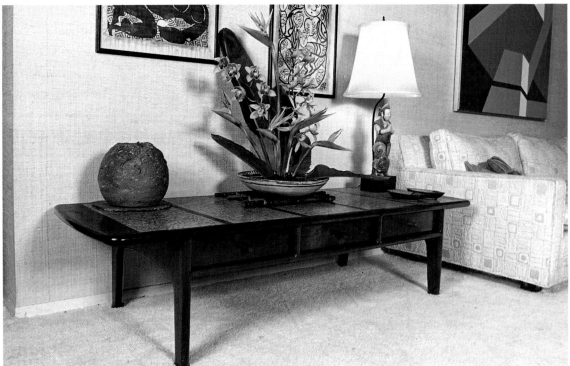

English brown oak pedestal chess table *(top)* with upholstered
brown oak chairs; cork and walnut table with drawers *(bottom)*.

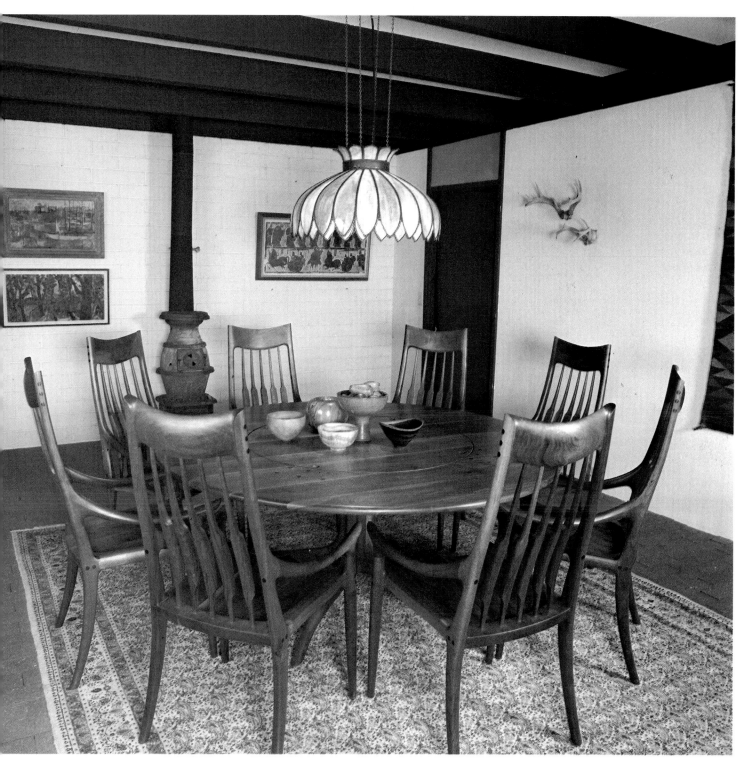

Walnut dining table with lazy susan and spindle-back chairs.

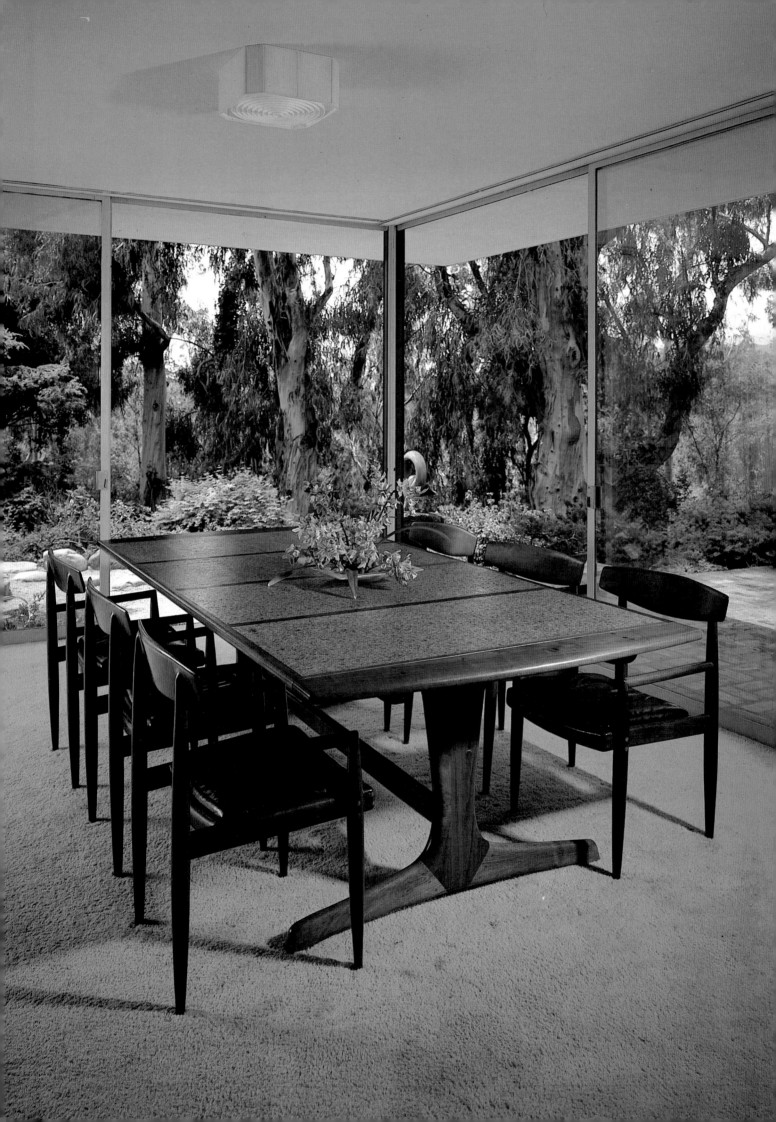

4
"Take A Picture With Your Eyes"

AN ABLE TEACHER can make some-
one aware of what good design is,
can bring a person's talents to
life. Going to school and having a fine instructor helps, of course, but if
a person does not have that inherent quality of vision, then I do not
think that schooling will help him succeed in producing good design.

I was once in the Indian country, driving with my family on an old
dirt road. It was raining, and the car was sliding all over the place. Sud-
denly a group of Navajos came over the hill on horseback. It was just
like a dream or a western movie.

Our son said, "Dad, stop quick. Take a picture," but I dared not
stop for fear of getting stuck in the mud.

Marilou, our little daughter, cried, "Take a picture with your
eyes!"

Sometimes it is hard to know where a design idea comes from.
Years ago we had a horrible rainstorm and flood. The street to the west
of ours was damaged badly. A few days later Freda and I turned the
corner. We stopped in surprise. The storm had washed away the dirt

around a huge eucalyptus stump, leaving all the roots exposed. That eroded tree looked like the base of my pedestal tables. People had often told me that my pedestal tables looked as though they had grown right out of the earth.

How interesting that this happened. I took a couple of finished pedestals without the tabletops and photographed them with those eucalyptus roots. Maybe I had seen something, and my subconscious expressed it in those pedestals. I later did a table that, instead of having four legs, had six. Later still I did a communion table that had eight legs, which looked even more organic than the four-legged ones.

It is difficult for me to explain how I reach the conclusion on how a chair is to be made—the height, the depth, the width, the cant of the seat to the back—I have no formula or answer. I do it all by eye. I do it by feel. I use the measure of my hand rather than a rule. In essence, there is no logic to this. Design is a matter of instinct and feeling, a matter of intuition and inner impulse. It cannot be systematized and rationalized.

When I started making furniture I did not know anything about it, not one thing. I did not subscribe to any magazines. I lived in a very small, provincial town, a farming community. During the Depression the only place you could go was the library or corner drugstore. That was all we had to do.

I had no formal training of any kind, no formal training in any of the arts. I went to work as a graphic artist with no experience. I became a commercial artist, a layout artist. I used to draft letters one-sixteenth of an inch high with a brush. I learned to do architectural drafting. I worked for an industrial designer. I worked for a sculptor. All of these things led me into furniture, though I knew none of the technical details of making it. I just did things the way I thought they ought to be done, and many of the things that I did worked.

With the upholstery, I would figure out what I wanted to do and tell the upholsterer.

He would say, "It can't be done."

And I would answer, "Why don't we try it anyway?"

Then very reluctantly he would do what I asked him. For a long time, however, when he would see me drive up to his shop, he would disappear.

This one small experience taught me to be more adventurous and inventive and creative. Those who are strong enough to detour around what they have been taught in school are the ones who grow.

People have asked me how I go about developing a design. There are three things that I emphasize: eye, hand, and heart. If you do not have that combination, whatever you do is not going to be successful. I see so much furniture that just does not have any heart in it, furniture without a soul.

There are very many fine woodworkers who can take somebody's drawing and interpret it and make a piece. Anybody can learn to use machinery. I think it is best when the person who designs is also the person who makes an object. It is design that is difficult.

The ability to do good design arises from a special quality of vision,

from a special talent; you are either born with it, or you are not. (Of course, a talent may be dormant if it is not used).

Design does not exist just on paper. It pervades every step in the creation of a piece of furniture. For me, the individuality of a table or of a chair begins when I select the wood from which I am going to shape it. It continues to develop as I saw the raw piece, shape and turn the parts, and finally assemble the whole. A chair leg may suddenly look a little heavy or a tabletop a little thick. When they do, I change them.

I have met several woodworkers from Europe. They were very fine craftsmen. They could follow drawings to the smallest detail, but such work was sterile because they followed the drawing mechanically and literally. When they designed on their own, the result was not very good.

A simple object is the most difficult to design and the most difficult to make. Attempts to be "different" result in mere cleverness and have little value. To be original just to be original leads nowhere; the design fails to transcend the woodworker's ego. The object designed to make an impression might survive its first impact, but then it might not. Yet to duplicate past or present work is fruitless: it is quite impossible to improve, for example, on a Chippendale piece.

A designer-craftsman is one who is capable not only of designing an object but of making it as well. I think the reason that so much industrial design is so lifeless is that the person who has designed it has never made a thing in his life. Somebody else even made the prototype.

Drafting-board designers are not capable of conceiving a truly complete design themselves. Part of the final concept of an object comes from the practical solving of the draftsman's problems by an artisan who works directly with materials. It happens too often that a designer is left wondering if what he is seeing for the first time is what he designed. Or he may see something that he wants changed; so he calls for one or two mock-ups, and sometimes many more, before the final result is achieved.

It is difficult to transmit one's ideas to someone else, and this is a point in favor of the individual designer-craftsman. He can make changes as he works. If a piece does not look right, he can correct it. He is designing as he makes the piece; it is his own design, not another person's. He is not designing for a machine, a production, or a mass consumer market but for an individual customer seeking the finest quality of workmanship. The best results occur when the designer is also the craftsman. The two should not be separated. The tasks share equal responsibility.

For me it is not enough to be a designer only. I like the challenge of designing and making each piece: the drawing, the layout on wood, the joinery, the forming, the sanding, and the finishing. I am totally involved. I want to be able to work as I please, to change a piece of wood into an object that contributes something beautiful and useful to life. To work for myself gives me a feeling of satisfaction and contentment. Some have called this feeling a therapeutic or emotional outlet, self-centered snobbishness. This criticism notwithstanding, to be able to work

as we please is a God-given privilege. I personally hope that this feeling is transmitted to those who use the objects that I have designed and made.

When I started, I designed pretty much the way I do now. Over the years, I have refined my pieces. Each time that I do a piece that I have done in the past, I think that I have improved it. This is true even when I use a template, which I do on some of my work in order to get proportions. I usually make a rough sketch, cut out a template, then trace it on a piece of paper to see what the piece will look like on both sides. But this does not determine what the finished piece will look like because, after the piece is put together, I will take a little off here and a little off there until it is pleasing to my eye.

When I first started, I would make a sketch. I would make a small model, then a full-scale model, and then I would make the finished piece. I discovered that this resulted in a lot of wasted time; so I eliminated, first, the model, then, the full-scale prototype, and finally, the small drawings, except in the case of customers with whom I had only contact by mail. In those cases, with new pieces I would send the customers drawings and explain what I was making. This saved much time.

Once I make a prototype, I see many things I want to change. I do not make another prototype; I just make the changes in the piece as I work. Perhaps I can do this designing as I work because I have made so many pieces.

People ask me why I do not go off on a tangent and work in different directions. My answer is that I have not really perfected what I am doing now. I do not think I ever will. Every commission I receive remains a challenge.

A person only has so many things that he can make. Just imagine if you had a thousand customers and each one of them wanted a different chair. You would have to start putting curlicues on them just to make them different. I do not think you have to change just for the sake of change. If the piece is good, it's good. Ten different chairs can evolve from one design.

I have a wealth of ideas stashed away in my head. I see hundreds of pieces that I would like to make, and no matter how busy I may be with work that must be done, I do take time to do three or four new pieces a year. It gives me an opportunity to renew my energy and thoughts: at times it does get rather monotonous making a set of twelve chairs (though in the end each has its own personality).

The American Craft Museum in New York was planning an exhibition entitled "The Bed" (1966). Paul Smith, director of the museum, asked me to design a bed or something related to the idea of beds for the exhibition. I agreed. My daughter-in-law, Kathryn, was about to have a baby; so I thought it would be fun to make a cradle. It would have met the challenge of the exhibition—a cradle is a bed—and it also would have been something I had made for my grandchild to use.

One idea begets another. Most cradles are so low that mothers almost break their backs laying the baby down and picking the baby up.

Why not bring the cradle up to the mother? I started with that. Then I thought, why not enclose the cradle in a cabinet, with storage space for blankets above? This is the way my cradle hutch was conceived. I try to make each of my pieces beautiful and pleasing; yet no matter how well designed and crafted, I want each piece to be useful. Each time a person sits in one of my chairs, eats at one of my tables, or opens one of my cabinets, I want him to feel that particular piece was made especially for him to use. Knowing this, there is enjoyment for both of us: maker and user.

Museums and galleries often look for objects that are "different." Different things—unique or oddball things—get a lot of publicity, in newspapers especially. Chairs of this sort dare you to sit on them. I once tried a rocking chair in a New York museum and slid right out of it. I commented on this to the museum director, who chastened me, "Oh, Sam, you're not supposed to sit on it. It's just to look at."

To make something to suit yourself alone is simple. To make furniture to fit a cerain area, to perform certain functions challenges your ingenuity, your creativity, and your skill. It brings you up against yourself and taxes your capabilities. Such tests are important.

I think a real challenge, one that emphasizes the relationship between design and function, occurs when a client commissions a large amount of furniture to fit into a limited space and accommodate more people than is reasonable.

In high school, I remember, the advanced students in architectural drawing were given a project. We were to design a house with floor plan and elevations. I thought the house I designed was terrific.

The instructor said, "You could never build this house."

"Why?" I asked.

"It would cost a fortune," he said.

Then I could see: cost had been of no concern to me.

He said, "An architect should be able to design a house that can be built for a certain sum. This is the real challenge: to design a house and then build it within that budget."

It is the same with furniture. I think a lot of craftsmen today are being very extravagant, both in the types of furniture they are making and in their wasteful use of materials.

People in general and young people in particular maintain romantic notions about craftsmen and individualism. Yet today, with the increasing number of people making objects by hand, I am afraid that a lot of them are turning toward production, conformity, and sameness. They fall into the same old trap. You go to a crafts exhibition, and somebody has done something very successfully. At the next crafts fair you have four or five imitators. Instead of going in their own directions, people seem to come back to the ways of conformity.

I have been asked many times if it bothers me when I see pieces that resemble mine. This reminds me of an anecdote about Hamada, the Japanese potter. When someone asked Hamada if imitations of his work bothered him, he replied, "When I'm dead, people will think that all of my bad things were made by the other potter, and they will think that all of his good things were made by me." Maybe this is the way one should look at it.

Nearly every mass-produced article used in our homes today, regardless of material, was originally handmade by a craftsman, in many cases from the drawings of a designer or staff of designers. That craftsman knew not only how to interpret drawings but also how to use his tools and the material involved to accomplish what the designer had in mind. We marvel at the wonders of the machine, but nothing has been designed or made as wonderful as the hands of man. The machine has no human factors. What it produces has none of the elements of surprise or feeling that an object made by hand may have. It leaves no room for change.

I have had several opportunities to design for production, but I chose the way I want to go. You might say that I have been quite adamant about my methods and my convictions. Many years ago a big furniture manufacturer saw three pieces of my furniture at an exhibition and offered to license and reproduce them. I still have the company's letter. As I recall, it said they would make cuttings of a million of each of the pieces and pay me 5 percent of the gross. The pieces would have to be changed a bit, the letter continued, because of the machinery involved. I replied that, if they made changes, I would want to have final approval. If I no longer felt they represented my work, I would not want my name used. They wrote back that I was getting a little fussy and withdrew their offer. That was fine with me. Looking back on it now, if they had made three million pieces and sold them all at $150 apiece, that 5 percent would have accrued more than $22 million, but my career would have been over.

I have never regretted that I did not go into commercial production. Years later another big company was interested in my pieces, but that deal also failed to go through. I really did not push it. I was no longer interested.

In manufactured items, someone comes out with a good design, and the next year everybody copies it. That is another reason I never succumbed to designing for production.

I have been called selfish (in a friendly way) because I do not produce more. It has been said that only the affluent can buy my work and that, if I had people working for me, people whom I supervised, thus increasing my production, I could lower my prices, and more people could enjoy my furniture. I just do not see it that way because a lot of people who are not affluent have my furniture.

There are woodworkers whose employees make their pieces from start to finish. Other woodworkers have parts manufactured and assemble them in their own shops. I cannot do that. I will not do it. Every piece that goes out of my shop, I have made.

No, my workshop will remain a small operation. If I were to run my business as a large production shop—by *large* I mean several employees—this would destroy what I have done since the beginning. It is difficult not to be lured by royalties for pieces that one has designed, and yet I do have standards, I do have beliefs, and I do have integrity that guides me.

Henry Dreyfuss was concerned about me. After we had become good friends, he wondered what would happen to my family if I were

incapacitated, since I was their only source of income. He took it upon himself to write to about eight of the finest manufacturers of furniture in the United States. In each case, I received a letter from the president asking me to send photographs of my work. In each case I wrote, thanked them for their interest in my work, and stated that I was not interested. Later Henry asked me what had happened, and I told him. He laughed and said, "That's what I thought you would do."

This kindness was typical. He always talked to me about designing for production so the royalties would be coming in. Then he would have second thoughts and say, "I should never have asked you, because I'd be doing what you're doing if I could."

Of course, if I cannot work, then everything stops. This is the only drawback, but you accept this. Fortunately, I have never been in a situation where I was not able to work.

I think there is enough ego in all of us so that we like to have people recognize what we do. It would be rather difficult for a person who works with his hands—a sculptor, a painter, a jeweler, a woodworker—to produce and produce and produce and never sell anything. Craftsmen are human after all. When our work makes someone else happy, it is given more meaning. A little recognition gives us motivation and satisfaction.

I remember many years ago returning from the post office and handing my wife the mail.

"Anything good?" she asked.

"A rejection notice," I replied, feeling sorry for myself.

Her answer was, "Sam, sometimes it is good for the ego to be rejected."

How very true: we must take inventory of our priorities quite often.

Among the many visits to the house and shop, one particularly surprised me. I received a phone call: two people wanted to come see me right away. I replied that it would be better if they came in the evening.

"Where are you from?" I asked.

"From Hawaii," they replied.

I asked them to come have dinner with us, but they stated that they had to return that night.

"All right. Come have lunch with us," I said.

So, pretty soon the two fellows from Hawaii arrived, bringing pineapples, mangoes, and papayas. I thought it was nice of them to do that.

In the conversation during lunch, I asked them how long they had been here. They said that they had just arrived that morning.

"What brought you?" I asked.

"We're on a pilgrimage," they answered.

"Where to?"

They replied, "Right here."

Though embarrassed, I thought, "How very kind of them to feel this way about my work." Even today I am nourished and honored by that event.

Since then I have made several pieces for Paul Ho (one of my two Hawaiian "pilgrims"). Come to think of it, he has a desk ordered that I should get started on.

This kind of recognition—any kind of recognition—puts responsibility on the receiver as well. I get a lot of letters from customers, woodworkers, and other people who like my furniture. If people have taken the time to write me, then it is my responsibility to acknowledge that recognition. I am not a writer—my hand cramps after five letters—but I try to answer each letter soon after receiving it. People are important to me.

It is not surprising that young people look forward to recognition. But when young people come to my shop, I often ask, "Just what are you seeking? Why are you doing this?"

The first thing many of them say is, "I want to be recognized."

Then I reply, "Do you have a portfolio?"

Maybe they have made one or two pieces. I think their priorities are a little mixed up.

Young people are impatient to absorb and learn. How difficult it is for them to understand that it takes many years to absorb what there is to know. One never stops learning. Each day brings something new.

I find it rather difficult to impress upon apprentices that, even though I can teach them everything I know technically about tools and about how to put pieces together, I cannot teach design.

How does a young craftsman come to this quality of vision? One important route is through looking at and being open to so many things that are available to us. Museums and galleries provide one source of such experiences, but there are beautiful things all around us. It is the way of looking that is important.

I think a serious young woodworker can learn much more working in a production shop than anywhere else. There are some schools where the instructor has had practical experience, owning a shop of his own, working full time as a professional. At these schools the students can absorb some of instructor's experiences. But too often schools hire recent graduates to be instructors. This is a very negative situation not only for the school but for the students as well and even for the instructor. In conversation among craftsmen and teachers many years ago at the "Role of Crafts in Education" symposium, held at Niagara Falls, the consensus was that a school should not hire anyone in the crafts field who had not had at least five years practical working experience outside the educational system. I think this is a sound idea, but unfortunately it is not widely practiced.

When I am asked advice about woodworking schools, I usually say to a young person, "Tuition is going to cost you about four thousand dollars a year or more, plus your room and board. It's going to be a two- or three-year course. Can you afford it?"

My advice is, "Use the four thousand dollars to buy equipment and learn by trial and error."

Many years ago I spoke at Purdue University, and a young fellow said to me, "Sam, you're not a purist."

"What do you mean?" I asked.

"You use power tools," he said.

I laughed. "Well, if you are going to make a living, you are surely going to have to produce. You are going to have to sell those pieces if you are going to eat. I just don't think that I can produce enough to take care of my family working with hand tools alone."

Even so, in the beginning, I did use hand tools, and I was able to produce. Now, of course, I use power tools: I have a very complete shop. Yet by the time I get through doing all the shaping, the sanding, the joinery, and all of the finishing, without hesitation I would say that 80 percent of the time it takes to produce a piece involves handwork.

Another young man, with whom I corresponded, wrote me that he used only hand tools, and antique hand tools at that. One day I received a letter from him saying that he had found that he simply had to purchase a few power tools, and now his production was up to where he could make a meager living.

In addition to recognition and romanticism, the young are hung up on material security. I think we are so submerged in our way of living, our material approach, that we forget that there is more to life than that.

For me making a good piece of furniture is very satisfying. When I sell it, it gives satisfaction to the buyer too, and that is a bonus. It is the same with painting or playwriting. The joy is in creation and later in giving pleasure to others. (But too often we forget the spiritual side of life.)

A lot of craftsmen today—not all—are more interested in what they are paid than in what they create. I have never given undue consideration to the size of my income; of course, I have to support myself and my family. If my pieces had not sold, I probably would have had to change directions, but fortunately that was not necessary.

I love wood, or I would not be working with it. Nevertheless, I do not build up a mystique about it. A craftsman must respect his material. Out of this respect comes a fusion that allows the creation of an object, the making of which brings a satisfaction and contentment that few people ever experience. How much more meaningful it becomes if one wears a bit of humility that allows him to acknowledge that it is truly God who is the Master Craftsman. He uses us. Our hands are His instruments.

I have been asked many times how I feel about my work: Does it bother me that, after "putting so much of myself into a piece," I have to let it go? My answer always is that I have received much joy in the making, now someone else will get joy in the using. In this way I am paid twice.

Emerson wrote, "I look on the man as happy who, when there is a question of success, looks into his work for a reply."

The smell of wood in my shop is more pleasing than a desk in an office. For me and my family the assets of working as we do outweigh the liabilities that others may think might overpower the designer-craftsman who does not conform with the crowd. The potential income from designing for industry is less significant than the contentment we derive from working and living our way.

5
At Home

ANY PEOPLE, when they see that I work and live in the middle of a seven-acre lemon grove, express surprise. Sometimes I have the feeling they think it is a fairy-tale kind of existence: the honest craftsman and his family living happily in a secluded, charming environment. But it has taken me thirty-five years of hard work to establish not only my reputation but my home, my physical surroundings.

When I first started in woodworking, Freda and I lived in a tract house in Ontario, California; my workshop was in a single-car garage for about four years. All that time I kept talking about moving out to the country. Finally, in 1951, Freda said, "Why don't we do it? I'm tired of hearing you talk about it."

I looked in the paper that evening and found two acres with a house for sale in the foothills below Mount Baldy. I went out to look at it and thought, "Oh, boy, what a disaster!" Its redeeming features were a lovely avocado tree and a little dingbat shack that was livable. The owner wanted an awful lot: ninety-five hundred dollars, which I did not

have, and five thousand dollars down. He would not trade equity either. Naturally I thought that was the end of it.

Then, about three months later, he called and asked if we would trade equity after all. We gave him what equity we had in our tract house, and we traded properties. My artist friend, Phil Dike, helped by lending us the remainder of the down payment, telling us to pay him whenever we could.

People exclaim that we were lucky to get our place for so little, but ninety-five hundred dollars was a lot of money in 1951. Later we bought the rest of our property for one hundred dollars a month at 5 percent interest from an old fellow next door, who had become a very good friend of ours.

When we moved to the property, I did all my work in a chicken coop that was there. The floor of the coop was dirt, and its roof was so low I had to bend over in order not to bump my head. I worked in that coop for two years, and then I poured a concrete slab for the site of a future shop and worked on it, without walls and roof, moving my things back into the coop at night for protection.

One day an eighty-five-year-old contractor friend called and said, "Sam, you just can't work outside that way. You've got to have a shop. Buy some lumber, and I'll come over and put it up for you free of charge."

I called the lumberyard and explained the situation, and they gave me the lumber, saying I could pay them whenever I was able. My friend, our minister, Pastor O. B. Devine, another young preacher, and I put the studs up over the concrete slab and put on a tin roof. Over the years I put the siding on. The saga of the workshop is not glamorous; it just evolved. The first part we built is twenty by forty feet. An addition is twenty by twenty-four, and a later addition, twenty-four by twenty.

Originally I was going to fix up the little shack of a house, but even though Freda had it looking very nice, it was in such a state of disrepair that we decided to build a new house. I poured the slab for it in 1954, and in 1956 I built what became the first part of "the house that grew." That first part had one large room that was a bedroom, kitchen, and dining room combined, a little bath, and two bedrooms for the children. Our house has since grown from that beginning. I always point out that if I had not built our house myself, we would never have been able to afford it.

The house just evolved naturally over the years: I converted the carport into a living room, then transformed this to that and that to this, and kept adding on. I would buy a few two-by-fours at a time, and after enough had been accumulated to add another room, I would start to build.

I am not an architect, I certainly would not call myself a house designer, but the house does not look like a patched-up job. It does not have a front, back, or sides because I have always felt a house should be a monolith: it should look handsome regardless of the angle from which you approach it. Sometimes we have people walking around trying to find the front door. I do not use drawings when I am adding onto the house. I just hold up a two-by-four and think, "That looks pretty

good," and then nail it up. I do it all by eye. In fact, sometimes when putting a post up, I sight everything on the door jambs, just assuming they are straight. My rationalization is that doing it my way gives the house a little character.

I have gotten permits for all the building and additions. The first time I got a permit was pretty funny. I was going to build a little guesthouse; so I drew some really nice plans and presented them.

The young inspector who came out just shook his head and said you have to do this and you have to do that.

"Jeepers," I said, "I'm building this for myself. It's going to be built better than any contractor would build it."

Then he became interested in my furniture. He got kind of excited about it. I guess he figured, if I could build furniture that way, I could build a house that way too.

Another time, when I was building Freda's studio, an inspector came out to do an environmental impact report. I started off badly with him because, as he walked into the house, he lit up a cigarette, and I told him I would appreciate his not smoking in the house. Unfortunately, he was miffed, but once inside the house, he said, "This is handmade furniture. Who made it?"

He too became quite interested in the furniture and the house. He approved the permit but never came around to see the completed studio. Naively I thought that, since they had not come around for the final inspection, it would not be on the tax rolls. But, needless to say, it was.

I do not have the time to build the house the way I build a piece of furniture. I do fantasize about building a small, perfect house where all the woodwork is beautifully shaped. I have managed to add little touches to our house, for instance, by putting wooden hinges and latches on every door, each one different. For the structure I use mainly redwood with little areas of drywall, which makes a beautiful setting for some of our things. The floors are red brick. The overall effect is warm and comfortable.

I have tried to do some things that help us live more easily. Freda wanted all of her counters in the kitchen about six inches higher than normal so that she would not have to bend over when cooking or chopping. People are surprised how much more comfortable they are than the ones of standard height. Where that standard came from I do not know; they are uncomfortable for most people, but builders go on building them.

Having my wife here with me is important to me. The closeness of my whole family is important to me. My son, Slimen, lives next door, and my daughter, Marilou, lives in the neighborhood. I like having my family about me. My son, my daughter-in-law, my daughter, the grandchildren are a way of life for me.

I have been fortunate to have some of my grandchildren growing up right next door; they are in my shop nearly every day. Sometimes they help me, and sometimes I have to shoo them out. The cradle hutch that was included in the American Craft Museum's exhibition "The Bed" was the one I made for our oldest grandchild. It is now part of the museum's permanent collection. My wife was very upset that I had sold

the cradle our first grandchild slept in. I promised her that I would talk to Paul Smith, the museum's director, with the idea of making another one and exchanging it for the original. Sometimes the craftsman, his family, and what he makes get fairly intertwined.

Some of the additions to our house have been dictated by outside forces. For years the threat of a freeway that would go right through the property has been bandied about. Consequently I have changed some of my plans because I figured, if the freeway should go through, why spend so much time and money on the house? About three additions back, I decided not to build a big thirty-five-by-eighteen-foot room and instead built a smaller room. The smaller room is looser and more festive, a little more sophisticated. That freeway threat affected me by unleashing a desire to be creative in a lighter way.

One day my grandson Aaron, who was eight years old at the time, came to me very concerned and said, "Boppa, are we going to move?"

He had heard his father talking to someone about the freeway, and that person had asked if the freeway was "going to get us." I told Aaron that the freeway would not be coming through for a long time, maybe ten or twenty years, and that he should not worry about it because it was so far off in the future.

He said, "It isn't a long time for me. If we have to move, Boppa, are we all going to live together again?"

I said, "Sure, we'll build a house for all of us."

Aaron's question made me wonder if our sense of security is false, but I finally realized the children would bounce back easily if we were separated. On the other hand, Freda and I would probably suffer gravely. It is unsettling to find that what we think is a secure life may in fact be an illusion. Freda and I have been deeply grateful and happy that our grandchildren have been able to share our lives; it seems to us to be the best way of life the world has to offer.

My home, my shop, and my family are very important to me, both on a personal level and as an environment for work. I have often wondered what I would do if I had to drive to work in an industrial area. Would I be turning out the type of thing I do now? When I drive into Los Angeles, I am completely exhausted by the time I return home, but I can work in my shop until midnight, and it does not bother me a bit. I guess that answers my question.

Frank Lloyd Wright said, "What you do is, you buy a little Nash Metropolitan, and you fill it full of gas and head out away from the city in the direction you want to go. Wherever the Metropolitan runs out of gas is where you build your house."

Unfortunately, today suburbanization has spread everywhere. Alta Loma was a town of one thousand when we moved here in 1953, and today the population is nearly sixty thousand. Luckily our property is secluded from the shopping malls and the neon lights so that we can imagine we are still in the country, but the rapid growth of this area means nearly everybody is a stranger. I used to be able to go down to the post office for the mail, and maybe six or seven of us would stop and talk a bit. Now there is often a line clear out the door, and nobody knows anybody else. I still try to stay involved in the community to a

degree, however, and certainly this issue of the freeway is high on my list of concerns.

Needless to say, a craftsman's world is no different from that of other people. He or she has a role in a community—a city, town, or whatever—and also a circle of friends that probably extends far beyond the immediate community. Though the house and shop are cut off from the new Alta Loma, I do not cut myself completely off. I have appeared at city council meetings, and I am very vocal about some of the things that have happened. It would be easier to deal with things in a smaller community, and if I were younger, I would love to participate more. But, then, I am involved in the American Craft Council; I just cannot spread myself too thin. I feel that if a position of responsibility cannot be filled the way I think it ought to be, then it is better not to attempt it at all.

The areas now eaten up by shopping malls and housing complexes used to be citrus groves. Our lemon grove is one of the few working groves left. I knew we would never make a living from it, but I never thought I would have to pay for the privilege of having it either. It is a very productive grove, but somehow the economy is such that it is nearly impossible to realize a profit from small citrus groves. Last year we picked twenty-five hundred field boxes of lemons. Not counting what I had to pay out for watering, disking, furrowing, and pruning, I wound up having to pay seventy-five dollars to the packing house to pick the fruit. It is evident, however, that I would rather take a loss and live in the middle of a lemon grove than in the middle of an empty field.

We have also planted orange trees, avocado, apricot, and plum trees. Freda and our daughter-in-law, Kathryn, do the vegetable gardening. Freda also does most of the gardening around our house. For relaxation I get out and water and do some of the planting, which I consider to be two of the bonuses I receive from having my shop adjoin the house.

Working on the house really is another wonderful form of relaxation for me—sometimes to Freda's chagrin since the house is never "finished." Recently I have been thinking of getting hold of a big eight-by-twelve- or eight-by-fourteen-foot beam and running it across one of the beams in the kitchen and dining room area, which has sagged a bit. I have some wonderful eucalyptus posts for the yoke. I am also thinking of cutting a door in the second-story gallery and running a large deck outside. Occasionally I even think I would like to build the whole house over, but it is only a thought. These kinds of things are an extension of my woodworking.

Some people might find having a shop adjacent to the house too distracting. I think it is a matter of discipline. Also having a supportive spouse is extremely important, especially if your shop is in your home. I think my work and my living environment are inseparable. There is no question of distraction. Of course, it would be easy to linger over breakfast or lunch, to come in and sit and read, or to putter about the house. It takes discipline, but I do not think I could work any other way. It is, as a whole, a way of life—my way of life.

One of the benefits of the kind of work I do and the way I do it is that, if someone comes to see me, I can just drop everything and visit. I

am never too busy to share my time. Often I go right on working, though I never use power tools when people are around. I shape or sand usually. Two or three thousand people from all parts of North America and distant countries too visit us each year. Sometimes I wonder how I get any work done, but I manage. Most people are interested in what I do, which still surprises me.

Visitors often comment on our collection of art objects. Freda and I both feel that life is too short to live without things that are pleasing. Life without beauty would be very dull. Nevertheless, neither of us has acquired for the sake of acquiring. I remember somebody saying that collections are not owned; we are simply caretakers of them during our lifetimes.

Visitors also comment that our collecting impulses seem very broad, not narrowly focused as is often the case with artists or other craftsmen. I think this is because we have not consciously collected. Many of the objects we have are things I have traded other craftsmen for. Many of our Indian pieces have been given to us by our Indian friends. We have Indian rugs and oriental rugs, Indian pots and modern pots, modern woven pieces, paintings, and carousel horses. Freda says I have all the fun of buying things, and she has to figure out how to pay for them. Yet there are many things we are conservative about with regard to our wants. I am Spartan in some ways and a spendthrift in others.

Friends have admired the way we display our things. They say, "I wish you would arrange something like that for me."

I reply, "That isn't arranged. I just put those things there."

I have a friend who hired an interior decorator to place her collection of religious artifacts in a cabinet that I had made. I asked her what she did when she dusted, and she said she had photographs she went by to make sure the objects were put back exactly in the same positions. She has a good sense of design, and I am sure that if she just relaxed about it she could do better on her own.

I stay away from designing interiors because it is completely out of my sphere. Some decorators whom I have recommended to customers go crazy because they end up spending hours with the customer selecting just one fabric. It is a very time-consuming thing. It is a pity that many people do not trust their own judgment.

I have been surprised when some people have wondered if the way I live does not give the impression that material comfort for craftsmen comes easily and quickly. Young craftsmen have to understand that I have been working hard for thirty-five years. Many young people expect success overnight. They are impatient. They think that all you do is buy some tools and make some furniture, and people break down your door wanting to purchase it. Certainly meteoric careers do occur. Some young craftsmen do make things that are shown in big exhibitions, and they get lots of publicity. Then the attention dies just as suddenly, and they wonder what happened.

During the many years when we did not know from week to week whether we were going to have enough money to make the house payments, I was always aware that even if we were broke, I had the happiness of being able to produce work with my hands. It was and continues

to be a rich satisfaction: to be able to work with my hands makes me the man that I am.

I hope that my happiness with what I do is reflected in my furniture. Furniture, any furniture, tells a story, the story of the person who made it. I do not try consciously to make my pieces reflect their maker, but I hope that my furniture is an outgoing part of my personality and my way of thinking. I hope that it is vibrant, alive, and friendly to the people who use it. Some furniture that is beautifully made can be cold and soulless. There are a lot of beautifully done chairs that dare you to sit in them. I repeat over and over that I want my chairs to invite a person to sit. I want my chairs to embrace that person, to give comfort. No matter how beautiful a chair is, if it is not comfortable, it is not a good chair.

My environment is a wonderful one, but again, it is something that was created by hand. The making of it is even more satisfying than sitting back and enjoying the finished product. I am also keenly aware that my wife, my family were an integral part of it. The whole thing—the house, the grounds, the workshop—is to me a reflection of how Freda and I feel about life and living. I hope it spells out joy to others.

Latch for front gate made of redwood.

Looking north across our lemon grove to Cucamonga Peak *(top, left)*; my roadway sign *(top, right)*; front gate made of redwood *(bottom, left)*; outside on the south patio *(bottom, right)*; looking south from gallery doors, opened flat against glass walls *(opposite)*.

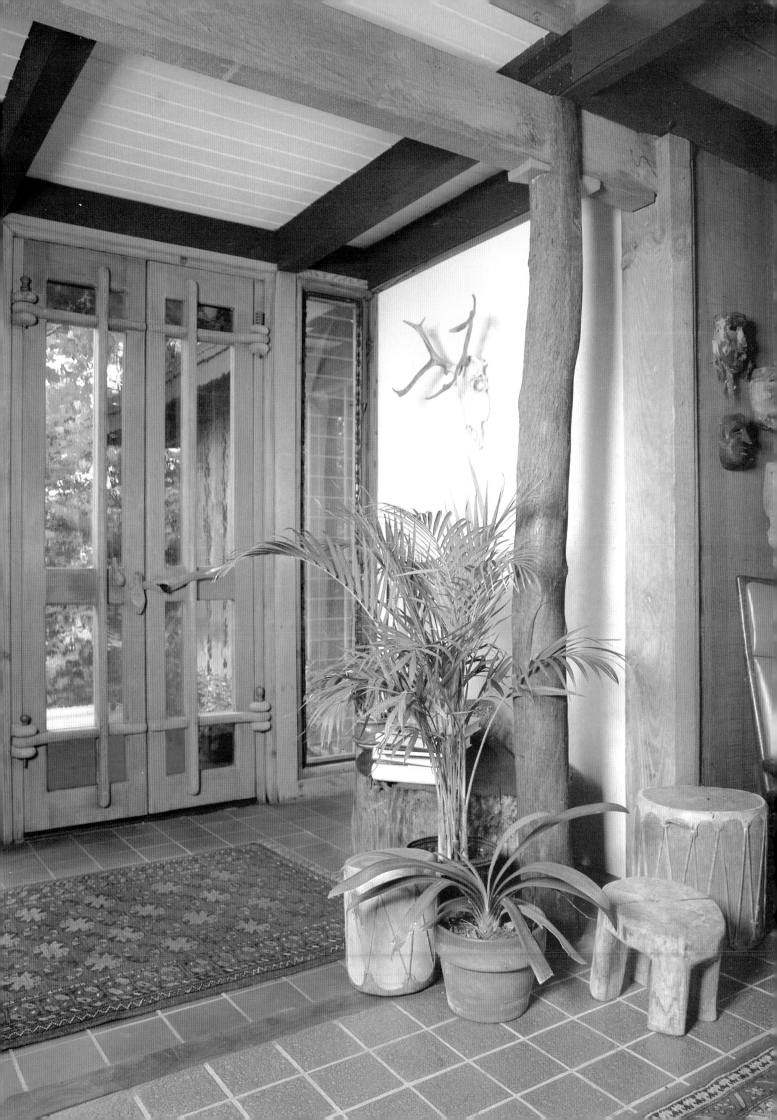

Looking along north side of house from front-door entry *(top)* my brother, Jack, and I did all of the rock work. The olive tree was a pencil-sized twig when we planted it. Our nephew Nasiff, Freda, and I at dinner *(bottom)*. Kitchen from breakfast area: hanging plants are suspended from pulleys for easy watering *(right)*. Small dining area *(opposite)*: the chairs and square, rounded pedestal table have been used since 1950.

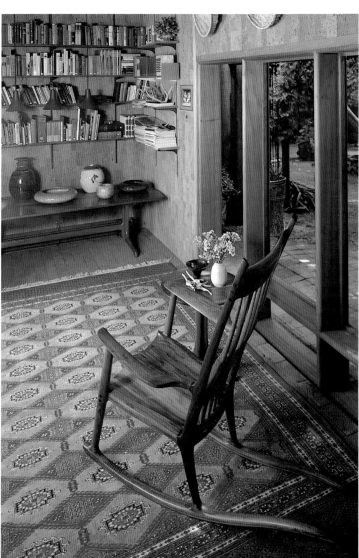

Freda and I relaxing on a sofa I made in 1950 *(bottom)*; lunchtime
(top); Freda's rocking chair and small (twenty-inch diameter) ped-
estal table *(right)*; dining area *(opposite)*: drop-leaf table with three-
place bench and cabinet hutch *(in background)* with wood-hinged
writing surface.

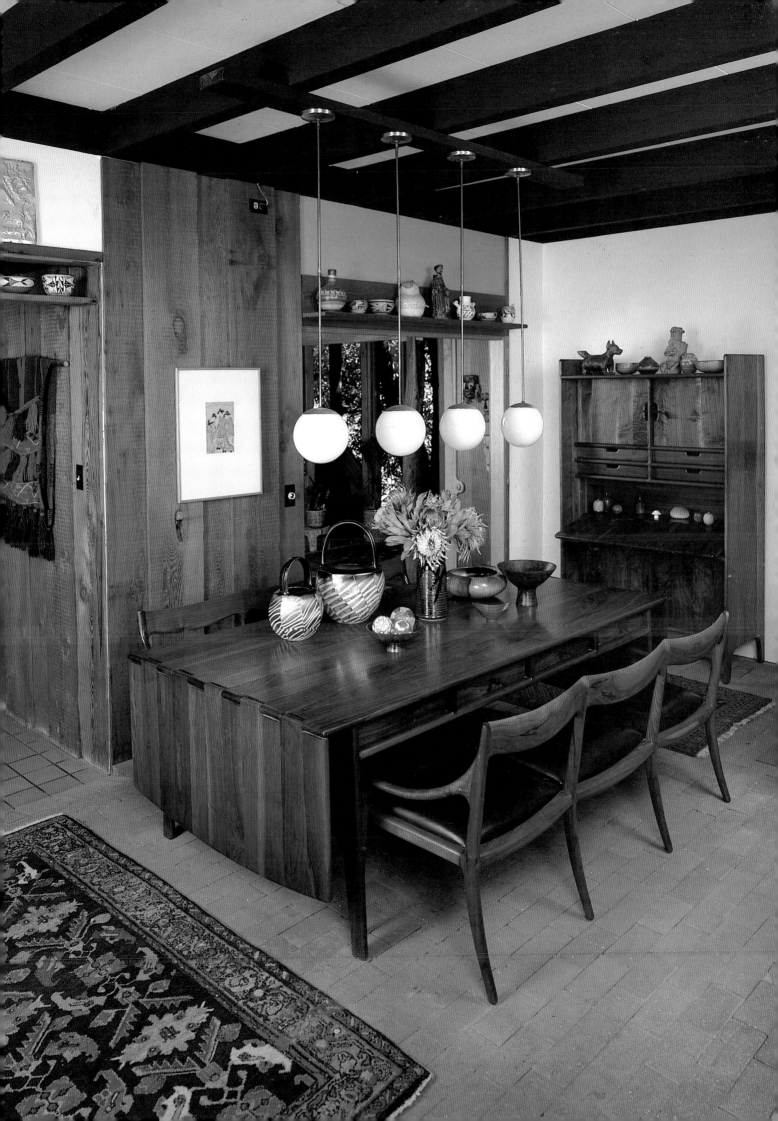

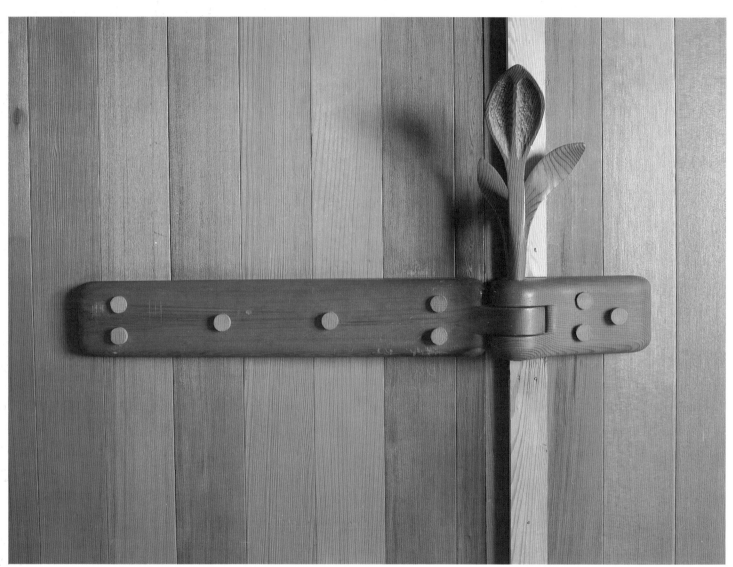

Fleur-de-lis latch between master bedroom and Freda's studio
(above). Making latches is a great deal of fun for me. Each door in
our home has a different kind. Lower and upper galleries from
south side of house *(opposite)*: doors open inward on wooden hinges.

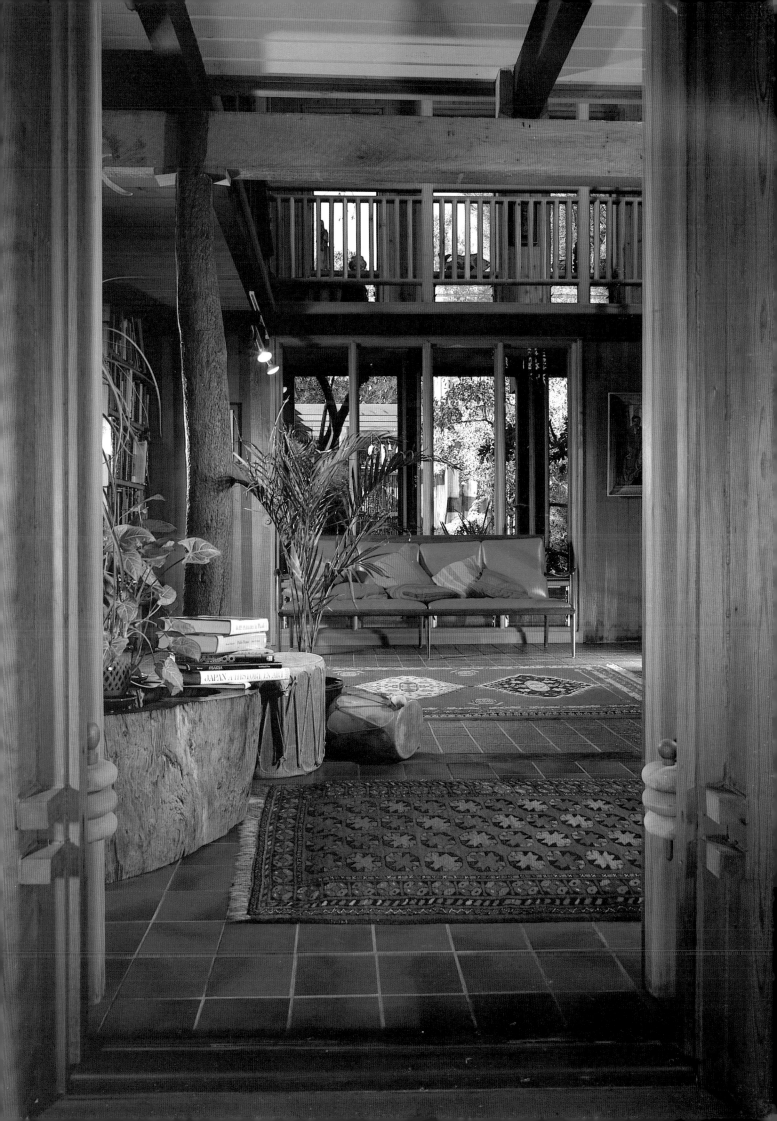

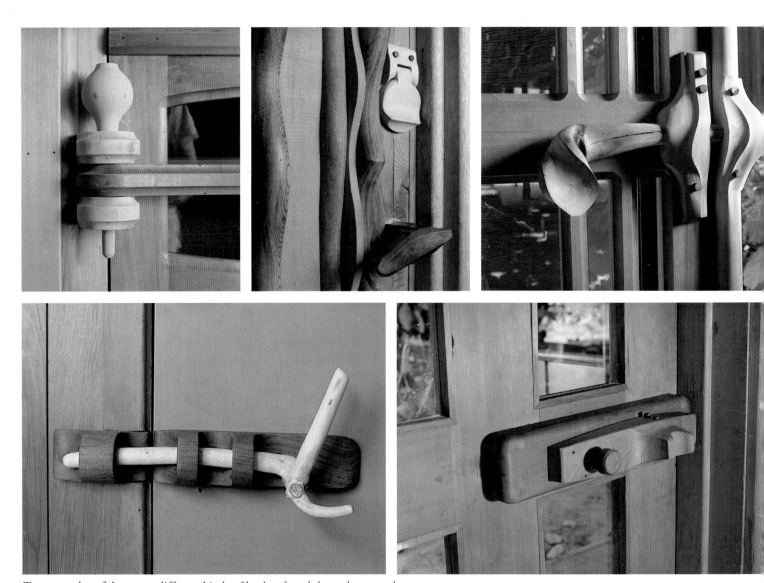

Ten examples of the many different kinds of latches found throughout our home.

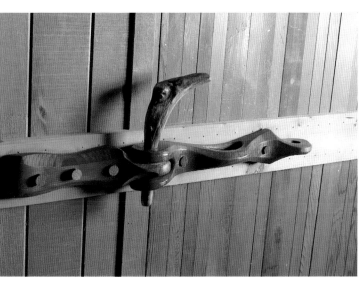

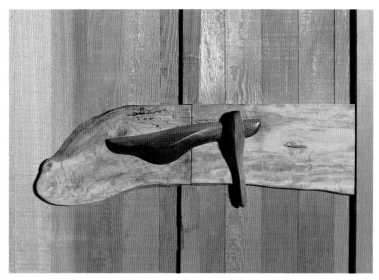

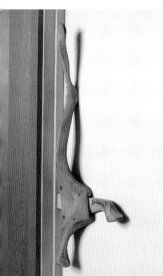

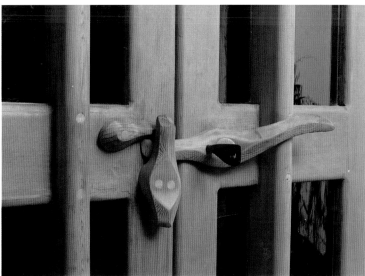

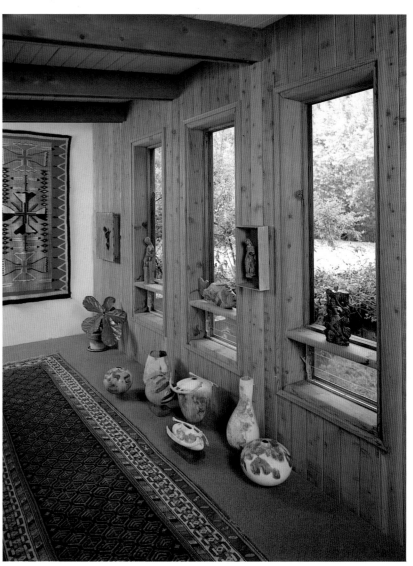

The piano room *(top)*: two walnut rockers and a brown oak rocker; paintings by Jack Zajac, Robert Frame, and Millard Sheets. All the brick floors were laid by my nephew Nasiff and me. Mexican folk art figures: "The Wedding" *(bottom)*. Gallery *(right)*: Navajo blankets on the walls, oriental rugs on the floor. Rick Dillingham made the pots. Lower floor of gallery *(opposite)*: we heat our home with wood stoves. The pottery is Acoma, Zuni, Zia, and Santo Domingo.

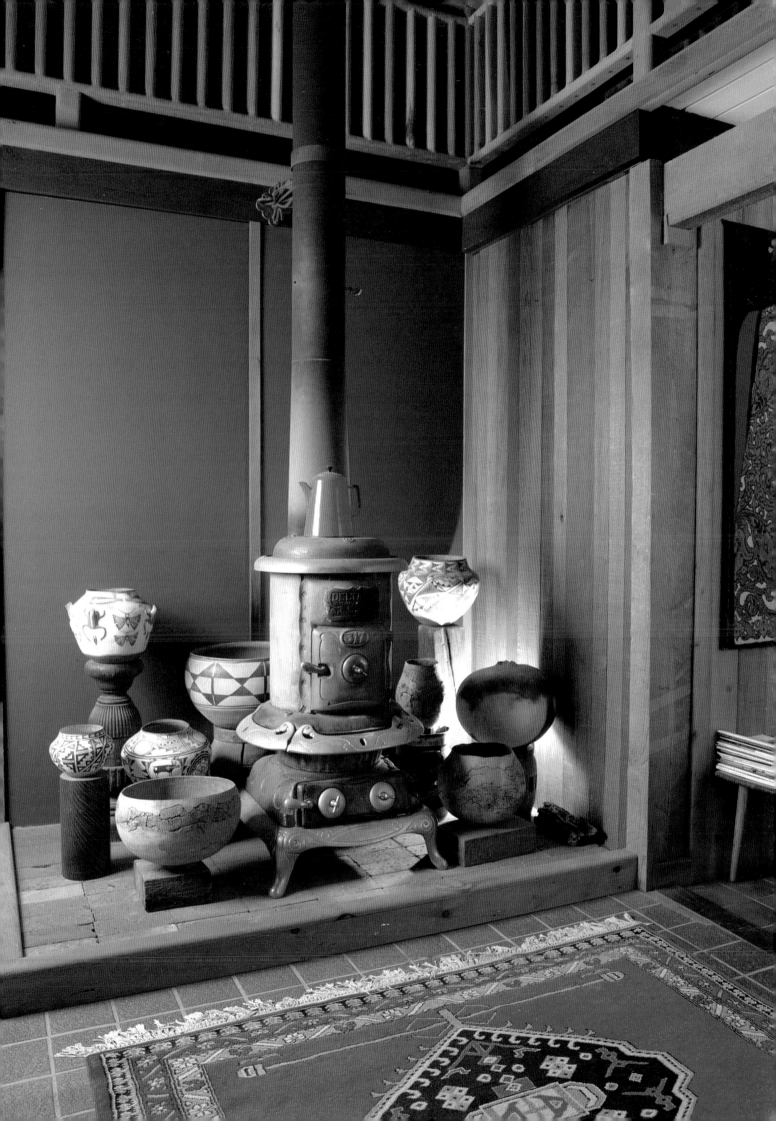

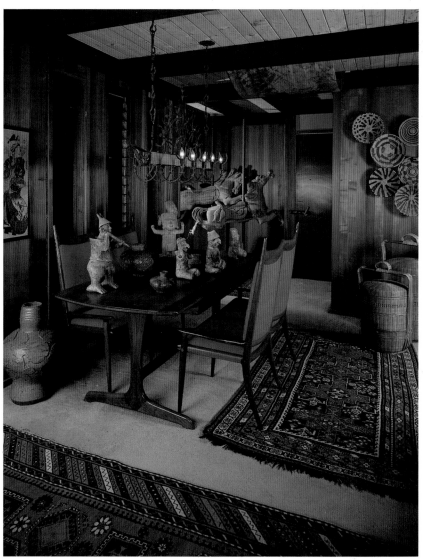

Pair of Parker Carousel horses *(top)*, stripped of paint; natural finish. Part of our collection of pre-Columbian figures and pottery *(below)*. Small dining table with four drawers and settee *(right)*. Wrought iron light fixture made by Carl Jennings hangs above more pre-Columbian figures. On the floor are Chinese wedding baskets, and on the walls are African baskets. I got carried away designing our bedroom *(opposite)*; it measures twenty by thirty-six feet. We traded the Navajo blanket for half a chair.

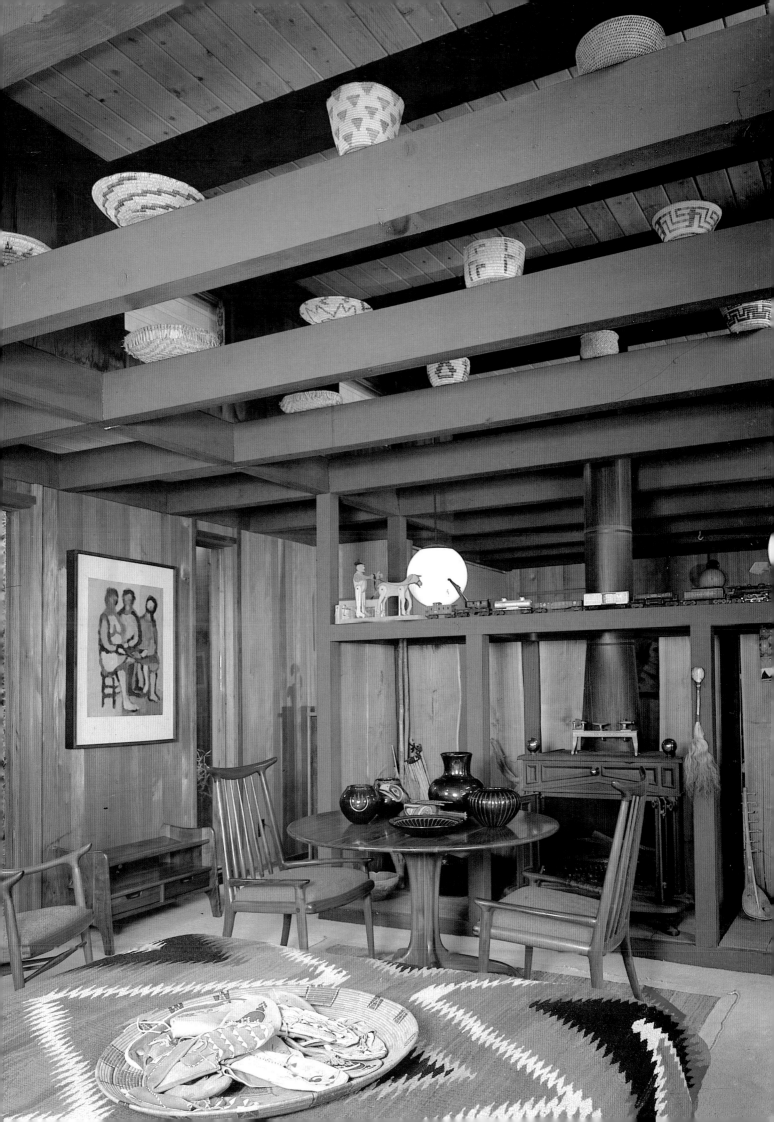

EPILOGUE

There is one thing that I remember very vividly as I look back over the years: my wife once said to me, "Sam, God has been very good to us." I hope somehow, in some way, that I have been able to give some of this blessing to others, perhaps in this book or in my lectures and workshops. I have tried to do this in the furniture that I have made for so many who have become my friends. So much of me goes with each piece that I make; how good it is that, in making each new piece, a renewal takes place. So it continues: a renewal in my commitment to my work and to what I believe.

In this world there is so much beauty; it is ours if we would only look. I remember walking under some eucalyptus trees in Santa Barbara with our children. They were gathering seed pods. Marilou brought one to me and said, "Dad, look at God's sculpture." If only we could look through children's eyes!

Too often we who make objects—and I speak of all media—become quite taken with what we have done. We accept all credit, all praise. We become smug and conceited. I believe no man has ever designed anything that approaches the complexity of the simplest flower or the grandeur of a great redwood tree. God is the Creator of all things, and the beauty He has given us is awesome.

I look forward to continuing working with my hands, to be able to share with all of my family and friends the joy and satisfaction I have had in working with wood.

Thank you. Blessings/Peace.

CHRONOLOGY

1916 Born in Chino, California. First son, seventh child, of Nasif Nader and Anise Nader Solomon Maloof. (Parents born in Douma, Lebanon.)

1934 Graduated from Chino High School. Began work as a graphic artist.

1941–45 Service with U.S. Armed Forces. Promoted to master sergeant, 1942.

1947 Worked with Millard Sheets.

1948 Engaged to and married Alfreda Louise Ward, June 27.

 Established independent workshop in a single-car garage, Ontario, California.

 First exhibition, Los Angeles County Fair.

1949 Birth of first child, a son, Slimen (1966: Slimen marries Kathryn Golden; two children: Samuel Aaron and Amy Rebecca).

1953 Purchased property in Alta Loma, California; made furniture in chicken coop.

 Birth of second child, a daughter, Marilou (1975: Marilou marries; two children: John Solomon and Alan Toivo).

1955 Built present workshop.

1959 Designer/woodworker/technician for Dave Chapman, Inc., and U.S. State Department project in Iran and Lebanon.

 First of family to visit ancestral home, Douma, Lebanon.

1963 Designer/woodworker/technician for Dave Chapman, Inc., and U.S. State Department project in El Salvador.

1973–76 Craftsman-trustee, American Crafts Council.

1975 Named fellow, American Crafts Council.

1979– Trustee, American Crafts Council.

1983 Working and very grateful for all that has transpired.

Exhibitions (since 1970)

"California Design," Pasadena Museum, California (included in all eleven exhibitions held from 1954 to 1971).

1970 "OBJECTS:USA," Smithsonian Institution, Washington, D.C.

1971 "Woodenworks," Renwick Gallery, Washington, D.C., and Minnesota Museum of Arts, St. Paul (1972).

1974 "In Praise of Hands," World Crafts Council, Toronto, Ontario.

1976 "American Crafts," Museum of Contemporary Art, Chicago.

"Cream of Wood," Following Sea Gallery, Honolulu.

"Exhibition of Liturgical Arts," Forty-first International Eucharistic Congress, Philadelphia.

"Please Be Seated," Museum of Fine Arts, Boston (solo exhibition)

"Vignettes from American Art and Life 1776-1976," Honolulu Academy of Art.

1977 "American Crafts 1977," Philadelphia Museum of Art.

"California Craftsmen," The Hand and the Spirit, Scottsdale, Arizona.

"Contemporary Works by Master Craftsmen," Museum of Fine Arts, Boston.

Fellows exhibition, American Crafts Council, Winston-Salem, North Carolina.

"L.A. Collects Folk Art," Craft and Folk Art Museum, Los Angeles.

Solo exhibition, Contemporary Crafts Gallery, Portland, Oregon.

1978 "Exhibition Six," Following Sea Gallery, Honolulu.

"Form, Function, and Fantasy," J. M. Kohler Arts Center, Sheboygan, Wisconsin.

Vatican Museum, Rome, Italy.

1979 "New Handmade Furniture," American Craft Museum, New York.

1980 "Thirty Americans," Galveston Art Center, Texas.

Vice-President's Mansion, Washington, D.C.

1981 "California Woodworkers," Oakland Art Museum, California.

"Made in L.A.," Craft and Folk Art Museum, Los Angeles.

1982 "Sam Maloof," Gallery Fair, Mendocino, California.

1983 "Crafts: An Expanding Definition," J. M. Kohler Arts Center, Sheboygan, Wisconsin.

"Wood Invitational," Craft Alliance, St. Louis.

BIBLIOGRAPHY

Books

Bishop, Robert. *Centuries and Styles of the American Chair: 1640–1970*. New York: E. P. Dutton, 1972.

Bishop, Robert, and Coblentz, Patricia. *American Decorative Arts: 360 Years of Creative Design*. New York: Harry Abrams, 1982.

Craft Art and Religion: Second International Seminar. Rome, Italy: Vatican Press, 1978.

Craftsman in America, The. Washington, D.C.: National Geographic Society, 1975.

Dudgeon, Piers, ed. *The Art of Making Furniture*. New York: Sterling Publishing Co., 1981.

Emery, Olivia H., and Andersen, Tim. *Craftsman Lifestyle: The Gentle Revolution*. Pasadena, California: California Design Publications, 1978.

Evans, Helen Marie. *Man the Designer*. New York: Macmillan, 1973.

Fairbanks, Jonathan L., and Bates, Elizabeth B. *American Furniture 1620 to the Present*. New York: Richard Marek Publishers, 1981.

Gatto, Joseph A. *Elements of Design: Color and Value*. Worcester, Massachusetts: Davis Publications, 1974.

Hall, Julie. *Tradition and Change: The New American Craftsman*. New York: E. P. Dutton, 1977.

Masterpieces from the Boston Museum. Boston: Museum of Fine Arts, 1981.

Paz, Octavio, and the World Crafts Council. *In Praise of Hands: Contemporary Crafts of the World*. Greenwich, Connecticut: New York Graphic Society; and Toronto: McClelland & Stewart, 1974.

Stoebe, Martha G., in collaboration with Billings, Hazel S., and Stoebe, Wallace. *The History of Alta Loma, California, 1880–1980*. Alta Loma, California: B & S Publishing, 1981.

Woodenworks. Washington, D.C.: Smithsonian Institution; and St. Paul, Minnesota: Minnesota Museum of Art, 1972.

Calendar

Wood 83. San Luis Obispo, California: Preuss Press, 1982.

Films and television

Handmade in America. Producer (for ABC): Barbaralee Diamondstein. 1982.

On the Go. Producer (for NBC): William Kayden. 1959.

Sam Maloof: The Rocking Chair. Producer: Bob Smith. 1983.

Sam Maloof: Woodworker. Producer: Maynard Orme. 1973.

Periodicals

American Crafts, October-November 1981, pp. 4-8.

American Forests, June 1957, pp. 12-13.

Architectural Digest, November-December 1971, pp. 76-80.

Better Homes and Gardens, March 1951, pp. 258-59.

Bonytt, April 1962, pp. 82-84. (This is a Norwegian magazine.)

Craft Horizons, May-June 1954, pp. 15-19; May-June 1964, p. 93; June 1966, pp. 16-19; May-June 1970, p. 64; August 1971, pp. 16-19.

Creative Crafts, October-November 1960, p. 14; January-February 1961, pp. 3-7; May-June 1971, p. 14.

Fine Woodworking, November-December 1980, pp. 48-55.

House and Garden, April 1968, p. 94.

House Beautiful, February 1954, p. 84; May 1954, p. 151; October 1954, p. 173; December 1954, p. 117; June 1961, p. 112; April 1962, p. 146.

Living for Young Homemakers, December 1955, pp. 88-91.

Long Beach Independent Press Telegram ("Southland Sunday" section), 22 March 1970, pp. 24-25.

Los Angeles Examiner ("Pictorial Living" section), 30 September 1956, p. 12; 25 March 1962, p. 8.

Los Angeles Times ("Home" section), 28 October 1951, pp. 24-25; 30 March 1952, pp. 10-11; 8 August 1954, pp. 13-15; 12 September 1954, pp. 19-22; 28 November 1954, pp. 19-20; 11 September 1955, p. 10; 22 January 1956, pp. 14-15; 29 January 1956, pp. 24-25; 15 July 1956, pp. 20-21; 27 January 1957, pp. 12-13; 25 August 1957, p. 20; 26 January 1958, pp. 18-19; 4 January 1959, p. 12; 10 January 1960, pp. 12-14; 17 January 1960, p. 40; 8 January 1961, p.35; 12 February 1961, p. 18; 10 September 1961, p. 17; 25 March 1962, p. 12; 9 September 1962, pp. 18-19; 20 October 1963, p. 23; 15 March 1964, p. 24; 27 September 1964, p. 30; 24 January 1965, pp. 20-22; 14 May 1967, p. 18; 21 July 1968, pp. 18-21; 29 September 1968, pp. 14-19; 12 September 1971, p. 12; 6 February 1972, p. 30; ("Midwinter" section), 2 January 1958, p.60.

Mechanics Illustrated, February 1983, p. 20.

Pacific Woodworker, February 1982, pp. 12-15; June-July 1982, pp. 6-13.

Perfect Home, April 1974, p. 2.

Scan, 22 February 1964, pp. 3-4.

PSA, September 1982, p. 74.

San Francisco Chronicle ("Sunday Bonanza" section), 16 May 1965, p. 42.

School Arts, March 1981, pp. 29-31.

St. Louis Globe-Democrat ("The Magazine" section), 26 February 1983, pp. 11-12.

Workbench, November-December 1982, p. 19.

Awards

1959 Hardwoods Industry Exhibition, Museum of Science and Industry, Chicago.

1962 Gold Key, National Home Furnishings League, Southern California Chapter.

1967 Outstanding Excellence of Craftsmanship, AIA, Pasadena Chapter.

1969 Craftsman Apprentice Program Grant (first recipient), Louis Comfort Tiffany Foundation.

1972 Craftsmanship in Allied Arts, AIA, Inland (California) Chapter.

1975 Fellow, American Craft Council.

1984 Fellow, National Endowment for the Arts.

1984 Collection, St. Louis Art Museum.

1985 Fellowship, John D. MacArthur and Katherine T. MacArthur Foundation.

1985 Living Treasure of California, State of California.

1985 California Classics, Los Angeles Craft and Folk Art Museum.

1986 Collection, Dallas Art Museum.

1987 Collection (five pieces), Los Angeles County Art Museum.

1988 Collection, Twentieth Century Wing, Metropolitan Museum of Art, New York.

1988 Gold Medal, American Craft Council.

PHOTOGRAPHER'S NOTES

An assortment of cameras and lenses was used to take the photographs for this book. Most of the color interiors were taken with a Sinar 4x5 and Schneider Super Angulon. 90mm f8 lens. The studio color shots utilized a 4x5 format with a Schneider 150mm f5.6 lens and a Schneider Symmar-S f5.6 210mm lens. A Mamiya RB-67 with a 90mm f3.8 lens was used for the bulk of the black-and-white photographs taken in the studio and the workshop. Because of its easy maneuverability, the Nikon F with 50mm f1.4 lens and F2 with 105mm f2.5 lens were also used.

The film used for the color interiors was Ektachrome types A and B. Exterior color photographs were shot on Ektachrome 64 and Kodachrome 64 films. All studio color shots were taken with Ektachrome type B. Panatomic X was used for most of the black-and-white studio shots. The workshop black-and-white photographs were shot exclusively with Tri-X film. HC-110 was used for the black-and-white developing and E-6 for the color processing.

Composition: CONTINENTAL TYPOGRAPHICS, Woodland Hills, California
Printing: TOPPAN PRINTING CO., Tokyo, Japan
The Typeface used is BEMBO